626
660-9068

Look!

It's a

WOMAN

Writer!

pioneers in Irish feminist publishing

CATHERINE ROSE
Ireland's first feminist publisher, founded Arlen House, 1975

EAVAN BOLAND (1944–2020)
Artistic Director WEB/Women's Education Bureau

DR MARGARET MAC CURTAIN (1929–2020)
Director, Arlen House/WEB, 1970s–1990s

RÓISÍN CONROY (1947–2007)
Co-founder/publisher, Irish Feminist Information/Attic Press

MARY PAUL KEANE
Co-founder and literary editor, Attic Press

We stand on the shoulders of giants

Éilís Ní Dhuibhne
EDITOR

Fa Cathleen :
Looking forward to welcoming
you to Ireland in person!

Look!

It's a

WOMAN

Writer!

Irish Literary Feminisms
1970–2020

Warmest wishes,
Catherine Dunne

ARLEN
HOUSE

Look! It's a WOMAN Writer!

is published in 2021 by
ARLEN HOUSE
42 Grange Abbey Road
Baldoyle, Dublin 13, Ireland
Phone: 00 353 86 8360236
arlenhouse@gmail.com
www.arlenhouse.ie

978–1–85132–251–0, *paperback*

Distributed internationally by
SYRACUSE UNIVERSITY PRESS
621 Skytop Road, Suite 110
Syracuse, NY 13244–5290
Phone: 315–443–5534
supress@syr.edu
syracuseuniversitypress.syr.edu

Typesetting by Arlen House

Cover image by Rosie McGurran
'The Weaver's Table, Inishlacken', 2016
private collection

Contents

Acknowledgements

Many people have been involved in this book's creation, and all deserve my heartfelt thanks. First of all, I want to thank all the contributors for their enthusiastic co-operation, their wonderful essays, and especially for their cheerful patience.

Martina Devlin's thoughtful and perceptive foreword is much appreciated.

Míle buíochas to Rosie McGurran for her beautiful painting on the cover. Thank you, Rosie, and not for the first time.

For encouragement and advice, a big *go raibh maith agat!* to my friends Professor Helena Wulff in Stockholm and Professor Margaret Kelleher, UCD, and to Professors Robert Savage, Suzanne Matson, Elizabeth Graver and James Smith in Boston College. Christian Dupont, Burns Librarian, Boston College, and my son Ragnar Almqvist in Washington DC have also been very helpful.

Catherine Dunne and Lia Mills have generously shared editorial work and proof reading. I am hugely grateful to them for their invaluable assistance.

Some work on this book was carried out while I was Burns Visiting Scholar in Boston College, at the Baltic Centre for Writers and Translators, Gotland, and at the Tyrone Guthrie Centre, Annaghmakerrig. Thanks to these institutions for their generous hospitality to me as a writer.

The teachers, editors and publishers who have encouraged and enabled my writing career are far too many to list. But I would like to express my gratitude in particular to those who helped in the early days: David Marcus, Mary Paul Keane, Anne Tannahill, Ailbhe Smyth, Caroline Walsh, Caoilfhionn Nic Pháidín, Seán Ó Cearnaigh and Cliodhna Ní Anluain. Also to Patsy Horton, Blackstaff Press, and to those who read, translate and comment on my work, especially to Giovanna Tallone, Luz Mar Gonzales Arias, and Dimitar Kambourov.

Finally, a huge thank you to Alan Hayes of Arlen House, an inspirational publisher whose promotion of Irish women writers during the past several decades deserves the highest acclaim.

Arlen House wishes to thank Luke Morgan for help with numerous images. And most especially to Dr Damian Smyth and the Arts Council of Northern Ireland for consistently supporting writers.

Ireland's earliest short fiction anthologies by women writers

The Wall Reader (Arlen House, 1979); *Sisters* (Blackstaff Press, 1980); *A Dream Recurring* (Arlen House, 1981); *The Adultery* (Arlen House, 1982)

In 1978 Arlen House: The Women's Press announced the first ever short story competition for women writers, sponsored by Maxwell House and judged by Eavan Boland, Mary Lavin and David Marcus. Over 1000 women, all previously unpublished in 1978, responded. As Boland says in her introduction to *The Wall Reader*, 'These ten accounts of disappointment, adventure, self-realization have tones and colours that could hardly have been projected twenty years ago in Ireland'. *The Wall Reader* was an unexpected success – reaching No 1 in the bestseller charts for many weeks in summer 1979. The 2nd competition, now open to poets also, was judged by Eavan Boland, Richard Llewellyn, Maire Mhac an tSaoi and Wolf Mankowitz, while the 3rd was judged by Benedict Kiely, Máire Mhac an tSaoi and Jennifer Johnston. Winners of these competitions, published in the anthologies, include Mary Rose Callaghan, Ivy Bannister and Fiona Barr (who was then published in Blackstaff's *Sisters* anthology in 1980). In 1981 a bursary scheme worth £500 was created for 5 longlisted writers (including a woman in prison). Ruth Carr was awarded £100, presented at a ceremony in Dublin by Beryl Bambridge, pictured below with Catherine Rose, October 1981.

Ruth Hooley, Belfast, receiving her share of the Maxwell House bursary from the celebrated novelist Beryl Bainbridge, at the Project Arts Centre.

Martina Devlin

Another tribe lived in close proximity to mine when I was growing up in the 1960s and 1970s. Often, I found myself on the outside looking in at them – observing their strange customs and behaviour. There was ample opportunity because that other tribe was composed of my five brothers.

From the outset, I was curious and more than a little envious. Their bicycles were flashier. Their slang was snappier. Their comics were cheekier. Their clothes were fitter for purpose. Mischief was tolerated from them – passed off as rascally high jinks. Trespassing in the convent grounds, playing in an overgrown place we called the jungle, begging for empty lemonade bottles from workmen on building sites to profit from the refund system in shops; all forbidden to my sister and me, yet somehow forgivable if the boys did it.

Initially, the differences between their tribe and mine were infinitesimal but over time they intensified. By my teens, another disparity had surfaced. Responsibility for chastity. It landed entirely on a girl's shoulders. We were instructed to patrol not just our own behaviour but that of the opposite sex. It was as if we were meant to envelop ourselves in cellophane to guarantee a sanitised version of life.

Little by little, however, social mores shifted. Holes punctured the cellophane. Air and light sneaked in. Possibilities, alternatives, opportunities revealed themselves and we girls developed expectations. Generally, our mothers urged us on.

At school, most of my class wanted to be one of the *Charlie's Angels* team, a US television series in which three feisty women worked as investigators in a private detective agency. At breaktime, we debated which angel we'd prefer to be and why. The show was glamorous, pacey and fun, although the angels' secret power wasn't nearly as imaginative as Spiderman's or Superman's. Their gift was an uncanny ability to keep blow-dries immaculate while karate-kicking criminals into submission. Still, at least, women were depicted on an equal footing to men, and breaking into professions traditionally associated with them.

By the 1980s, when I began training as a journalist, there were plenty of women in the building whose sole function wasn't to answer phones and fetch coffee. After our training finished, however, few of us were encouraged to settle into the newsroom – the most exciting part of the operation where front page scoops happened (sometimes). Instead, we were hived off to features, supplying copy for the women's pages, magazines and supplements, and if we had a column it was meant to focus on domestic issues. We didn't write editorials and we certainly didn't edit newspapers.

There was even a name for slots where photographs of women would appear in the paper. 'We need some totty top right on page seven,' a senior production journalist would cry, meaning a gratuitous shot of an attractive young woman. If you complained, you were 'difficult.' Looking back, it feels as if I'm describing a distant civilisation, rather than practices which continued well into the 1990s. Since then, every branch of the media has become less macho,

although pockets of resistance remain. The glass ceiling is cracking – it could still use a few hard whacks, mind you.

Some sixteen years ago, when I began writing in what was then the male preserve of the 'op-ed' (opposite the editorial page, the most prominent opinion slot), I was the first and only woman doing it on a weekly basis for the *Irish Independent*. In time, I'm glad to say, others joined me. But women like us didn't sprout by chance or because of any inherent exceptionalism. Quite simply, we benefited from opportunities denied to earlier generations.

The silver bullet in Ireland was free schooling. In 1967, parents no longer had to pay secondary school fees for their children, a public policy initiative which drove social change. Before its introduction, one child in three was hanging up their satchel after primary school, and by the age of sixteen only a third of children were still in fulltime education. Everyone gained, of course, both individual and society – but it proved transformative for women.

It seeded women with the confidence to express themselves through the written word. And a harvest of Irish women writers emerged producing novels, short stories, poetry, essays, plays and journalism instead of the letters and diary entries into which their literary aspirations might otherwise have been cramped. Here, in the pages of this book, they take us with them on their journeys towards and beyond that holy grail, publication.

Writers are born as opposed to made – wanting to be one has to beat inside somebody like a pulse. But not everybody born with the capability of becoming a writer can fulfil their potential. Life throws up obstacles: lack of means, lack of self-belief, lack of opportunity, lack of supports. Education can circumvent at least some of those barriers because it trains people to think, and to express the outworking of those thoughts in writing. Schooling helped that post-1967 generation to become what Julia O'Faolain calls head hunters. Her 2013 memoir *Trespassers* cuts to the chase: 'It

was the man's head we wanted really: the seat of his mind and soul. Trained to think male minds superior, how could we not be head hunters?'

With secondary school education now freely available irrespective of gender and family circumstances, girls learned something with far-reaching consequences. The female mind was smart – every bit as keen as the male's. The tripwires – I should not, I ought not, I must not, I cannot – were neutralised. Education was our Trojan horse and it sneaked us inside the citadel. Those with the writing gene were given a fighting chance.

It didn't automatically deliver publication for women with notions about writing. Men remained the gatekeepers – and gatekeepers are engineered to exclude people. However, publication did become somewhat easier, not least because of the feminist presses springing up. Even then, attracting attention for the text in its own right, without a smokescreen of preconceptions, could be problematic. These women had to battle self-doubt, reviewers' doubts and societal doubt, as they explain in their essays. If publication is a piece of work's intended destination, and usually it is, then rejection derails a writer. It is demoralising and destructive; some never recover from it. To ignore the slings and arrows and keep going takes courage – these women persisted.

When they started writing, their subject matter ranged from powerlessness and escape to the impossibility of either power or escape. Their canvas broadened during the course of their careers. But then, as now, they were expressing their sense of identity, and it deviated conspicuously from the *cailín deas* of national stereotype. It meant women could – and did – leave a candid record of who they were. As opposed to how others represented them.

An achievement worth celebrating? As the characters in those comics belonging to that other tribe, my brothers, tended to say: you bet.

Éilís Ní Dhuibhne

INTRODUCTION

The idea for this collection of essays came to me in the
aftermath of the Waking the Feminists movement,
established in 2015 in protest against the poor
representation of women playwrights in the Abbey
Theatre's programme commemorating the centenary of the
1916 Easter Rising. Many of the complaints and points
raised by the young(ish) women who were vocal in
Waking the Feminists reminded me, and my sister writers
and friends, mostly aged sixty or over, of the points we
had been making since the 1970s and 1980s, in groups such
as the UCD Women's Studies Forum, founded by Ailbhe
Smyth in 1983. Although we were fully supportive of
Waking the Feminists, and aware that in the Irish theatre
world, in particular, gender equality has not been
achieved, I felt that the earlier revolution regarding gender
issues in Irish literature had already been largely forgotten.
And I wonder how many current theatre practitioners,
female or male, know that 30 years ago there was a
movement established to address the status of women in
Irish theatre, founded by some of the contributors to this
book?

Now, in 2021, the fiction scene in Ireland might seem to
be dominated by women. Eimear McBride, Sally Rooney,
Nuala O'Connor, Claire Keegan, Sara Baume, and many

other brilliant writers have achieved great success and international recognition. They emerged into a literary world where even the term 'woman writer' can sound passé and irrelevant. But the scene in which these writers deservedly thrive was created by the previous generation, the female writers who emerged in the 1970s, 1980s and 1990s, into an Irish literary salon which was dominated by men to an extent which seems almost unbelievable today. In order to document the difference between then and now, as far as Irish literary history is concerned, I decided to assemble the essays in this book.

I did not ask contributors to address the question 'What has changed?' because we know the answer: a great deal where women and writing are concerned. I simply asked them to write about their own literary journeys. I believe the story of women writers in Ireland since the mid-twentieth century is very important in the history of Irish literature and for the history of Irish society – indeed I believe the change regarding gender representation which has occurred in the field of literature to be more revolutionary, profound and historically significant than anything else that has happened in the closing decades of the twentieth century. It is a story which needs to be told. And who better to tell it than the writers themselves?

Twenty-one writers, from the Republic of Ireland and Northern Ireland – poets, fiction writers and playwrights, writers in Irish and English – have written new essays for this collection. How they chose to write about their artistic lives I left to themselves, and as a result the essays are marked by originality, and are delightfully varied as to style, voice, concerns and even length. What the writers have in common is that they are women, and that they were born in the middle of the twentieth century – most in the 1950s. Several of the contributors enjoyed reflecting on and writing about their own literary careers. Others told

me they found the exercise more difficult and painful than they had anticipated.

I know that there are many more good women writers who were born in mid-twentieth century Ireland who are not included in this volume. Some who were invited could not contribute, for various reasons. Others were not asked, due to oversight, and also because of inevitable space issues. To them, my sincere apologies. There is room for much more writing of this kind, and for more memoirs and anthologies. Let us regard this as a beginning.

Why the 1950s? Dates are significant. When and where you are born affects your destiny.

David Lodge, in his memoir, *Quite a Good Time to Be Born*, observes that as a writer he was lucky with his birth date, 1935 – it meant free secondary and university education was available in the UK at the right time for him; so he began publishing novels when authors were still cherished by publishing houses, and could earn significant money. Timing matters.

You could say that the 1950s, twenty years later, was quite a good time to be born, if you happened to be an Irish female baby with a pen in her cradle. And that is when most of the writers in this book were born. Most were babies of the 1950s, some were born in the 1940s and one in 1960. My guess is that our lives would have been very different had we arrived on earth twenty years earlier. Would we have become writers at all? The essays here reveal that we would have wanted to be writers – many contributors mention their childhood writing. But, to purloin the title of Catherine Dunne's essay, would we have been writers for life? It is one thing to start, quite another to go on and start again, as every writer knows.

If one looks through a narrow historical lens at 1954, the year of my own birth and of three others in this anthology

(Mary O'Donnell, Catherine Dunne, Mary O'Malley) one could be forgiven for deducing that it was one of the worst years of the twentieth century in Ireland in which to be a writer, or a woman. That is not to condemn the 1950s out of hand. On the positive side, some aspects of Irish culture dear to my heart – Irish language, oral tradition and literature in Gaelic – were genuinely respected by state authorities and funded as much as limited resources allowed. And, as we should remind ourselves when confronting the present housing crisis, during the 1950s many social and affordable houses were built in the Dublin suburbs and elsewhere, in a relatively-successful attempt to ensure that people had a comfortable home. (I was born on one of the new estates of the 1950s in Walkinstown, County Dublin, a sort of 'affordable home' as far as I can discover). But the 1950s is also the decade associated with the highest levels of emigration in the twentieth century. Poverty was widespread. As Irish society has gradually discovered and acknowledged over the past two or three decades, women who were perceived to have transgressed the puritanical sexual rules were often treated very badly. The recent report on Mother and Baby Homes (2021) reveals more evidence of the deep misogyny which permeated Irish society.[1] Attitudes relating to homosexuality, contraception, abortion and divorce were firmly in line with the teaching of the Roman Catholic Church. All were illegal.

1954 was the Marian Year – a year devoted to the veneration of the Blessed Virgin. (The personal name which recurs most often in this anthology is Mary – Mary Morrissy, Mary O'Malley, Mary O'Donnell, Mary Rose Callaghan. One could include Moya Cannon and Máiríde Woods among the Marys). Barbara Tuchman in *A Distant Mirror*, her vivid history of the fourteenth century, writes that 'Women were considered the snare of the Devil, while at the same time the cult of the Virgin made one woman

the central object of love and adoration.'[2] One could suggest that in its essential if unarticulated fear of the female body, and its proud and voluble adoration of the unbodied ideal, the Virgin Mary, spiritual Ireland in 1954 was still a distant mirror of the Middle Ages.

Literature could not but be affected by the restrictive atmosphere of the time. Ireland now prides itself on its literary heritage and cherishes its writing tradition, to a degree. But writers were not cherished in the 1950s. Saints and scholars, yes, with the emphasis on the former. Not real live writers. This was particularly the case if they were novelists or writers of fiction in English. All our good novelists and short story writers suffered at the hands of the censor: Edna O'Brien, John McGahern, Norah Hoult, Frank O'Connor, Sean O'Faolain, Kate O'Brien. Their books rubbed shoulders with works entitled *Bound Ankles* or *Original Bitch* and *Sasha Gets Ravaged*. And anything that 'Advocates the unnatural prevention of conception, advocates contraception.'

We are inclined to laugh at the follies of our forefathers and foremothers now, and joke that you were nobody if you were not banned. But for the Irish writers whose books could not be sold in their own country, it was not always a laughing matter. I also suggest that the calumny of having one's book banned because it was deemed immoral would have had a more significant impact on women writers than on men, and certainly did not create an atmosphere which encouraged girls to embark on a literary career. Only the bravest and the best, like Kate O'Brien and Edna O'Brien, risked it – it probably helped to live outside of Ireland.

1954 was one of the worst years for banning; 300 books made it to the censor's list.[3] Perhaps things had come to a head? Although the banning of literary fiction that made any reference to sexuality continued into the mid-1960s, it began to slow down as the 1950s progressed. By the end of

the 1960s the censor focused only on manuals giving information on 'unnatural forms of contraception' and abortion. The Irish love affair with novelists who had resisted the mood of the land and had written against it during the dark days was about to begin.

And what did all that banning and puritanism matter to an infant, providing, of course, she had the basic luck to belong to a family which could look after and cherish her and could afford to stay in Ireland?[4] Most of the women who have contributed to this anthology were born during an all-time low. I don't think that necessarily means that the only way was up, but in the case of this country, much began to improve as the babies of the mid-century came of age. So, yes, although it was not an encouraging year for grown-up Irish novelists, 1954 was quite a good year for a baby writer to be born.

Changes occurred in the 1960s and 1970s which benefited everyone, but particularly women and particularly writers, and, eventually, perhaps inevitably, because everything hangs together, women who were writers. The introduction of free secondary education in 1966; the introduction of grants enabling more children to go to university in 1967; accession to the EEC (now the EU) in 1973 and legislation encouraging equal opportunities for women's employment – notably the lifting of the Marriage Bar in the Civil Service in 1973, were all major developments which changed the landscape for all women. By the time the babies of the 1950s were of an age to have babies themselves, 'unnatural forms of contraception' as the censor put it, were available. This was arguably the single greatest improvement in the condition of life for women; it paved the way for multiple other changes improving women's wellbeing and enabling them to have some chance of fulfilling themselves professionally, artistically and financially.

Women have been creating literature for a very long time, in Ireland as elsewhere. But until the late twentieth century they were in a minority. (Tellingly, only a tiny proportion of novels written in the Irish language in the twentieth century were by women). We have, of course, remembered and celebrated certain Irish women writers – we cannot claim that Maria Edgeworth, Somerville and Ross, Lady Gregory, among others, were ever forgotten or disregarded. But, before the commencement of feminist academic interest in Irish women writers (started in 1980 by Eavan Boland, editor at Arlen House), most were neglected or completely forgotten – they had no chance to become canonical. To their number belong Lady Morgan, Katharine Tynan, Eva Gore-Booth, Maura Laverty, Norah Hoult, Sheila Fitzgerald, Teresa Deevy, Janet McNeill, Annie Smithson, Elizabeth O'Connor/Una Troy. By the 1950s or the 1960s, only a tiny handful of women novelists or poets were well-known, and often they were not all well-liked – Mary Lavin, Kate O'Brien, Edna O'Brien. Mary Lavin escaped the censor – maybe short stories are safer than novels? Kate O'Brien, a bestselling novelist in England from 1931 to 1958, was hardly spoken of in Ireland when I was growing up. Edna O'Brien was censored and dismissed: the title of one of her books, *A Scandalous Woman*, could describe the way she was regarded in Ireland in the 1960s.

Norah Hoult, who published 24 novels and 3 short fiction collections dealing largely with the lives of women, and had the distinction of being banned more often than almost anyone else, was living in Greystones until 1984. Her last novel, *Two Girls in the Big Smoke*, was published in 1977 when she was 79. I had not heard of her, although I was a voracious reader and student of literature, until 1984 when Arlen House published her in the short fiction anthology, *Woman's Part*, and in 1985 a new edition of *Holy Ireland*, her best novel, with a preface written by herself –

her final piece of writing. These books were bestsellers for Arlen House.

Apart from key legislative and practical developments, there were winds of change throughout the world in the 1960s which began to influence Ireland in the 1970s and 1980s. Cultural feminism and literary feminism were flourishing in the United States, the UK and Europe. From the 1960s the second wave feminist movement forefronted writing by women and developed feminist theories of literary criticism. The drive to encourage more writing by women, and the rediscovery and republishing of books by women was a phenomenon which began in the 1970s. Virago Press, founded in London in 1973 by Carmen Callil to publish books by women, launched its first book, *Fenwomen*, in September 1975 (as a co-publication with a mainstream press). Simultaneously, in September 1975, Arlen House also published its first book, *The Female Experience: The Story of the Woman Movement in Ireland*, from Galway. In 1975 Arlen House, Ireland's first feminist press, was an independent company owned by a woman, Catherine Rose (with her husband). Soon Margaret Mac Curtain, Janet Martin, Terry Prone and Eavan Boland came on board.

Feminist literary theory was to have a profound effect on the production of literature by women in Ireland (whether the writers were aware of it or not). Popular feminist books, such as Simone de Beauvoir's *The Second Sex* (1949), Betty Friedan's *The Feminine Mystique* (1963) and Marilyn French's *The Women's Room* (1979) were making an impact on the way women thought. *The Women's Room* was Number 1 in Ireland in summer 1979; it was knocked off the top spot in the bestseller charts by *The Wall Reader*, the very first anthology of short fiction by Irish women writers, edited by Eavan Boland, published by Arlen House, funded by Maxwell House. This anthology includes the first story ever written by Mary

Rose Callaghan, and future anthologies in the series include poems by Ivy Bannister, both contributors to this volume.

When Catherine Rose founded Arlen House in 1975, the babies of 1954 were just coming of age. In 1984, when said babies had reached the age of thirty (the most usual age for any writer to publish her first novel according to Jane Smiley)[5] Mary Paul Keane and Róisín Conroy established Attic Press in Dublin – Conroy focused on feminist and political books, while Keane established Attic's literary list. Indisputably, these publishing houses served women's writing in the most important and practical way: they published and promoted it. But they also had a symbolic significance. They highlighted facts relating to the previous history of Irish letters – for instance that women's voices had been to a great extent silenced or ignored. And at the same time they changed the marketplace: they created a literary atmosphere in which it became fashionable, popular and profitable to pay attention to women's voices. Imitation is the sincerest form of flattery. As is pointed out in some of the essays in this anthology, it was not long until other publishers, and male writers, were undergoing a change of mind and heart about the value of women and women's experiences as suitable subject matter for literature. The library changed. The book changed. And the Irish imagination changed. Women's lives and experiences were deemed to be worth writing about. Women were no longer discouraged from exploring the domestic quotidian in fiction and poetry.

It was against the background of this exciting, revolutionary, controversial, above all lively literary scene, that the writers in this volume emerged. Indeed, they and their work created that scene. Most published their first books in the 1980s and 1990s. Several published initially with women's presses – Arlen House, Attic Press – or with presses which were not specifically feminist but which

welcomed women writers, Poolbeg, Salmon, Blackstaff, Coiscéim, Cló Iar-Chonnacht, Lagan and Summer Palace. For Irish language women writers, Cló Iar Chonnacht, Coiscéim and Cois Life have been ground-breaking.

To a writer nothing is as encouraging as publication. But other factors were involved in the transformation of the energy and the nature of Irish literature from the 1970s onwards. Foremost among these was the gradual rise of the phenomenon of writers' workshops, creative writing classes and writers' groups. Today, most Irish universities offer degree and graduate programmes in creative writing. That is a relatively recent phenomenon. Until the 1980s, creative writing courses and workshops of any kind were thin on the ground. Listowel Writers' Week was held for the first time in 1970 and was one of the first providers of creative writing workshops in Ireland, followed by the National Writers' Workshops held in UCG and funded by the Arts Council – Áine Ní Ghlinn participated in one of these in the 1980s. Several writers in this volume mention Listowel as an encouraging influence. Women were often in the minority, or not present at all, in early workshops which were dominated by male writers. The formation of women-only workshops – spearheaded by Eavan Boland – was undoubtedly a factor in supporting and encouraging women to write and to keep on writing. As I remember the trailblazing Boland saying, the workshops generated oxygen. Liz McManus, Máiríde Woods, Ivy Bannister, Evelyn Conlon and I were participants in the National Women Writers' Workshops, run by Arlen House, funded by the Arts Council, and facilitated by Eavan Boland in the 1980s. The Women's Educational Bureau (WEB), founded by Arlen House in 1984 with Eavan Boland as creative director, was the national association for women writers and organised wide-ranging events and provided training and support. The Cork Women's Poetry Circle, founded by Máire Bradshaw, led to Tig Filí arts centre and Bradshaw

Books which was a thriving publishing outlet for women from 1986 to 2017. Moya Cannon recalls how important for her was a workshop run by Dermot Bolger at the Grapevine Arts Centre in Dublin; she describes poetry readings in the Eblana Bookshop in Dublin, while the importance of the Cúirt Festival, founded by Fred Johnston in Galway in 1986, cannot be overestimated. The Irish Writers' Union was founded by Jack Harte in 1987, and the Irish Writers Centre, also established by Jack Harte in 1991, ran – and runs – workshops and courses on all aspects of writing. I am certain that, for women in particular, these workshops, groups and classes have been of considerable significance. Writing is a solitary occupation but writers encourage and learn from one another. Male writers had traditionally met in pubs – think of Paddy Kavanagh, Brendan Behan, Tony Cronin in McDaids in Dublin or the young ambitious Yeats meeting fellow writers at 'The Tabard' or 'The Cheshire Cheese' in London. For women, the writers' workshops and writers' groups provided a feasible alternative to the literary pub, a place where they could meet, read each other's work, share ideas and opinions.

It should also be noted that some women writers signed book deals with London publishers in the 1970s and 1980s, important voices such as Jennifer Johnston, Julia O'Faoláin, Clare Boylan, Maeve Kelly, Maeve Binchy, Ita Daly – while Molly Keane had an unexpected, late career revival in the 1980s. Often, though, their books were published in hardback editions only, so audience and sales were subsequently limited.

The twenty-one essays in this volume are all personal and all different. But certain themes emerge. A majority of the writers – although not all – wanted to write and began to do so when they were children. In her beautiful honest essay, Mary Morrissy tells us 'Your first attempt at fiction

is in the summer of 1967, at the age of ten. It's very hot. Of course it is; it's a summer in the past.'

'I plagiarized children's stories and re-imagined them with myself as main character,' writes Áine Ní Ghlinn. Mary Rose Callaghan says: 'I found a diary entry from age thirteen: "I will be a writer"'.

Medbh McGuckian tells us: 'So in the 1950s I wrote endless compositions in a neat backhand they were always getting me to turn italic. They were as far away from real life as possible. I was a boarder at Malory Towers with my very own dressing gown (plaid), slippers and a tuck box for midnight feasts. I had a puppy called Shep whose adventures filled several exercise books.'

Moya Cannon, on the other hand, recalls: 'I was not one of those young people who always knew she wanted to be a writer.' And Celia de Fréine declares: 'Nothing in my childhood suggested I might become a writer. No single event or set of circumstances encouraged it. I was a child who had little thought for the future.' (Although when one reads her stunning essay, one says, yes, there were signs, although maybe not the obvious ones).

Unsurprisingly, almost all contributors mention a love of reading, stories and language as the primary reason for their interest in writing. But in addition, either at the start of their writing lives or along the way, some were inspired clearly and directly by impulses which can be termed political or feminist. Indeed, the challenges of life for women in Ireland, and the slow pace of political and legislative change, galvanised some women into writing. Like the previous generation of writers – O'Connor, O'Faolain, O'Brien – they had something to write against. Lia Mills, like most of our contributors, wrote from childhood. But she was motivated to write her first novel by anger and frustration at the way rape victims were treated: 'In Ireland, a person who is raped appears in court in the capacity of witness. S/he is not entitled to legal

representation.' Her desire to explore the position of abuse victims compelled her to write *Another Alice*. 'I have to say, I didn't much want to be the one to write Alice, but I knew I had to be.'

Catherine Dunne, although a writer from childhood, felt compelled to begin her first novel in the 1980s. She campaigned actively in the abortion referendum of 1983: 'We lose. Women will continue to pay the price for another thirty-five years. And in 1986 the Divorce Referendum also fails ... I know that Ireland is not a good place to be a woman. I don't want to be here anymore. But Canada turns us down. With a four-year old child and an increasing sense of restlessness, I write.'

Evelyn Conlon, also an early writer whose first books appeared in the 1970s and whose first stories were published by David Marcus in 'New Irish Writing', changed direction and found that it was harder to get published as a result: 'My interests and subject matter changed. I wanted to write about how we – women, men, the entire country – were beginning to jump over the wall. I was affected, the way some writers are, by all that was happening around me. But these stories didn't fit on the national grid.'

I was a writer from childhood, and started publishing before I had any sense of feminism or any awareness of the position of women writers in Irish literary life, but I attribute my determination to persevere as a writer, in spite of several competing interests, to my baptism as a feminist in UCD in the mid 1980s.

Mary Dorcey also wrote from childhood: 'As a small child I was forever making up stories, songs and poems and exasperating any adult who would listen by reciting them.' But gender and LGBTQ politics played a huge role in her later literary development: 'The student politics of the 1960s and early 1970s in the UK and the US laid the foundations for my politics. I learned about civil rights, the

women's liberation movement, the black power movement and went on anti-war marches.' In 1982, her first collection of poetry aroused shock. It had to be published in London by a lesbian feminist press. In Ireland: 'No one had ever seen the word lesbian on the cover of a book of any kind before this, or poems that celebrated love between women.'

Liz McManus has been a professional politician – a county councillor, then a TD and Junior Minister, and her fiction reflects an abiding interest in social justice. Celia de Fréine's second collection of poetry, the highly-successful *Fiacha Fola*, focuses on the Hepatitis C scandal (1600 women developed Hepatitis C as a result of being contaminated by Anti-D immunoglobulin. The Irish government and health board fought hard to deny responsibility for this mistake).

Unsurprisingly, the writers from Northern Ireland had a radically different experience of politics from those in the Republic. What Anne Devlin, with her gift for always finding the fitting phrase, describes as 'the wave of history' – in which she and other writers from the North were, inevitably, 'swimming' – has had a more striking and stronger impact on writers from Northern Ireland than on those who lived through peaceful change in the Republic. Hotly debated and emotionally tempestuous as the gender wars here were, they never erupted into open violence on the streets. Anne Devlin was more directly affected than most. But the Troubles, beginning when they were teenagers or young students, were the inescapable context for writers Medbh McGuckian, Sophia Hillan, Ruth Carr and Cherry Smyth. Cherry Smyth writes: 'Once I dreamt that I was taken to a deserted house by the IRA and tied to a chair, about to be shot. "I can't die," I cried. "I have more to write".' For Ruth Carr, the Troubles meant that the first time she won a literary prize, the awards ceremony was cancelled: 'It was 1969 and, due to the state of unrest, the

award ceremony at the New University of Ulster (as it was then called) was cancelled. I received a letter with a cheque in the post. I remember also that when the poem was later published in the school magazine, it was a sobering experience. The subject was my father and our struggle to communicate with one another. This difficulty was confirmed by the fact that he was very proud of my success but ignored what the poem was asking of us both.'

Sophia Hillan, however, points out that the 1970s in Queen's University, Belfast, had its compensations: 'For those of us who were there, however, it was also the glorious period when Seamus Heaney was on the staff teaching such distinguished contemporaries as Medbh McGuckian, Paul Muldoon and Ciaran Carson.'

Sectarian politics in the North always tend to push everything else into the shadows, but the women of the north were far from blind to gender issues. Sophia Hillan, for instance, remembers that it was difficult for a married woman to use her maiden name, and that women were paid less than men for the same work (in her case, as a secondary school teacher – in Dublin, as it happens, but the situation would have been the same in her native Belfast in 1975). And however glorious it was to be taught by Seamus Heaney, Medbh McGuckian remembers the undeniable gender bias in Queen's.

It took until 1985 for the first anthology of Northern Irish women writers, *The Female Line*, edited by Ruth Carr, to be published, by the brilliantly-named Northern Ireland Women's Rights Movement.

While it is indisputable that the changing gender politics in Ireland affected their literary careers, particularly in the provision of opportunities for publication, many contributors do not feel they were directly influenced by gender, or any, politics in their personal literary

development. Other factors were more important in their formation.

Geography, in the broad sense, is one of these. Mary O'Malley was inspired by the impact of the economic recession of the 1980s on her native Connemara to concentrate on writing. She returned from Portugal, where she had been a university lecturer, to Galway in the late 1980s: 'Connemara, where I'm from, was devastated, emptied of hope and youth. Everyone that could go had left. It was the time of the illegals [in the US] ... If I was serious about writing, it had to be now.' Mary Rose Callaghan writes, simply, 'I became a writer when I went to America. It would never have happened if I had stayed in Ireland.'

Ivy Bannister, however, had the opposite experience. She became a writer because she emigrated from New York to Dublin. The title of her essay, 'Dublin Made Me a Writer', speaks for itself: 'Dubliners weren't in the least like New Yorkers. They weren't in such a hurry. They noticed each other. They milled about in a ferment of awareness, observing and remembering. Everyone was writing, acting, painting or dreaming; and if you were on the street, likely as not, you wanted to talk.'

Phyl Herbert is a native of Dublin (like nine of the contributors to this anthology, confirming Ivy Bannister's sense of Dublin as a crucible of literature – indeed the publisher of this book is one of the founders of Dublin UNESCO City of Literature, Dublin being the fourth city in the world to have been awarded this prestigious designation). Phyl also found Dublin to be a city of literature. Her own story is perhaps the most dramatic and moving in this anthology, and it is intertwined with a fascinating account of Dublin's theatre scene (still contentious from the point of view of gender equality, as the Waking the Feminist movement attests): 'Dublin in the

1970s was a place where drama unfolded in a number of basement theatres.'

Moya Cannon writes: 'As a recent graduate of history and politics, I thought that I would be writing political poetry. Instead, I found that the imagery which came to me was full of the windy skies, the mountains, headlands and shores of my Donegal childhood. Every writer writes out of the strata of emotional, intellectual, physical and spiritual experience laid down since earliest childhood.'

Mary O'Donnell, from Monaghan, while quite feminist and very conscious of gender issues, pays tribute to place as a key element in her formation as a writer: 'I also read Patrick Kavanagh, whom I love with a fervour that has as much to do with the place he came from as it has with the poetry. I know his landscapes, desolately beautiful, and how such places can turn people to either madness or writing. The light in the reeds of poorly-drained fields before Ireland joined Europe, the ice edging a lake on a winter's morning, or the fields bulking up with oxeye daisies in July: all this provides an insight into some of the things I believe Kavanagh responded to.'

Much goes into the formation of a writer. Several contributors mention influential teachers, mainly encountered in secondary school. Parents who encouraged reading – and, sometimes, writing – are also honoured.

What is mentioned most frequently as a key factor is early reading. Most contributors recall how they loved stories or poems or plays or films when they were children. Favourite authors and books which are mentioned several times are also perhaps not surprising, reflecting the popular children's literature of the 1950s and 1960s: Enid Blyton is probably the most frequently mentioned. Louisa May Alcott – and her famous character, Jo March – crops up more than once. Máiríde Woods represents many when she writes: 'I read omnivorously – classics, comics, Patricia Lynch, Angela Brazil as well as

every Enid Blyton I could find. In a world where goodness was important I fell in love with *Little Women* and Jo. As a homesick boarder in Loreto, Coleraine I was consumed by *Jane Eyre*.' Ivy Bannister says: 'I was thirteen when Daphne du Maurier's noir novel, *Rebecca*, convinced me that I wanted to write.' Surprisingly, nobody mentioned as an influence Eilís Dillon, one of the biggest names in children's (and adult) literature from the 1950s to 1990s.

It's worth observing that the reading material which first engaged the writers, when they were children, was mainly written by women – traditional writers of children's fiction. Another recurring trope is that, as our authors got older, in school and especially in college for those who went on to third level to study literature, the writers they read were mainly, almost exclusively, men – again a reflection of the syllabi of the 1960s and 1970s. Medbh McGuckian remembers her reading lists at QUB: 'In the 1970s the whole scene became militarized while the literature course at Queen's was even more colonial, apart from Joyce and Yeats. Seamus Heaney introduced us to Kavanagh and McNeice, but the only women mentioned were the Americans Emily Dickinson and Sylvia Plath, both highly eccentric, while the Russians Akhmatova and Tsvetaeva were only heard of in graduate school. All of these women were portrayed as weird or suicidal.'

Máiríde Woods – also from Northern Ireland – did not find the English syllabus in UCD any more inspiring or gender balanced than Medbh's in Belfast: 'But when I reached UCD in the 1960s I lost my way. The English syllabus was very different from the A-level one I had loved and seemed designed to put a young person off. Mainly we read minor texts by dead authors. *Comus* was the one that evoked my greatest loathing. The student's feelings about these were deemed irrelevant.'

Gender balance was not a term with which we were familiar in the 1970s, and professors, teachers and editors – not to mention students – simply didn't consider it.

The writers of the essays in this book were born, or raised, in a Republic of Ireland and Northern Ireland in which women were second-class citizens who did not enjoy the same rights as men. They came of age just when the issue of gender equality was being agitated for, and was starting to effect political change and legislation. They are growing old on an island where a great deal has changed, for the better, as far as women are concerned. They have participated in, and created, a new and more egalitarian literary scene through their literary activism, but above all with their writing. They were, quietly, movers and shakers. They are literary survivors.

'I am 73 years old and I'm in the middle of writing my third novel,' writes Liz McManus, who has stayed the course while also bringing up four children and pursuing a successful career as a journalist and as a politician. Mary O'Donnell began writing when she was in hospital at the age of twelve. Her latest book was published in 2020. I published my first short story in 1974, and my latest book in 2020, 46 years later. Moya Cannon published her latest collection in 2019, Celia de Fréine in 2020, both have new books coming out in 2021, as have Evelyn Conlon and Phyl Herbert among other contributors.

And so it is with all of the women here. They had a talent and they have worked and kept their focus through decades in which every kind of event that life throws at human beings, happy and sad, has occurred: love, marriage, motherhood, professional careers other than writing, financial worries, serious illness, divorce, bereavement. The impetus to become a writer was innate in most of us. But if the environment had not been reasonably supportive, had it been even more difficult to

find publishers and readers than it was, had it not been for the feminist movement which changed the patriarchal view of literature in Ireland, would we have continued?

'Start. Finish. Start again.' 'Ever tried. Ever failed. No matter. Try again. Fail again. Fail better.' Men writers have been following these pieces of advice for a long time. It is only since the second wave of feminism, which lapped up on our shores in 1970, that women writers in Ireland have been let in on the secret, have realised that it's not enough to start. You must go on.

The generation of women writers born in and around the middle of the twentieth century constitutes a key group or school of writers, a group that had not yet been given a name, but which was ground-breaking and which has and will always occupy a significant place in the history of Irish literature. In due course that history will be written by academics and literary scholars – some of it has been written already, in articles and books and MAs and PhDs about the writers included in this volume. But now the story is told by the writers themselves.

Here, in their own words, the story of the women who are the way-pavers of post-modern Irish women's literature.

NOTES

1 The dark story of Ireland's mistreatment of women and children is told in books, government reports and media programmes such as *Redress* (RTÉ, 2 March 2020). See the *Final Report of the Commission of Investigation into Mother and Baby Homes* (Dublin, Department of Children, Equality, Disability, Integration and Youth, 2021) and Caelainn Hogan, *Republic of Shame* (Dublin, Penguin Ireland, 2019).

2 Barbara Tuchman, *A Distant Mirror* (Penguin, 1978), p. 53.

3 I have taken this figure for the period reports on censored books from *The Irish Times*.

4 It is worth noting that none of the writers in this volume were brought up in an institution such as an industrial school or an orphanage. Phyl Herbert, however, refers to her experience in a

Mother and Baby Home (where she was treated well, as it happens). Some men with dark experiences became writers of note – Mannix Flynn, Patrick Galvin. The poet Connie Roberts grew up in an industrial school in Offaly in the 1970s. She won the Patrick Kavanagh Award for her debut collection, *Little Witness* (Arlen House, 2015) which was a bestseller and is now in its 3rd edition.

5 Jane Smiley, *Thirteen Ways of Looking at the Novel* (New York, Knopf, 2006).

1980–1987
Classic Literature series

In 1979, Arlen House, inspired by Carmen Callil's recent launch of Virago Modern Classics, announced a new series of classic literature by Irish women writers whose books were out of print and forgotten. Eavan Boland was series editor and she championed Kate O'Brien, writing the preface to *The Ante Room* (1980). In 1984 Arlen House founded The Kate O'Brien Weekend (now Limerick Literary Festival) to commemorate her life and work; the first event was organised by staff member Louise Barry, and included a reading by Maeve Kelly.

Other authors championed included Norah Hoult, Anne Crone, Janet McNeill and Katherine Keane (grandmother of Madeleine Keane, now *Sunday Independent* literary editor). For Norah Hoult, the financial support given and interest shown in her work must have been helpful in her final years. Many other titles were planned and announced – with inspired suggestions by Janet Madden-Simpson – but they fell foul of the vagaries of publishing and funding agencies.

The titles published were critically acclaimed and large sellers. They demonstrated that Irish women had a distinctive literary heritage which was worth exploring, commemorating and celebrating.

Look!

It's a

WOMAN

Writer!

Between 1980 and 1997 Irish Feminist Information, Attic Press and Basement Press published annual diaries for women, including, in 1995, one issue of *The Gay Diary*. These diaries, entitled variously *The Irish Women's Diary and Guidebook*, *The Attic Guide Book and Diary* and *The Attic Book of Contacts and Diary*, included numerous articles, reading lists, national and international contact information, menstrual calendars, illustrations, photos, cartoons and adverts.

Co-ordinated by Róisín Conroy, Mary Paul Keane, Carole Ward, Therese Caherty, Emer Dolphin, Ailbhe Smyth, Michelle Cullen, Gráinne Healy, Marie Cotter, Patricia O'Brien, Ruth Burke Kennedy and Feargha Ní Bhroin, among others, the diaries were essential sources of information (particularly in the pre-internet age). They were also huge sellers, with some issues selling up to 10,000 copies.

Cherry Smyth

Famished
Cherry Smyth

Pandep Press

CHERRY SMYTH

ONE WANTED THING

Cherry Smyth
Hold Still

Test, Orange
Cherry Smyth

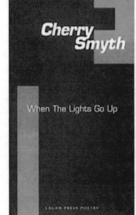

Cherry Smyth

When The Lights Go Up

LAGAN PRESS POETRY

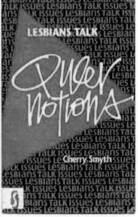

LESBIANS TALK

Queer Notions

Cherry Smyth

CATCHING MYSELF ON

1 *How Did It Start?*

Start there. Start where the rain on the window started, from Donegal, in scraggy veils from the north-west, from what was called the South, that lay at once over the sea and overland. I could have made maps to understand where I was but the lines meant nothing without words and slowly words made contours make sense.

2 *Words for Weirdos*

Words that made the weird, the wonky, the wacky, the wan, laugh or look up, look longer – stare. Words mapping weirdness, the one remove of weird, closer, not to normal, but to the wholeness and clarity of belonging. Wait, weirdo gets approval through a racket of words put in a weird quiet. Simple. 'That's wheeker!' A way with words. A path to clapping, soft in the hard, eyes welling up. Writing made me weep: the hot, happy, alive-to-sweetness greet.

3 *'If You Can't Say Something Nice, Say Nothing'*

I'm only saying to touch the unsaid, the unsayable. 'You said it!' That fire in the eyes, the heat of exclamation when something new has been found, something deep's been dug up, something too sad for words, released in syllables.

Find, exhume, let go. A kind of communion, making a community of looks, of knowing, then going on linked by understanding, mutuality. Writing made thoughts sayable, made self knowable: my thoughts and theirs; my self and others'. But there's a danger in digging things up. Half a gold bracelet always longing for the other half on the shores of the Bann; a calf longing for its shin on a beach on the border. Only recently did I learn that 'Houl yur wheesht!' probably comes from the Irish *fuist* meaning 'hush'.

4 *Of Course it Mattered that I was a Girl*

From the ratio on the plate to the sister-sized ambition, the lesser inheritance. Who says? Long tall Sally says. The fierce injustice of brother portions. Rebel, rebel, you've torn your dress. A job of my own, a house of my own. There was a word for it: the F-word. An orgasm of my own. Alice Walker called it pearl. Toni Morrison called it Sula. Ann Brady called it Frances Molloy and rang the bells with our clappers. I chased away the magpie but kept my fingers crossed. Like I believed. That's how a shrine starts, with a finger, a pebble, a feather, a pen. The Mary Dorcey shrine. The altar of Audre Lorde. The kneeling at the tabernacle of Adrienne Rich. Only ever able to touch myself when I'd quit that island, played Joan Armatrading 'All the Way from America' on repeat in a rented room in Haringey. I read and clubbed and protested my way out of the North and never looked back. But the poems did. Always looking over my shoulder, sounding home in my ear. The sweet, sexy sheugh of it; the messy, bloody clarry of it. Hot tramp, I love you so. 'You are nothing but a sexpot!' my mother said. I was ironing Dad's vests. A puff of steam.

5 *Some Words, the Mind Chews, Never Swallows*

The pasty taste and shape of fadge; the shaded, spicy hide of dulse. 'A poem must rival a physical experience.'[1] Some art, some poems pull the whole body in, into the electric peace in the mind of its maker. Three roundish shapes move from grey to beige to white in a William Scott painting* that happens like an event. And holds. I have been the white round falling off the edge and the hand-rounded beige patted on a floured table; I have shrunk to grey, embarrassed by the form I take, wishing for leaner, the lighter grey circle under the limpet, its muscular retraction when hit by light.

6 *Are All Poems a Waking Dream?*

The dreamt poem is a marvel the awake mind has lost. Is the dreamer a better poet or a kinder critic? Once I dreamt that I was taken to a deserted house by the IRA and tied to a chair, about to be shot. 'I can't die,' I cried, 'I have more to write.' At times I need a gun to my head. At times my head is a gun. At times I am the commander holding fire, rigid with outrage, nimble as a dancer. She passes as a pedestrian.

7 *All Words Have Already Been Used*

8 *'Sectarianism Kills Workers'*

The only Ulster graffiti that ever reached me, opened me instead of closed me, flowered a way to see difference, division under another sun. I kicked with the wrong foot but I kicked. You can't make contact if you're not there. I made what wasn't there, there: a post-prod nationalist queer. It was always there. Entering Free Derry as part of the first Gay Pride Parade in the mid-80s was the first time I felt civically free in my own country. The second time was at my first poetry book launch in Belfast's Old

Museum Arts Centre. Writing is a way to speak while you're shut up. Writing speaks for you when you're not there. I left and kept returning in language. In language, I never left.

9 *Rust and Stone, Blood and Bone*

All the hauntings of flesh and place, the lost, the leaving, the gone. Writing, like a forked hazel stick, twitched and dipped to loss and inhabited it as if to re-people it, in me, in the land. It's a slow walk, a listening walk. Sometimes it's a waiting watch to see if something will come alive again. Then you realise *it is you* you are waking and you can write. What I couldn't face, I wrote. It has been a kind of shield, a mirror to Medusa, that turns biting snakes to rock. Many rocks make a causeway, a stepped path across water, a Cubist landscape that made myth touchable, made Paris approachable. There's a warrior in it, this idea of a cunning shield, both reflector and deflector, a myth-maker. She goes back, years later, along the river's edge, past where seaweed and sheep's wool catch on the barbed wire in dark and light webs, along the hush, or *hois*, of the backdunes where tides eat at an old pier, looking for the other half.

10 *Says She to Me, Was Thon You? Says I, Who?*

NOTES
1 Mary Ruefle, *Madness, Rack and Honey: Collected Lectures* (Seattle, Wave Books, 2012), p. 131.
* The William Scott painting referred to is 'Still Life (MJ2)', 1958, oil on canvas.

Cherry Smyth is an Irish poet and art writer living in London. Her fourth collection, *Famished* (Pindrop Press, 2019), a book-length poem, explores the Irish Famine and how imperialism helped cause the largest refugee crisis of the nineteenth century. *Famished* also tours as a performance with vocalist Lauren Kinsella and composer Ed Bennett, drawing on the power of collective lament, using music and expanded singing. Smyth also writes for visual art magazines including *Art Monthly* and has written essays for Elizabeth Magill, Orla Barry, Mikhail Karikis and others.

Twitter @CherrySmyth
Instagram @cherrysmythpoet
www.cherrysmyth.com

BIBLIOGRAPHY

When the Lights Go Up (Belfast, Lagan Press, 2001)
One Wanted Thing (Belfast, Lagan Press, 2006)
Test, Orange (Tonbridge, Pindrop Press, 2012)
Hold Still (London, Holland Park Press, 2013)
Famished (Glasgow, Pindrop Press, 2019)

Evelyn Conlon, *Where Did I Come From? A Sex-Education Book for Young Children*

Evelyn Conlon published this sex education guide for children in 1982. *Where Did I Come From?* was illustrated by Madeleine O'Neill and distributed by Arlen House, Women's Community Press and, in the UK, by Turnaround. It went into subsequent editions in 1983 and 1984. A brave, essential book, it was the first of its kind to be published in Ireland.

Mary Morrissy

CRINGE

I *The Town of Fibs*

Your first attempt at fiction is during the summer of 1967. You are ten. It's very hot – of course it is; it's a summer from the past. But no, really, it was. The tar on the road curdles and softens and gives off a singed smell. It is too hot to walk on in bare feet. The soundtrack is Scott McKenzie's 'San Francisco (Be Sure to Wear Flowers in Your Hair)' – written for another summer entirely in Haight-Ashbury, the exotic elsewhere. Meanwhile you're on a holiday in a rented house in Portrane, with your mother, two brothers and sister – and your father on weekends when he escapes his civil service job in Dublin, fifteen miles away.

You are going through a tomboy phase, wearing hand-me-down shorts from the boys and a grey sweatshirt they've both grown out of, sent from relatives in America. Sweatshirts are unknown in Ireland at the time, so this quintessentially American fashion item is much coveted and envied. It gives you an extra swagger. You don't know where the idea comes from but suddenly – it seems – you decide you're going to be a boy. (Now, of course, you understand why – your sister, then a cute two-year-old cherub who came as a great surprise – to everyone – has inherited your mantle as the baby of the house). You have unconsciously found a way out of that conundrum. You

will keep on wearing your brothers' clothes as you do now, you will call yourself 'Mark' which requires only the change of one measly letter in your given name. The transition shouldn't demand too much of anyone else, you think. When you get back to Dublin, you'll get your hair chopped – it reaches to your shoulder blades and is plaited for school. Despite all the internal planning, you decide to keep this new identity secret for the moment until you have perfected it. While the holiday lasts you live as 'Mark', but tell no one. ('Mark' does not survive the summer).

Your father arrives on Friday nights. On Saturday mornings you go swimming with him. The route to the beach is along a sandy track, lined with spiky dune grasses. On one side is a picket fence and behind it is a field filled with an assortment of homes – chalets (glorified sheds, really) built with odd bits of timber, railway sidings and corrugated iron. There are caravans tilted at precarious angles with breeze-block doorsteps, and old train carriages, tarted up in bright colours, grounded on brick towers as if to stop them escaping.

'That's Baile Phib,' your father says pointing to the summer shanty town. 'This is where the Number 19 ends up.'

(Baile Phib is the Irish translation of Phibsborough, a northside Dublin suburb, and is familiar to you from the destination window on buses).

You can barely credit this – that the 19 bus travels this far? Into the country? As far as the sea? But he says it with such authority that you believe him. He is your father, after all.

II *Caesar's Gallic Wars*
Three years later he will die, after an eight-month long illness. You don't know this until about two weeks

beforehand. In your mind he has been sick for so long that you find it difficult to remember him any other way. Every day when you come home – you're in secondary school now – you climb the stairs to the bedroom to tell him the news of the day. It is usually dull fare – what you read in English or did in Irish, something from history, a bit of Latin translation. But one day a visitor comes to school, someone from the outside, and provides a break in the routine. You recall nothing about this emissary – not even if it was a man or a woman. But you do remember the slide show in the school hall about the perils of smoking and its links to cancer. You tell your father all about it. The slides have given you lots of ammunition – those tumour-pocked lungs in ravishing technicolour, as lurid as bottled babies in formaldehyde. You spare him none of the detail, describing how the rogue cells spawn and multiply and overwhelm the healthy organs of the body that fall, good soldiers slain in an uneven battle. You draw on all the metaphors of war that were used in the presentation. He asks questions; you rattle on.

I see, he says, as you talk about the statistics of certain death.

As far as you can remember, he reacts no differently than if you'd been describing a lesson from your Folens French primer or talking about Caesar's Gallic Wars. When you've run out of steam, he pats your hand – his has turned to claw – and tells you to run downstairs and start your homework. As you reach the door of the room, a terrible thought strikes you. What if *this* – cancer – is what he has? But no, you dismiss the idea as being like something you'd see in a book or a film. For years afterwards you think you might have hurried his death along by describing its process to him with such forensic relish. Even now, you cringe when you think of it.

III *The Spirit of Progress*

After some almost accidental publication in your late teens, you are scribbling away. That's the best description of it, an unwilled, spontaneous act not weighed down by the burden of expectation. It's a background activity.

In the foreground of your life, you're broadening your horizons. In 1979 you get a working visa for Australia. Australia is your dream world, the place you've always wanted to see – its landscape, its largeness fascinate you. You get copy-editing work in Sydney, live in a flat with some Irish ex-pats on Station Street, Wentworthville, a far-flung western suburb. It's not quite the harbourside penthouse you fantasised about but you feel that great inhalation of freedom that comes with stepping off the island. Ireland, that is.

You are seduced by life in Sydney, an impossibly futuristic city to your eyes used, as you are, to the dimmer confines and darker mood of your native Dublin. Here everything seems open, possible. Perhaps it's that which prompts you. Or is it the repetitive and restricted diet of women's magazine journalism – your working day involves editing down recipes. Or has the lucky country liberated some aggrandised sense of your secret self? Whatever it is, you decide you will devote yourself to writing, forsaking all others – apart from your six-month boyfriend whom you've promised to go back to Ireland for. You make this vocational decision in a small town called Junee close to the border of New South Wales with Victoria, roughly halfway between Sydney and Melbourne. You're on your way to visit cousins you've never met who live in a place called Sunshine – which you've always imagined as a bushy, untamed place, a cross between the set of *The Flying Doctors* and *Skippy*. (You realise your mistake when you actually see Sunshine).

You step off the train – which is, improbably, called 'The Spirit of Progress'. Even the trains here have aspirational

names! You're joined by the train's catering staff – this is where the shift changeover is. There are two hotels on either side of the street, their barred balconies baring their teeth at one another. You choose the Loftus Hotel. Impressions of brown, both inside and out. Room 11 overlooks the railway tracks and the rhythmic drumming of trains passing through and the clangour of the level crossing bells continues through the night haunting your waking and sleeping. In the bedside table there is a Gideon *Bible*. There are sounds of revelry from the bar downstairs, but you're too shy to go there on your own. Who would the clientele be? Sheep shearers? Farmers? Commercial travellers? Instead you snack in your wainscoted room, then lie on the bed staring up at the stilled fan in the brown-varnished ceiling and will yourself to create meaning in your life. (You're 22 and think this is within your control). Now is the time, you tell yourself. You will write, you will write, you will write.

IV *The Black Hole*

This optimistic spirit doesn't persist once back in Ireland, but the decision holds. You're writing, all right, but now it's a desperate, furtive activity that can't be named or admitted to and doesn't amount to much. (When you cared less about it you had more success). The most important thing about it is that no one must know what you're doing. You're married to a musician (the boyfriend from the section before). Your young husband has no such qualms. He's out in the world, performing. It isn't that he hasn't struggled, but at twenty-seven he's on the road, sure of his gifts and sure of yours, even though you aren't. When he tells people you write, you cringe. You'd die if people knew; you cannot claim to be a writer without proof.

The proof threshold is never defined, even to yourself. When you face the blank page you're suffused with a

poisonous cocktail of emotions peculiar to the writer – two parts dread to five parts loathing. Dread that your material is so thin it will disintegrate on the page, that you simply don't have enough ideas, that your world is too small and too narrow to write out of. The loathing is reserved for what you do manage to write, which seems paltry and timid. So you hedge your bets. You keep quiet about the writing in case it doesn't work out. You have a day job as a journalist and you define yourself by that.

You're living in a 'commune' at the time, a shared household with some half-baked ideals about subverting the confines of the nuclear family. Six of you have banded together, two couples and two singletons, and bought – miraculously – a large Edwardian house, two storeys over a basement, on an elegant square in south Dublin, with a thin sliver of sea visible from the back windows. The house has seventeen rooms with intact plasterwork and marble fireplaces. There are lots of wine-fuelled discussions about how you'll use all this space. A jazz room, a library, a Japanese room?

One of the other young women in the house, J, (from that flat in Wentworthville) is also a tyro writer and you two plan to carve out territory you might use as a joint study to write in. The space you earmark is the coal bunker, a dank hole under the granite steps that lead to the front door, with no natural light bar the manhole up above through which the nineteenth-century coalman once poured his merchandise. It's not even watertight. Moisture seeps in from somewhere and you can't stand upright in it. Cringe has found a home. Here is where we think our writing belongs. A black hole.

V *Chekhov's Gun*

You attend a writers' workshop – your first – hosted by several eminent writers. One, a man, says you are not a short story writer; Chekhov is his model. Another, a

woman, berates you for being 'evasive', both personally and in your writing. (Ironically, when you read back over this early work, you smart at how much is unwittingly revealed). Both pieces of expert advice depress you – the first for its dogmatism, the second for its condescension, its whiff of therapy, the implication that you have to fix yourself before you're allowed to write.

Your first 'real' publication – a story in the literary pages of *The Irish Press* comes after three years in the commune, but your marriage has fallen apart by then. The question that exercises you all through this period is this – is there a price you have to pay for writing? Is it husband and children, or being a writer? You seek out answers from other writers. Alice Walker, author of *The Colour Purple*, writes in an essay that 'women artists should have children – *assuming this is of interest to them* (her italics) – but only one.' Anne Tyler recalls being asked at the school gate by another mother if she's found work yet or is she still 'just writing'.

Either/or? It's a dichotomy that persists throughout the 1980s – your child-bearing years – and despite being a card-carrying feminist some part of you believes you can't have it all. No one, not your ex-husband certainly, has ever put the choice to you in these terms. No, this is a virus of doubt you've cultivated all by yourself. A journalist with *The Observer* interviews you after your first novel is published. You are thirty-seven. She notes you are single and describes the book as 'your baby'. You bristle when you see it on the page. But she has hit on a truth inadvertently. The child of your writing is always looking to be fed even if it's only thin gruel. Despite the cringing, the deep-seated denial, the 'black hole' thinking, the writing prevails. From this distance, you see what a false choice you made for yourself. Now you see your uncertainties as a chronic anxiety about your womanhood, not a gun to your head to write.

VI *Whimper, whimper, you're dead!*

After three books and into your forties, you go through a publication drought. It's a dry patch that lasts thirteen years. It isn't that you aren't writing – no, in this period you write two more novels and a collection of short stories, but you just don't get published. Suddenly it's as if your work is toxic. Your editor rejects two novels; your agent says she can't sell your work anymore. After twenty-three years you're back at the beginning again. And it's worse second time around. Because at the beginning you have hope; you have the dream of being published to sustain you and it can be nursed behind closed doors. Now you're 'out'; your secret vice is no secret anymore. As the rejections pile up, you realise there's a kind of infectious suspicion of the writer who's been published and then dumped. *Is she damaged goods in some way? Trouble in some shape or form?* And you ask yourself the same questions. Was it something you did? Or failed to do? Were you ungenerous in your success? Did you deserve the success in the first place? Did you take it for granted? Has your work suddenly become terrible? Were you ever any good? Have you lost the capacity to judge your own work? Is there anybody interested in your kind of writing anymore? Is your writing relevant? Is it worth continuing?

You very nearly surrender. You've given up the day job and you teach intermittently so you have no fixed identity anymore. Or a fixed income. You don't want to be the kind of teacher who once, long ago, wrote. You consider what else you might do; you toy with the idea of becoming a speech therapist – a road not taken at an earlier stage. At least that way you'd be doing some good. Anything is preferable to this dead end. But, for some reason, you persist with writing. Not out of courage or confidence, but out of dogged, fatalistic commitment. And because of all the other life choices you've made to facilitate it.

Instead, you learn to adjust your attitude to publication, which becomes a lucky by-product of writing, not a transformative end result. You're writing now for its own sake, to have a body of work even if no one wants to read it.

There's a different cringe factor to deal with. You start to avoid literary functions and the company of other writers because of the inevitable question. *When's the next book?* You quip that you're writing for your posthumous reputation. But that begs another question. If your work can't be read, does it exist? And if you're a writer, that calls into question *your* existence. Are you already dead?

VII *You Only Live Once*
But you're not – you are published again. You reach your sixtieth year. More behind you than ahead. A shifting in the sands of time. It's not all bad. Contrary to the beginning, you've too many ideas now and not enough time left to pursue them all. It's a kind of richness you never imagined, a superfluity the mileage of years has to offer. All the distractions of life that got in the way of your writing have accumulated into a storehouse for fiction. There's still the problem of words being dead on the page. And the dwindling band of readers. You're writing historical fiction, a subgenre, at a time when the literary novel is being declared terminal. You're writing in the realist mode, when neo-modernism is in vogue. And sci-fi and steampunk and fantasy and autofiction – and a million other more edgy narrative options. But one thing the drought has taught you – you can only write what you write.

Sadly, the cringe persists, if not for you then for others. It may be more diluted but the binary ultimatum hovers in the questions your young female writing students ask – is writing worth it, or how can we live and write, or I want

children, or I have children and how is that going to work, or should I just give up?

As if you might know the answer.

And you still don't.

MARY MORRISSY

Mary Morrissy was born in Dublin in 1957. She is the author of three novels, *Mother of Pearl, The Pretender* and *The Rising of Bella Casey* and two collections of stories, *A Lazy Eye* and most recently, *Prosperity Drive*. Her work has won her the Hennessy Award and a Lannan Foundation Award.

She is currently working on a speculative novel about Nora Barnacle.

She is Associate Director of Creative Writing at University College Cork and a member of Aosdána.

BIBLIOGRAPHY

A Lazy Eye (Jonathan Cape/Scribner, 1993)
Mother of Pearl (Scribner, 1995/Jonathan Cape, 1996)
The Pretender (Jonathan Cape, 2000)
The Rising of Bella Casey (Brandon, 2013)
Prosperity Drive (Jonathan Cape, 2016)

Janet Madden-Simpson's *Woman's Part: An Anthology of Short Fiction By and About Irish Women 1890–1960* (Arlen House, 1984). The book was published in hardback and paperback editions, and was distributed internationally by Marion Boyars publishers, London and New York.

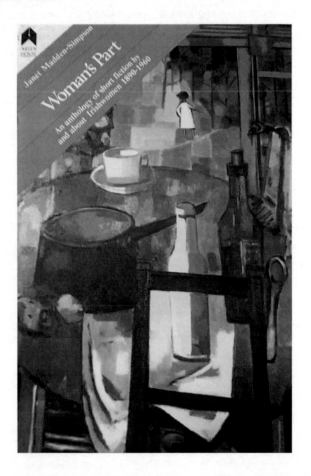

This was the first reclamation anthology of short fiction by Irish women writers, with stories by Norah Hoult, Dorothy Macardle, Maura Laverty, Jane Barlow, Mary Lavin, Erminda Esler, Mary Beckett, Geraldine Cummins, George Egerton, M.E. Francis, Elizabeth Bowen, Katharine Tynan, Edith Somerville, Violet Martin (Martin Ross), Elizabeth Connor (Una Troy). Many of these authors had been completely forgotten by this time; some were still living.

Lia Mills

THE WORLD SPLIT OPEN[1]

What would happen if one woman told the truth about her life?
The world would split open.

– Muriel Rukeyser, 'Käthe Kollwitz'

I 1992

1992 was not a good year to be a woman in Ireland. It was
the year of the X case and other high profile instances of
violent sexual assault and murder.[2] There were rape camps
in Bosnia no one could do anything about. One sordid,
dehumanising story followed another. Because abortion
was back on our national radar, the airwaves were shrill
with accusation, denial, claim and counter-claim, opinion,
judgement. It was so loud and ugly no one could hear
what anyone else was saying. No one wanted to hear what
anyone else was saying. It felt absolutely lethal.

One Saturday morning I sat in a friend's kitchen,
chatting and reading *The Irish Times* while our children
played outside. There was sunshine in the room; tea in the
pot, a cat asleep on the windowsill – peace, in other words.
I turned a page and found myself reading an account of an
ongoing rape trial. The report quoted the defence lawyer
as saying that the prosecution case rested only on 'the
mere question of consent.'

The *mere* question of consent?

What other question was there?

It came to me then that the lawyer could say what he said because no one would hear (or do I mean care?) what his question actually meant. He was saying that sexual consent was insignificant, irrelevant, that it could not matter less. He was asking the most rhetorical of questions: why should a court of justice waste its time on such trivialities?

Someone said, 'That's his job.'

So much for peace.

It was the case then, as it still is, that in Ireland a person who is raped appears in court in the capacity of witness. S/he is not entitled to legal representation.[3] What that means in practice is that someone who has survived a devastating, intimate and deeply-personal assault is required to give evidence to someone else – highly-educated, highly-qualified, highly-trained and, not incidentally, highly-paid – whose job it is to make that witness sound like a liar.

While I ranted about all this in my friend's kitchen, it came to me that as long as everyone was striking a position, or advancing a theory, or acting in the interests of one party or another, one side or another, and all the time advancing one political agenda or another, the voice of a complainant could not be heard.

There was too much white noise getting in the way.

But people might listen if such a story was written as fiction. And I knew exactly how to write it. The character who would become Alice peeled herself from the floor of my mind. She stood up in full view and waited to see what I'd do next.

A bit of background, here.

At the time I was working in WERRC, the Women's Education, Research and Resource Centre in University College Dublin. A combination of personal experience,

knowledge of other women's experiences, extensive reading and exposure to feminist theory had led me to recognise that sexual violence – like many other aspects of human life – exists on a continuum we all inhabit. I believed then and still do – witness the #MeToo movement – that every woman experiences some degree of sexual compulsion, threat or outright violence in her lifetime. The only surprising thing about this is the level of denial that goes with it.

What happens to you is one thing. What happens next will determine whether and how you survive what happens. I had been what was euphemistically known as 'molested' as a child and into my teens, more than once, by more than one person. I used to think it was something about me, that they could smell something off me that let them know they could do what they wanted. Later, my teenage self went looking for trouble, found it and was raped there, in one of those *your own fault, stupid!* situations. Say nothing. Tell no one. I wrapped that girl, that experience, in a dense shroud of silence and buried them with all the others.

I would never have been able to put the words in that last paragraph together or sit with them for any length of time, let alone leave them there for someone else to find, if I hadn't had daughters of my own. The possibility that they could be forced into situations I had been in provoked a murderous rage in me that I'd never been able to feel for myself.

I'm a great believer in the osmotic power of fiction, the way it draws a reader into other worlds and other lives, to bring us to places we wouldn't ordinarily go. As readers we can set aside our preconceptions and go under the skin of a character, see what they see, feel what they feel. In shifting previously-fixed perspectives, in teaching us empathy, a good novel can change us, mind and heart. As Barbara Kingsolver has memorably said, fiction is the

opposite of racism, the opposite of war.[4] It invites us, without fuss, to consider what it might be like to live another person's experience, a different kind of life.

If everything and everyone around you conspires to deny what you know is real, your perception of reality will be warped. If the world tells you that your experience is other than it is, that it's not even yours, that you have no right to name it, let alone talk about it – then you can be forgiven for misunderstanding the nature of a self. This is the problem I gave to the character of Alice in the novel that became *Another Alice* (Poolbeg, 1996). The story is about a woman, abused as a child, who is in danger of abusing her own daughter and looks for help. On another level, the novel is about who is allowed to tell a story and how it might be done when every atom and fibre of a person's being screams out against it and accuses her of lying. Alice is a fictional character, what happens to her is not word-for-word what happened to me, as some might think, but I knew what I was writing about. What mattered was not that it had happened to me but that these things happen at all.

I have to say, I didn't much want to be the one to write *Another Alice* but I knew I had to do it, no matter how scared I was (shitless, if you must know). And that, right there, is the moment when I became a writer. When the insistent call of the novel overcame the howling demons that warned against it, the voices that told me, day and night, that of all the insanely self-destructive things I had ever done, this was by far the worst.

After a lifetime of trying and failing, trying and giving up, that's when my real writing life began: when it was the story that mattered; when the character's demand to be heard was the most urgent of all the voices in my head; when I committed myself to the novel and knew that I had to see it through to the end, no matter what.

I had been writing for years without sending much out.

Looking back I can see that nearly everything I wrote until that morning danced around and hinted at, but managed to evade, things I needed to say. For a million reasons, some more genuine than others, I had been too afraid to say them.

II *Previously …*

(1) *Reading*

Do you remember the exact instant when you knew you could read? I don't mean the process of learning to recognise each separate letter, or of dragging your finger along a line syllable by syllable, spelling it out word by painstaking word. I mean that immense, life-changing moment when the words stir, lift, form themselves into sentences that speak inside your inner mind and guide you through the world of a story?

Reading doesn't happen where the eye meets words-on-paper but somewhere nameless deep inside the private mind, lighting it up, showing so many ways out: walls that can be taken down, windows, many secret doors. A book is, itself, a door. Reading tells you that there are worlds beyond the one you're frozen in, that you don't have to stay where or what you are. It tells you that you're not alone, that the human mind is a permeable thing, that it can be safe to connect with others. And here's a newsflash: the imagination is not gendered – it's not even species-specific. There are no fixed borders there, no boundaries. I couldn't get enough of it. If you'd asked my small child self what in the whole wide world I wanted to be, I'd have said, *a book*.

(2) *Writing*

Writing is hard. Don't let anyone tell you otherwise. My tolerance for my own early failures was low. I wanted to write strong, living sentences, sentences that would flare

as bright as strips of magnesium ribbon, words that could pierce the hardest heart. Mine came out groggy, leaden, hoarse – misshapen creatures that shrivelled and died in the light of the page.

I didn't know, then, that the apparently inevitable progression of a self-contained, finished piece of writing is an illusion. Stories don't emerge from the imagination as a seamless, perfectly-shaped whole, proceeding from start to finish in one smooth, uninterrupted formal gesture. Nor do essays. They are written one word at a time, hardly ever in the right order. The words repeat themselves, slur, backtrack; they contradict themselves and undermine each other. It's worse than the dregs of a party when the troublemakers and the bores refuse to leave. There is blood involved, and guts. There is sweat and there are tears, sleepless nights and terrible self-doubt, much confusion and self-loathing.

It was the painful, tedious process of crafting an undergraduate thesis for an adult education/distance learning programme at Lesley College (Cambridge, Massachussetts) that taught me how writing is actually done. My ideas were chaotic and unformed. My early drafts were raw, unruly, awkward; but the discipline and focus of the degree programme, along with the presence and interest of a patient advisor who believed that I could do it, helped. A lot. Never underestimate the power of having someone waiting to read what you've written, someone who actually wants to read what you've written. (Thank you, Judith Cohen).

Writing that thesis introduced me to the concept of successive drafts and the need to keep going back to them, to try again. Coaxing each thought to let go of its certainties and open up its blind spots through the drafting process required qualities I didn't know I had and wouldn't, previously, have valued much: persistence, patience, determination, endurance. Writing meant going

back to re-read those drafts a thousand times more than I could bear. My subject was moral consciousness as represented in fiction written by women. It was a revelation to me that books and writers I loved were valid subjects for critical consideration. The existence of literary history and women's studies as living, changing disciplines I could engage with and contribute to was a revelation too. Nothing in my first, brief, abandoned experience of university in Ireland had so much as gestured in their direction.

III *1990*

Newly returned from ten years of living in America and the recent acquisition of a degree, I was accepted on to the first Women's Studies MA programme in University College Dublin, a university I had dropped out of more than a decade earlier.

One day I was cruising the stacks in the library – killing time before a lecture – when a slender blue spine leaned to my hand, a nudge that caused me to take the book down and open it. I'm a great believer in paying attention to the books that claim it, even if we don't always know why they matter at the time. This one was *Louise de la Vallière* (1885), a collection of poems by Katharine Tynan, her first published book. I flicked through it. Hmmmm. Back to the shelf. There were several volumes by Tynan, but I'd never heard of her. Not once. I took down Ernest Boyd's 1916 study *Ireland's Literary Renaissance*. It has no index, but a bibliography at the back yielded several women's names, including Tynan's: of a total of 50 entries, 12 were women. Apart from Eva Gore-Booth and Lady Gregory – both of whose names I knew only because of their association with Yeats – I had never heard of any of them. I grabbed a desk, jotted down notes. Back and forth to the stacks I went, piling books around me, noting titles, index entries and references, scrawling lists and marking connections.

In my first incarnation as a student in that university, I went to the library approximately twice and on at least one of those occasions I was looking for someone. From now on, I didn't want to be anywhere else. I soon graduated to the UCD Special Collections Reading Room, then the National Library of Ireland, the NLI Manuscript Reading Room, the microfiche readers.

I was genuinely shocked that the women I found in the footnotes, appendices and library catalogues, writers such as Emily Lawless, Alice Milligan, Ethna Carbery, Katherine Cecil Thurston and George Egerton – who all became subjects of my MA research and thesis – occupied such a blind spot in our literature. I shouldn't have been. It seemed that if Irish history and literary studies up to that point had its way, you could be forgiven for thinking no such creature as a woman had ever darkened the island. There were women in the myths and legends alright, but they were known for nothing so much as the ructions they caused among the men, who'd have been better off without them. Where there was trouble, a woman was surely to blame.

What shook me the most was my previous willingness to accept, not just the absence of women writers but, effectively, their non-existence, through my lack of curiosity. As if only women of our time have ever cared about questions like freedom, self-actualization, equality, survival or ambition, not to mention literature or art. The omission was unthinking rather than deliberate – passive acquiescence to a blind spot – but it amounted to betrayal just the same. I knew about the token few: Edgeworth, Somerville & Ross, Bowen, O'Brien; but except for the latter, I had an inherited expectation that their work could have no particular value or relevance to contemporary Ireland and may even be in some way inimical to it. It's shaming to admit to such intellectual laziness on my part but it's true, so I must.

I'd found my research topic and was quickly consumed by it. It seemed so obvious and so important I couldn't believe no one had done it before.

It had, of course, been done before. By Elizabeth Owens Blackburne (1877), Elizabeth Sharp (1887, 1890), Catherine Hamilton (1892, 1904) and B.G. McCarthy (1944, 1947) to name a few. The first reclamation anthology of the second wave feminist movement in Ireland was edited by Janet Madden-Simpson and published by Arlen House in 1984. *Woman's Part: An Anthology of Short Fiction By and About Irish Women 1890–1960* included work by fifteen women including Norah Hoult, Dorothy Macardle, George Egerton, Una Troy, Maura Laverty and Katharine Tynan.

The opening statements of their studies of the lives and work of women from earlier centuries could have been mine. Their expressions of confidence and certainty – that their retrieval and evaluation would preserve this work for proper recognition into the future – underlay every word they wrote. Yet their own efforts had been forgotten. We all know what Wilde had to say about the misfortune of losing one parent but this looked more systematic, or at least more habitual, than mere carelessness.

My research was specifically directed towards Irish women writers. Publishing houses elsewhere were already busy with women's writing more generally: Virago Press and the influential 'Virago Modern Classics' series, for example, which re-published an impressive list of Irish women writers in the 1980s. There was the Women's Press, Onlywomen Press, Pandora, Sheba … In Ireland we had Arlen House and Attic Press. Attic, in particular, from 1987 was doing the vital work of publishing new literary work by women, including the anthology *Wildish Things* (1989), edited by Ailbhe Smyth, and the groundbreaking series of LIP pamphlets – not forgetting the hugely popular annual *Irish Women's Diary and Guidebook*.

You might ask why it matters if a writer's work sinks

out of sight over time. Sink or swim, you might say. Survival of the fittest, all that. Readers read what they will and only the great survive.

It matters because the historically-assumed scarcity of Irish women writers is untrue. It matters because assumptions about their lack of value or relevance are wrong. It matters because when we look at Irish literature across the centuries but exclude women and other writers who don't conform to – or who write in direct opposition to – our notions of what is appropriately 'Irish', the shape and developmental trajectory we assume for it bears little resemblance to its actual shape. Worse, the texture is entirely missing. Without connective tissue, the body of a literature can't breathe, let alone grow or be coherent. It will eventually die. And it matters because the apparent vacuum is a deprivation for writers as well as readers of the future. How much time is lost when we need, not only to reinvent the wheel, but to reimagine it?

The whiff of threat indicated by the suggestion of opposition to our preferred version of Irishness is another reason why these writers matter. We'll never know what kind of country Ireland would be now if the Rising and the wars that followed it didn't happen, what kind of people we would be. But that doesn't mean we have to swallow the official narrative of national and cultural development uncritically. If we are going to look back at all, we should be ready to acknowledge that there are alternative stories to be found.

It's like coming across the ruined wall of what was once a town. If a brick is enough for you, there's no more to be said. But if it's depth, colour and movement you're after, if it's life you want – with all its mess, argument and contradiction, its soaring pleasures as well as its crushing defeats – a single wall won't satisfy you, it will only sharpen your appetite. And here's something else to think about: what does it mean for the study of literature if

generation after generation of academics continue to give out the same reading lists, tell the same story, inherit the assumptions of their predecessors?[5]

Throughout the 1990s I did what I could to make up for my own part in that selective amnesia: reading, teaching and writing about turn of the twentieth-century women writers and later generations. I came to love and value them, not just for their work, or their approach to the stories they told and the worlds they depicted, but for what I came to know of their writing lives, how they were received, what happened to them later. Other, more finely tuned, literary scholars were doing the same thing, to great effect. It felt as though we were part of an unstoppable movement. My focus shifted to contemporary writers. My own work began to be published.

WERRC was an exciting academic centre. The director was Ailbhe Smyth. Visionary, politically active and inclusive, she brought writers, artists and activists into the university on almost any pretext to talk about any subject. It was through WERRC that I got to know many of the people who would later become my friends as well as colleagues.

Ailbhe may have been the first person who heard me say that I was trying to write a novel. The word 'novel' might not have actually come out of my mouth – one more secret I was trying to keep – but I was moaning at her one day about the difficulties of trying to write, with a job, three young children and a husband who was working in another country. Considering that she was the person I was working for, she could have been forgiven for telling me to get over myself and get on with the task in hand (teaching – with a lot of photocopying thrown in). Instead she said, 'You should go to Annaghmakerrig.'

I had never heard of the Tyrone Guthrie Centre in Annaghmakerrig, a place where writers, artists and musicians go to focus on their work, away from the

demands and responsibilities of everyday life. I didn't see how I could go there or why they would let me in.

She waved away my objections. 'Of course they'll let you in. I'll give you a reference.'

And she did. And they did. I spent a glorious week in Annaghmakerrig. It was my version of coming out, as a writer. I met working writers and artists who spoke my language and shared my obsessions. No one laughed when I admitted what I had come to do. I finished my first draft there.

Another Alice came out in 1996. None of the things I'd dreaded happened. Instead, I had letters from people – mostly women but some men too – saying things like, 'It's as if you were there when x or y happened to me' and 'Thank you for telling my story.' It was more validation than I could have dared to hope for.

Here's the thing. A writer's job is to explore what it is to be human in our time; not to state the obvious but to lift our darknesses to light, to write the things that other people think but don't – or can't – say. It can feel as though you've been flayed, your innards spread across the street for the crows to pick at and the neighbours to use as speed bumps. But that's not you a reader sees on the page; what she finds there is a truth of her own.

My final assignment at WERRC was to co-curate a groundbreaking conference, 'Celebrating Irish Women Writers' in May 1999. More than 100 writers and 65 academics took part, across several Dublin locations, from Belfield to the Irish Writers' Museum via Newman House, St Ann's Church and the Irish Film Centre (as The Irish Film Institute was known then). More festival than conference, in the days before the current profusion of festivals, it really did feel like a celebration. There were so many of us. Look how many people turned up to hear us read and speak! We were never, ever going to go away.

IV *Now*

We're lucky, in Ireland. We have engaged and committed academics and literary scholars, many of them women (most of them, come to think of it, women) who continue to pay attention to writing by women as well as to women's history – not exclusively, because why should they? It makes no sense at all to repeat old mistakes by reversing polarities. Ideology can only take you so far before it begins to replicate old tyrannies and assumptions. While we're here I'd like to pay tribute to that ongoing work – because it is the academics and critics of today who influence the readers of tomorrow. It is generous work and not recognised or acknowledged as often as it should be.

The work of academic criticism is not a million miles away from creative writing, but it leans further towards creative reading, generating worlds of discussion and argument along with flashes of illumination. A book only lives when it is read. The extent and quality of a novel's life depends on the alert, discriminating and continuing attention of readers. Critics act as a conduit between fictional and actual worlds. It is an act of immense generosity to bring a critical intelligence to bear on someone else's work, to immerse yourself in it; to enlarge, promote and help to extend its life through discussion, introducing the work to new readers in new contexts and, crucially, passing the conversation on through the generations.

Soon after the Waking the Feminists furore erupted in November 2015, I was talking to a young woman playwright who said, 'Now that it's been pointed out to them, everything will change' – 'It' being the under-representation of women playwrights in the centenary programme, and other programmes, of our publicly-funded National Theatre, the Abbey. Her joyful conviction made me feel old and cynical. Just wait, I wanted to say but didn't. Just you wait and see.

Throughout the wider centenary commemorations of 2016, people seized on emerging information about the women who had taken part in early twentieth century nationalist, feminist and socialist movements with a similar joy of discovery: 'Look how interesting, dynamic and effective these women were. At last we know about them! We'll never forget ...'

Never say never. Those same women were being discovered, reclaimed and written about – extensively – from the 1960s and 1970s on by historians like Margaret Mac Curtain, Mary Cullen, Margaret Ward, Rosemary Cullen Owens and Maria Luddy. There were books and journals and conferences; there was the Women's History Association of Ireland, founded in 1989 and the Feminist History Forum and the Women's Studies Association of Ireland which predated that. No doubt there were groups that predated those. The Waking the Feminists movement itself seemed unaware of preceding work of literary retrieval carried out by literary scholars.

What is the mysterious mechanism and/or barrier that prevents information and awareness crossing over from minority interest to mainstream knowledge and holding it there, in plain sight? It's a reasonable question to ask, now that we are on a rising tide of public awareness of gender-related issues – again. Every generation thinks it has found a solution but what actually happens is that the generation that follows then fails to see the problem. Before we know it, we're back where we started.

On better days I think that maybe that young playwright and all the optimistic, determined women of her generation are right. Maybe we are finally reaching some level of critical mass that will make it impossible for women's work – in any field – to fade from the national (or wider) consciousness again, or not entirely. The early years of this century have seen so many talented, hardworking women writers emerge, many of them winning major

international prizes. Surely some of that work will survive? One social change that supports this hope is the prevalence of festivals and public readings. For a start, they make writers visible and audible to a wide general public. You can't say, 'There are no good women writers' when they're up on a stage right in front of you, making you laugh, making you cry, making you think.

What's more, the festival circuit brings together writers from all backgrounds and genders. The Irish literary community is small and gregarious. Most of us know most of the rest of us and if we don't know each other now, chances are we've heard of each other or soon will. This makes for a cross-fertilisation of ideas, an awareness of existing and new work, networks of support. Call me naive but I believe that we are open to and glad of new talent. What's good for one of us is good for all of us. My own experience of crossing the threshold from secret ambition and lonely practice at home to publication and acceptance as a professional writer supports that belief. Whatever practical help or information I asked for, I was given – once I knew enough to ask for it.

I've had personal and professional support from men as well as women – sometimes more. Conditions of production, reception and distribution are a whole other question, as are the exigencies of everyday life as they affect women and men in the real world; but I've taken up more than my fair share of space here already. Never ask a novelist for a short answer to a complicated question. Why settle for a dozen words if 100,000 can be found?

There is a horrible symmetry in the fact that, decades after that sunny Saturday morning when Alice first announced herself to me, sexual violence is still in the news. The release of stories triggered by the #MeToo movement continues. In 2018, as I began to think about this essay, Boko Haram kidnapped one hundred or more girls in Nigeria to force them into 'marriage' with their

soldiers. No one seemed able to do anything about it. At the same time, an ongoing, high profile rape trial in Belfast was the highlight of Irish news bulletins for weeks, with daily – sometimes hourly – updates. No one, young or old, male or female, could escape the sordid details. Any notion of a watershed seemed to have evaporated. That trial might just as well have been happening in our kitchens and living rooms, in our cars, in buses and on trains, in meeting rooms and offices, on phone lines.

It was impossible to escape the salacious nature of the coverage, or the painful details as they were exposed. One day's evidence seemed to lead in one direction, the next day's evidence suggested another. The four accused young men were eventually acquitted, but no one emerged from that trial unscathed. The light shed on the conduct of such trials was far from flattering to existing systems of justice; the media were accused of prurience. It could be argued that twenty-first century attitudes towards, and experience of, sex and sexuality were also in the dock. Those events were closely followed by the #MeToo movement and very public investigations into, for example, Jeffrey Epstein (who committed suicide in prison rather than allow his accusers their day in court) and Harvey Weinstein (whose trial opens on the day I finish this essay). We can only hope that people are talking – friends and partners to each other, parents to their children. We pick our way through sentences as hazardous as mined fields, trying to express the many levels of unease we feel about what one witness in the Belfast rape trial described as 'what's happening in this (court)room.' One story is pitted against another and as always, the key, the vital, the only question that matters is the question of consent.

And there's a whole new generation of writers to explore it: like Louise O'Neill (*Asking For It*), Lisa Harding (*Harvesting*) and June Caldwell (*Room Little Darker*), young women with enough courage and fire to blow the whole

subject of sex in today's Ireland wide open.

NOTES

* Author photograph by Simon Robinson.

1 Parts of this essay are based on and develop ideas contained in my 'Foreword' to *Irish Women's Writing 1878–1922: Advancing the Cause of Liberty*, edited by Anna Pilz and Whitney Standlee (Manchester University Press, 2016), an outstanding anthology of essays on conditions of production and reception as well as close readings of the work of Irish women writers by academics and critics.

2 In 1992, the Attorney General issued a restraining order on a fourteen-year-old girl ('X') who went to the UK for an abortion following rape. The case caused national and international outrage and reopened the wounds of the notorious 1983 Eighth Amendment to the Irish Constitution, subsequently repealed following a referendum in 2018.

3 Exceptions following changes in the law:
(1) The right to separate legal representation for a complainant only arises in court when the defence makes an application to the judge for leave to bring in evidence of previous sexual history. This right does not extend as far as legal representation during the trial itself.
(2) Under the new Sexual Offences Act the witness will be able to challenge a request for disclosure of counselling notes and be represented by her own barrister at a pre-trial hearing. (Source: One in Four).

4 Kingsolver said this at a public event in the Pavilion Theatre, Dún Laoghaire (June 2010) after her novel *Lacuna* won the Orange Prize for Fiction.

5 The *Field Day Anthology* row in 1991 illuminated the imbalance and brought it to wider attention. Three volumes claiming to be the definitive anthology of Irish writing demonstrated a shocking degree of gender bias. It took eleven years for a team of women scholars to produce *Volumes IV and V*, devoted to writing by women and other writers excluded by the earlier volume. Back to the footnotes/appendices we go ...

Lia, born in 1957, writes novels, short stories, essays and an occasional blog. Her most recent novel, *Fallen*, was the 2016 Dublin/Belfast Two Cities One Book Festival selection. She has contributed to anthologies such as *The Long Gaze Back* (edited by Sinéad Gleeson) and *Beyond the Centre: Writers on Writing* (edited by Declan Meade). Her work has appeared in, among others: *The Dublin Review, The Stinging Fly, The Irish Times* and *The Dublin Review of Books*. She is currently working on a collection of short stories. She is a founding member of the Freedom to Write Campaign (Ireland).

BIBLIOGRAPHY

Another Alice (Dublin, Poolbeg Press, 1996)

You Had to Be There! editor/curator (Dublin, Ballymun Regeneration Ltd, 2003)

Nothing Simple (Penguin Ireland, 2005)

In Your Face (Penguin Ireland, 2007)

Word of Mouth: Coping With & Surviving Mouth, Head and Neck Cancers, co-editor with Dr Denise MacCarthy (Dublin, 2013)

Fallen (Penguin Ireland, 2014)

Moya Cannon

MOYA CANNON *Hands*

THE
PARCHMENT
BOAT

Moya Cannon

Moya Cannon
Collected Poems

MOYA CANNON *Carrying the Songs*

DONEGAL TARANTELLA

'a deep intensity and searing lyricism ... a amazing birth of the earth'
NUALA NÍ DHOMHNAILL

MOYA CANNON

CARCANET

MOYA CANNON *Keats Lives*

Oar

MOYA CANNON

MOYA CANNON

Oar

SALMON POETRY

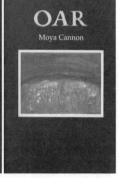

OAR
Moya Cannon

POETRY – A DOOR OPENING

I came to write poetry in my early twenties as a means, literally, of *ex-pression*, of getting some of the pressures and conflicts of being a young adult out of my head and onto a page. It saved my sanity then and has since brought me into contact with many wonderful writers, living and dead. Patrick Kavanagh famously said 'I dabbled in verse and it became my life'. This is how it happens.

I was not one of those young people who always knew that she wanted to be a writer. Apart from a few heartbroken lines written in real purple ink as a teenager (I remember mixing the red and blue Quink ink and being rather pleased with the colour), I didn't write a poem until I was twenty-two. Coming where I came from, being 'a writer' didn't present itself as an option and I was startled when an older brother suggested it to me as I was wondering what I should do when I left college. However, I cannot remember a time when I did not enjoy poetry. This was something which I received as a gift from my parents and teachers and from the culture which I encountered as a child and as a young adult.

I grew up in Dunfanaghy, a village in north-west Donegal. My mother had a deep love and knowledge of English poetry. She had studied English at Queen's University, Belfast in the 1930s. She was the first of her family to go to college and neither of her parents had more

than a primary education. As neither of them could sing a note, at social gatherings in their farmhouse in east County Tyrone during her childhood, entertainment frequently took the form of the recitation of popular poems. There was a great deal of romantic, nationalist verse – 'The Man from God Knows Where'. My mother remembered her father reciting two of his favourites – Robbie Burns's 'A Man's a Man for a' That' and 'Dawn on the White Hills of Ireland'. In my study I have a leather-bound copy of Burns's poems, given to my grandfather by a young nurse when he was very ill in hospital in Belfast as a young man. Gifts of words, like good tunes, are passed on.

As young adults my mother and her brother befriended the elderly poet, Alice Milligan, who lived near them at Mountfield, County Tyrone. Alice became an important presence in my mother's life. The first poem which I learned, apart from nursery rhymes and the rhymes in my infant school readers, was her 'When I was a little girl in a garden playing.'

My father was the principal of the local two-teacher primary school in Dunfanaghy. As a young man he had written poetry in Irish – lyrical, introverted, often religious poetry. He published under a female nom de plume, 'Róise Nic a'Ghoill', a play on the placename 'Ros Goill'. In teaching, he communicated to us his own pleasure in words, imagery and rhythm. I loved chanting 'The Little Waves of Breffny' or 'The Daffodils' or 'Duncan':

> He is gone on the mountain,
> He is lost to the forest,
> Like a summer-dried fountain
> When our need was the sorest.

I am reminded of Seamus Heaney saying 'A poem or a song learnt in childhood is fossil fuel for the soul.' (He did, of course, say this at a time when we still thought it was ok to burn fossil fuels).

I started secondary school in 1967, the year of the

introduction of free secondary education, and had the great good luck to have the doors of English literature swung wide open by Augustine Martin, through his *Exploring English* and *Soundings* anthologies. I was taught by two exceptional English teachers. In the Franciscan convent school in Falcarragh, which I attended until intermediate certificate, we had a diminutive young Scottish nun, Sister Dolores, who was both demanding and passionate in her teaching. Octavio Paz says that enchantment is one of the necessary qualities of poetry. One of my paths into enchantment was her reading of 'Sir Patrick Spens' in her Scottish accent. I can still feel Sir Patrick Spens's terror at being charged with a task to which he knew he was unequal, and I can still see him drowned on the bed of the North Sea 'Wi' the Scots lords at his feet.'

After the intermediate certificate I moved to Loreto College, Milford, where we were taught English by a Mrs Deeney. With a very formal teaching style and thorough preparation, she introduced her students to the delights of Donne and Herbert, of Wordsworth, Keats and Shelley, of Yeats, Kavanagh, Clarke and Kinsella.

I had a vague notion that if I got to university I would study English and French. However, by some flick of fate I won an entrance scholarship in history and decided to study history and politics instead. In my early years as a student at University College, Dublin, an older brother gave me birthday presents of a translation of Pablo Neruda's *The Captain's Verses* and a selection of Antonio Machado's early poems translated by the late Michael Smith. Neruda is a poet whose work I loved when I was young. But Machado is a poet to whom I come back again and again, as to a fountain.

Machado's own solitude is so profound that it becomes a companionship. It is, perhaps, the qualities of attention, detachment and understatement in his poems, allied to his

unabashed love of beauty, which give them their strength. Also, I was drawn to Machado because, in an age of logical positivism, which was the prevailing intellectual weather when I was a student, he spoke unselfconsciously, without embarrassment and in an utterly fresh way, of the soul – the soul as a garden, as a beehive in the heart. He had rescued the soul from the hierarchies and power structures which sought to control populations and he identified it as that in us which is drawn to beauty and that honours compassion and human kinship in its widest sense.

When I was a student, Pasternak and Yevtushenko were popular and their work was available in English translation. I was, at this stage, a passionate reader of poetry, but not yet a writer. A poet friend tells me that he almost believes that books are able to move around on their own – at times they seem to hide from us on our own bookshelves: at other times they fling themselves across our paths screaming to be read. The latter always happens when we need them most. One of the books that cast itself across my path was *A Net of Fireflies*, a beautifully-bound and illustrated collection of translations of Japanese haiku that an Australian friend, passing through Dublin, lent me in the year when I was finishing college. When I say that she lent it, it would be more accurate to say that she showed it to me – it was holiday reading given to her by a friend before she left Melbourne – and I buried my head so deeply in it that she, most magnanimously, not only left it with me as she headed on her travels around Ireland, but subsequently sent me a companion volume, *A Chime of Windbells*. Again, as with Machado, the experience was one of utter enchantment.

These were books which I encountered in my late teens and very early twenties, a time when we are open and aesthetically hungry. I cannot over-emphasise the importance to me of encountering this poetry in translation. The poems and songs which we enjoy at this

age are soul guides as we emerge from a confused, pupa-like stage to become our adult selves. And, perhaps, poems in translation are entirely our own in a sense in which the poems which we learn at school never can be. They are totally unmediated by teachers and we can feel the aesthetic force of them directly, can feel a kinship across chasms of culture and time with the poet who wrote them.

The mid-seventies were exciting years for Irish society and modern Irish poetry. Cracks were appearing in the deeply-conservative Catholic culture of post-independence Ireland and there was a flowering of poetry in response to the troubles in Northern Ireland. I spent many rainy Saturday afternoons in the Eblana Bookshop in Dublin, leafing through volumes of John Montague, Seamus Heaney, Francis Harvey, Michael Hartnett, Eavan Boland and Eiléan Ní Chuilleanáin. The latter two were still young writers in their thirties and I had no idea how, with Nuala Ní Dhomhnaill, they would transform the landscape of Irish poetry. The quality of their work and their confidence and courage in challenging presumptions of what constituted an Irish poem opened the door wide to the generation of Irish women of my generation, the 'free secondary education' generation.

I left college in 1977, started to teach in Dublin and went through a rather stressful and lonely period as my college community dispersed and I took on a demanding job. I loved poetry and music and decided to try my hand at them. The music is another story but, I went, with my friend Mary Armstrong for moral support, to a workshop run by the poet Dermot Bolger, who was about nineteen at the time. It was held in the Grapevine Arts Centre in a basement in North Great George's Street, and it was anarchic and wonderful. Among the members of my first literary community were Philip Casey, Patrick McCabe, Anne le Marquand Hartigan, Pauline Fayne and a delightful, gentle member of the Irish Armed Forces called

Donal Dempsey, who wrote surreal poetry and who frequently attended the workshop when he was meant to be on sentry duty at the army's camp on the Curragh in County Kildare. We always half-expected to hear that he had been court-martialled for his devotion to the muse.

None of us knew anything about literary fashion or proprieties, so we felt free to share our enthusiasms and to look at the poetry which we loved with a view to finding out how a poem worked – or didn't work. Dermot Bolger was once so lost for words after someone read a particularly obscure poem that he got up, mounted a bicycle, that he had carried down to the basement for safety, and silently cycled around and around our circle of chairs.

As a recent graduate of history and politics, I thought that I would be writing political poetry. Instead, I found that the imagery which came to me was full of the windy skies, the mountains, headlands and shores of my Donegal childhood. Every writer writes out of the strata of emotional, intellectual, physical and spiritual experience laid down since earliest childhood. Reading haiku and Machado, I became aware of the phenomenon of emotional resonance, of evocation as exemplified in the haiku form, of the way in which one clear crisp image, or the layering of two images, could have an effect equivalent to that of a musician's holding down a string lightly and playing a harmonic. I learned that what is stated is usually less important than what is evoked. A chance reference to Ezra Pound led me to his Chinese translations and his essays on poetry. My first published poem (under the Irish version of my name, Máire Ní Chanainn) appeared in David Marcus's 'New Irish Writing' page in *The Irish Press* in, I think, 1979. It was heavily influenced by Pound's Cathay and his 'A Few Don't by an Imagiste.'

Another, more distant, writing community centred around Listowel Writers' Week, which I had started to

attend at about this time, sitting in on Brendan Kennelly's poetry workshops. Brendan was a gifted and generous teacher. He said little but succeeded in creating a space where people felt free to air and discuss their work and have it gently pummelled into shape. The week was great fun, completely imbued with that energy and high spirits which I continue to associate with County Kerry. I attended the festival regularly from 1979 until the late 1980s and met up with a great range of writers, among them Anne Hartigan and Pauline Fayne whom I already knew, John F. Deane, Nuala Ní Dhomhnaill, Michael Hartnett, John Montague, Michael Coady, Edward Power, Gabriel Fitzmaurice and an eccentric, genial farmer who, we were told, 'owned eighty acres of the best farming land in East Cork, all gone to ragwort and nettles'. Not one, but two, muses had seduced him away from agricultural pursuits. He played the uilleann pipes and wrote under the pen name 'Dónal na Gréine'. Bryan MacMahon, whose short stories we had read at school, and John B. Keane, whose play *Sive* was one of the first grown-up plays which I had seen, in an Irish-language version when I was eleven or twelve, were major presences. Among the visiting foreign poets whom we heard in Listowel were Thomas Tranströmer, Ted Hughes, and the Romanian poet, Liliana Ursu. Some of the acquaintances formed at Listowel Writers' Week developed into deep and long-lasting friendships. For me, as is I think the case for most writers, community is essential to offset the solitude of writing.

I had a vague idea that I might become a historian and decided to teach at primary level for two years to finance a Master's degree. As two years became five, I began to take writing quite seriously. By the time that I had gone back to college and completed my Master's degree in international relations at Cambridge in 1983, although I had enjoyed the year greatly, I knew that it was poetry, not history, that I wanted to have at the core of my life. I toyed, briefly, with

the idea of returning to college to study English but had no way of financing further study. Also, English literature departments at that time were much preoccupied with literary theory and I could not see how this would be of help to me as I tried to learn how to write. University writer in residence positions and creative writing courses were virtually unheard of in Ireland at the time, so there was no prospect of making a living from poetry. Any poets I knew of had a day job unrelated to poetry, or else they worked as editors or taught literature. I decided to continue to teach at primary level. The short teaching day, I thought, should afford me time to write.

I took a chance and moved to Galway City. This gave me access to the granite coasts and quartzite mountains of nearby Connemara, to the Aran Islands, which I already knew a little having spent summers on Inis Oírr teaching in an Irish college, and to the limestone karst of County Clare. Galway was a particularly fortunate choice as I arrived at the beginning of an artistic renaissance. A lively and unpretentious literary community was coming together – among the writers were Eva Bourke, Rita Ann Higgins, Fred Johnston, Michael Gorman, Anne Kennedy and, very importantly, Jessie Lendennie and Mike Allen who set up *The Salmon* literary journal and Salmon Publishing. A few years later Mary O'Malley returned from Portugal to join that writing community, and Fred Johnston founded the Cúirt International Poetry Festival which created another focus and brought fresh voices to Galway – among them two of my favourite poets, Denise Levertov and R.S. Thomas. I had been introduced to Levertov's work by another poet, Pat O'Brien, and she became a very important voice for me.

Even before the inception of Cúirt, I heard Norman MacCaig read in the Atlanta Hotel on Dominick Street and was smitten by his pithy, short poems. Here was someone else writing about mountains and small lakes and doing it

so very well. His poetry reminded me in some respects of the luminous poems of Francis Harvey, whose *In the Light on the Stones* I had bought in the Eblana Bookshop years previously. Originally from Fermanagh, Frank lived in Donegal town and wrote about the Bluestack Mountains and, with deep empathy, about the people who lived in them. My neighbour, Eva Bourke, lent me a copy of Adam Czerniawski's anthology, *The Burning Forest*, introducing me to the rich world of Polish post-war poetry – another door opening.

Two other writers whom I met not long after arriving in Galway and with whom I developed friendships over the years were Tim Robinson and John Moriarty. Well before I met him, Tim's inspired maps opened gateways for me into the hidden crevices and time-deep wonders of the Burren and the Aran Islands. John kept doorways to the spiritual life open to me with his constant assertion 'We are not recycled groceries, there is something of the divine in us.' Although in their convictions and cosmologies they remained diametrically opposed to each other, Tim being a devout materialist and John believing that 'matter is spirit in hibernation', they became great friends. They shared a reverence for the earth and a fear of the destruction being wreaked upon it by the human race. John used to say that humanity is like the Titanic, arrogantly steaming directly towards an iceberg. In addition to his map-making and his writing, Tim devoted much energy to protecting the ecosystems of Roundstone Bog and of the Aran Islands. There was always a welcome and stimulating conversation in John's tiny house in Toombeola and in Tim and his wife Máiréad's tide-lapped house a few miles away at the end of Roundstone Pier. We used also meet at Clifden Arts Festival, founded by Brendan Flynn. Tim and Máiréad were immensely supportive of John during his last years, after he was diagnosed with cancer.

At this time another gift from a poet friend was a book

of translations, *News of the Universe: Poems of Twofold Consciousness* by the American poet, Robert Bly, a book that included translations from many traditions. It emphasised our links with the other forms of life on this planet. It introduced me to the work of Theodore Roethke, of Mary Oliver, of Rumi, of Rainer Maria Rilke and it explicitly affirmed a growing intuition, that if poetry is about anything, it is about nourishing the human spirit, whatever that may be. From the time I started to write poetry, I was surprised to find myself strongly drawn to the poetry and essays of American poets, or poets living in America – Denise Levertov, Theodore Roethke, Czeslaw Milosz, Mary Oliver and, more recently, Jane Hirschfield, Naomi Shihab Nye and Adam Zagajewski.

I had been publishing occasional poems in journals since that first publication in 'New Irish Writing'. Publication in David Marcus's page in *The Irish Press* was a rite of passage for writers of my generation. It was a few years later before I had a second poem published – in the poetry journal *Cyphers*, edited by Eiléan Ní Chuilleanáin, Macdara Woods, Pearse Hutchinson and Leland Bardwell. Through the Grapevine Arts Centre I heard of the establishment of Poetry Ireland by John F. Deane in 1979, joined it at its inaugural meeting in the fustily-atmospheric United Arts Club and bought the first copy of its journal, *Poetry Ireland Review*. Other poetry journals came and went and I got used to sending poems off, agonising endlessly over covering letters, and hoping that the returning scruffy envelope, with the address in my own handwriting, would be thin, signalling acceptance. I was only half-comforted by something I heard the Donegal poet, Madge Herron, say in a radio interview on the subject of young poets who came to her for advice – 'They have to write the bad poems out of themselves before they write the good poems'. Less painful was Ezra Pound's observation that it takes as long to learn how to write a poem as it does to learn how to

play a musical instrument.

Regional poetry journals are as useful to emerging poets as workshops, both in terms of airing the work and in putting writers in touch with each other. *The Salmon*, founded by Jessie Lendennie and her partner, Mike Allen, in 1981, and run from Auburn, their small house in the Claddagh, fulfilled this role wonderfully. A few years later Salmon Publishing published the debut collections by Eva Bourke (*Gonella*, 1985) and Rita Ann Higgins (*Goddess on the Mervue Bus*, 1986). My first collection, *Oar*, was published by Salmon at the end of 1990 when I was thirty-four. They took great care with the production and proofreading, the quality of the paper and the printing of the cover illustration, by the Roundstone artist and potter Rose O'Toole. I was delighted when it won the inaugural Brendan Behan Award.

After two years in Galway I had found myself teaching in a school for adolescent Travellers, mostly boys. These children were dealing with the challenges of first generation literacy – challenges very possibly experienced, as my principal pointed out, by some of our own great-grandparents or their parents. This encounter with the last vestiges of a purely oral culture was a real privilege. It was also exhausting. At weekends I often opened Tim Robinson's map of the Burren, picked out what looked like an interesting spot on it and hitchhiked down to County Clare to tramp among pre-Christian holy wells, little medieval churches, megalithic tombs and grey-white valleys of limestone karst; what Tim described as 'a uniquely tender and memorious ground'. Much of my first book came out of those walks in Clare – and out of the many inner conflicts of my life at that time. Galway was also a city full of traditional Irish music, with 'more musicians than people' as one young Clare musician put it. I was playing a little on the concertina, with my sister-in-law and friend, the harper Kathleen Loughnane, and that

seeped into my poems too.

In 1994, I applied for a career break to take up the offer of a writer in residence position at Trent University, Ontario – a very enriching experience. The faculty could not have been more welcoming. Among the people whom I got to know in Ontario was the brilliant short story writer, Alistair MacLeod. On the day on which I received confirmation of the career break, the then director of Poetry Ireland, Theo Dorgan, rang to ask me to take on the editorship of *Poetry Ireland Review* for a year. I did so, working on it partly in Dublin and partly from Ontario. Editing proved to be a creative exercise in itself and gave me an overview of what was happening in poetry in Ireland. During my period of editorship there was the excitement of Seamus Heaney's being awarded the Nobel Prize for Literature, an event that added, and continues to add, light and lustre to the world of Irish poetry. I was able to extend the Canadian residency with the help of a grant from the Irish Arts Council and to extend the career break to take up residencies in County Kerry, in Waterford City and in Derry City. Much of my second collection, *The Parchment Boat*, carefully edited and published by Gallery Press in 1997, reflected the experience of these residencies.

I returned to Galway and to teaching. One of the benefits of being an Irish poet writing in English is our visibility in America. US academia has long been a supporter and encourager of Irish writers, through awards, residencies and invitations to read at colleges and conferences. In 2000 I had a phone call from Tom Dillon Redshaw from the University of St Thomas in St. Paul, Minnesota offering me the Lawrence O'Shaughnessy Award. It was a wonderful affirmation at a time when I was not sure if my writing was going anywhere.

After a few years, however, between the demands of teaching and weekend trips to Donegal to visit my very elderly mother, I discovered it increasingly difficult to find

either time or energy to write. As one friend put it: 'You don't just need time to write; you need time around the time, to change mode'. So my election, in 2004, to Aosdána, the state-supported affiliation of Irish creative artists, came as an absolute liberation. It made it possible for me to give up full-time teaching. I continued to teach a summer course in the National University of Ireland Galway and to give readings at home and abroad.

With translation funding support from Literature Ireland (previously Irish Literature Exchange), I have had bilingual selections of poetry published in Spanish, Portuguese and German. Through my friend and translator, the Argentinian poet Jorge Fondebrider, I have visited Latin America several times and, in 2015, through that fosterer of Irish-Japanese literary links, Mitsuko Ohno, I had the great pleasure of visiting the country that gave us haiku.

The poetry publishing world has changed enormously since I began to write in the late 1970s. Thanks to the generation of Irish women writers immediately before mine, poetry by women is much more widely published in this country – although this is still not properly reflected in anthologies. Our two most recent Ireland Professors of Poetry have been Paula Meehan, Dublin city's most eloquent voice since Seán O'Casey, and Eiléan Ní Chuilleanáin. I regard myself as extraordinarily lucky to have been born at such a shifting, exciting time in Irish literature and to have had the benefit of gifts of education, books, friends and literary communities all along the way.

It is strange that such a solitary, sedentary activity should have brought me to many corners of the world, to Neruda's Santiago, to Basho's Kyoto and to Machado's Soria, and should have led to many rich friendships. But, as Theodore Roethke said, you only really feel like a poet in the five minutes after you have finished writing a poem.

MOYA CANNON

Moya Cannon was born in 1956 in Dunfanaghy, County Donegal. She was educated at Loreto College, Milford, University College Dublin and Corpus Christi College, Cambridge. She worked for some years as a teacher before becoming a full-time writer in 2004.

Landscape, archaeology and geology figure in her writing as gateways to deeper understanding of our mysterious relationship with the natural world and our past. Music, particularly traditional Irish music, has always been a deep interest and is a constant theme. She has given many readings with musicians and singers, among them the harper Kathleen Loughnane, the traditional singers Maighréad and Tríona Ní Dhomhnaill and the RTÉ Contempo String Quartet.

Moya has been invited to read in Ireland, Europe, in the Americas, North and South, in China, Japan and India. Bilingual selections of her work have been published in Spanish, Portuguese and German editions. She has been honoured with many prizes, including the Brendan Behan Award and the O'Shaughnessy Award and she was Heimbold Professor of Irish Studies at Villanova University in 2011. She has been editor of *Poetry Ireland Review* and is a member of Aosdána.

BIBLIOGRAPHY

Oar (Galway, Salmon Publishing, 1990/Dublin, Poolbeg
 Press, 1994/Co. Meath, Gallery Press, 2000)
The Parchment Boat (Co. Meath, Gallery Press, 1994)
Winter Birds (Minnesota, Traffic Street Press, 2004)
Carrying the Songs (Manchester, Carcanet Press, 2007)
Hands (Manchester, Carcanet Press, 2011)
Keats Lives (Manchester, Carcanet Press, 2015)
Donegal Tarantella (Manchester, Carcanet Press, 2019)
Collected Poems (Manchester, Carcanet Press, 2021)

Áine Ní Ghlinn

THE SMELL OF OLD BOOKS

I love the smell of old books. Sometimes I browse at book fairs or in secondhand bookshops – not just for the gems you occasionally encounter, but also for the smell. I like to get a sense – real or imagined – of the readers who have gone before. A hangover from childhood, I believe ...

As a small child one of my clearest memories is of the mobile school library. Roughly once a month, the library arrived at the gate of our small rural school in what appeared to me then to be a huge van. To me it was the biggest, the most exciting, the most magical van in the whole world. The 5th and 6th classes were assigned the role of librarians and selectors for the day. My world for the next month depended on their wisdom.

When I was finally old enough to join the selection committee, I must have driven everyone else mad. I would spend forever poring over every cover, feeling the texture, sniffing the smells of every previous reader.

I lived out the country in County Tipperary. The nearest village (with a shop, post office and an old railway station) was a mile away. There were very few children around so play dates were limited to the occasional visits from cousins at weekends.

Books were my life. I solved mysteries up and down the garden with Nancy Drew. My dolls and I camped out under discarded curtains and sailed an old crate with

Swallows and Amazons. I was *Heidi* running up and down pretend mountains. I was each of the March sisters – though usually Jo. Apart from Timmy the dog, I played every role in the Famous Five and the Secret Seven.

I read and I read and I read. I read the same books again and again. I read without judgement. Unlike my own children who had so many books they could choose what books or authors they wanted to read, I liked all books simply because they were books.

Many years later, when I began to review books I had to take the time to learn how to be a critical reader.

My background was a conservative one. My parents were primary teachers and, like most teachers of their generation, they were very Catholic in their outlook. There were always books in the house but my father would occasionally ban a book he thought inappropriate. How conservative was he? Well, most comics (including *Bunty* and *Judy*) were on the blacklist and as for the teenage *Jackie* – that had to remain well hidden under the mattress from his censorial eye.

Because our house was in a relatively remote area, I lived most of the time in my head. I wasn't lonely because this was what I grew up with. If it were now, I would find it incredibly isolated but, in those days, I knew no other life. I had a sister close in age and we played together, but if she weren't available I would just draw on a whole community of imaginary friends. We – my imaginary friends and I – made Robin Hood bows and arrows out of branches, we created tents from old sheets and curtains, boats from anything available and our adventures were endless and unlimited.

Without knowing what plagiarism was, I plagiarised characters wholesale from every book I read and wrote new adventures for them (myself always in a leading role). I created new characters and for them, I plagiarised old stories.

Going on to become a 'real' writer probably wasn't a huge step from there. It was simply a matter of learning not to steal. Gradually, I created new stories for new characters. I wrote angst-ridden poems for them. (Thankfully, none of these ever saw the light of day!)

I was at my happiest when reading or writing but I had no idea then that becoming a writer was even a possibility. It never occurred to me that I might – one day – see my name on an actual book.

When an inspirational English teacher presented me with Alexandre Dumas' *The Black Tulip* as second prize in a poetry competition in the Presentation Convent Secondary School, Thurles, it had a major impact on my life. Until then, my scribbles were for my eyes only. Nobody had ever given me any particular encouragement or told me that I had any particular ability as a writer. My father recognised that I had some talent but – in his view – writing was not a 'proper career' and was certainly not the safe, permanent, pensionable job he wanted for his youngest daughter. When I mentioned an interest in journalism as a career, he simply said 'No'. It was university or teacher training college. (In those days, when your father said 'No', it was 'No!' I can only imagine my own sons having a good laugh if I tried to control their career choice!)

In my teens, I was writing in Irish and English but an incident in the Gaeltacht in west Kerry changed all that. Dashing home on an ancient (and brakeless) bike from a clandestine meeting with some boys after a céilí, my carrier passenger and myself came off the bike on a sharp bend. I have no recollection of the actual incident. I simply woke up in Dingle Hospital in – of all places – the maternity ward! Every other bed was full – but you can imagine the tongues wagging about a sixteen year old girl ending up in the maternity ward.

A bed came available within a day or so and I was

moved into a private room. A nurse warned me that it was the room where Kruger Kavanagh had recently died and not to be afraid if he appeared at the foot of the bed. I'd know him, she said, by his constant winking. Convinced that she was having a laugh at my expense, I went back to sleep. To my horror and amazement, I woke up a few hours later to see an elderly man at the foot of the bed – and yes, he was winking at me!

I froze. The same elderly man, however, was not Kruger Kavanagh. He was an absolutely non-threatening and highly-inspirational character – Mícheál Ó Gaoithín, poet, storyteller and son of the famous (or infamous) Peig Sayers. He spent the next two days – right up to my discharge from hospital – sitting by my bed telling me stories and reciting his poetry to me. We talked about writing and the Irish language. He was encouraging and kind and he pleaded with me to continue to write *as Gaeilge*. (Having met Mícheál, doing *Peig* for Leaving Cert Irish was an absolute pleasure. Unlike my peers, I cherished every word).

I took Mícheál's advice about writing *as Gaeilge* ... and I suppose the rest is history.

I went on to UCD the following year to study English and Irish. Another chance encounter in the West Kerry Gaeltacht was with some students involved in UCD's Cumann Liteartha and Cumann Drámaíochta. Up to then, I hadn't met anyone else who wrote poems or stories *as Gaeilge*, so all my Christmases and birthdays had come in one. I was no longer alone! No longer an oddity!

I began to submit material to college magazines. I entered competitions – sometimes winning, sometimes not. But from here, the path was marked out. Not so much a conscious decision as a way of thinking. I wrote a few bits and pieces for the Cumann Drámaíochta – including co-authoring a Christmas panto. I wrote a few short stories – but there was a considerable interest in Irish poetry at the

time. Perhaps it had something to do with the group of *Innti* poets in UCC who had started their Irish poetry revival four or five years earlier.

When I left college at the end of the seventies, I became a teacher and continued to write in my spare time. By 1984 I had my first collection of poetry, *An Chéim Bhriste*, published by Coiscéim. As a new female voice, I was a novelty. Four years later, my second collection was published.

By then, I had moved out of teaching and into broadcasting and journalism. I still had dreams of writing 'stories' but as a freelance and short-term contract worker, I had to focus on work that brought in money to pay the rent.

Another chance encounter gave me further opportunity. Caoimhín Ó Marcaigh was Chief Editor with An Gúm and he asked me if I might be interested in doing some freelance translation work and in writing some general knowledge books for teenagers. I certainly was interested and wrote two collections of general knowledge 'stories'.

With a toe in the water and – by now – a few contacts in the market, a few children's books followed. Some with O'Brien Press, some with An Gúm. Later, I began to write for Cois Life, Cló Mhaigh Eo and *Leabhair*COMHAR as well.

Foras na Gaeilge, COGG, Poetry Ireland and Children's Books Ireland all offered some opportunities to share my love of books and writing with children in schools. These were (and still are) essential in terms of bringing in an income from writing. Scriptwriting for *Ros na Rún* kept the wolf from the door for a while and as the years went by, I found a part-time freelance way of life that allowed the opportunity to write, to do workshops, to do some part-time lecturing as well as spending lots of time with my own children.

For a number of years, I lived my dream.

Financially, it was, you might say, fine at the time! I was married and mine was the second 'part-time' income. I had no difficulty getting published. There was a demand for children's stories and teen fiction *as Gaeilge*. Gaelscoileanna wanted and still want both books and workshops. Reviews were sparse but working in the small niche Irish language market, direct contact with your readers is as important as a written review. Young readers are brutally honest and will tell you straight out what they do and don't like.

Now, however, as retirement looms ever closer and mine is the only income, the financial side of being a full-time writer is more of a concern.

Irish language books have a small faithful following but they don't have the broad market open to the English language writer. Children are reading less and less in every language. Translations to Irish from the bigger English names – for instance, J.K. Rowling – are gradually eating into that small Irish language market.

Yet, if the clock were turned back and I had that wonderful wisdom of hindsight, would I do it all again?

Yes! Definitely, definitely, yes.

Áine, born in 1955, is an Irish language poet, children's writer and part-time lecturer. She has written 31 books to date (5 collections of poetry for adults, 2 collections of poetry for children, as well as a range of YA novels, stories and drama for children).

She has won many awards for poetry and fiction. The most recent are a Patrick Kavanagh Fellowshop (2019), Duais de hÍde, Strokestown Poetry Festival 2019, Duais Fhoras na Gaeilge 2019 (Listowel Writers' Week) and she is a three-time winner of Gradam Reics Carló Irish Language Book of the Year. Her YA novel *Daideo* also won a CBI fiction award and Literacy Association of Ireland Book of the Year.

In 2020 she was appointed as Ireland's Laureate na nÓg.

BIBLIOGRAPHY

An Chéim Bhriste (BÁC, Coiscéim, 1984)

Gairdín Pharthais (BÁC, Coiscéim, 1988)

Directory of Women Contributors (RTÉ, 1990)

Mná as an nGnáth (BÁC, An Gúm, 1990)

Daoine agus Déithe (BÁC, An Gum, 1996)

Deora Nár Caoineadh/Unshed Tears (Dublin, Dedalus, 1996)

Daifní Dineasár (Dublin, O'Brien Press, 2001)

An Leaba Sciathánach (BÁC, An Gúm, 2001)

Céard tá sa Bhosca (BÁC, An Gúm, 2002)

Moncaí Dána (Dublin, O'Brien Press, 2002)

Glantachán Earraigh (BÁC, An Gum, 2003)

Lámhainní Glasa (Dublin, O'Brien Press, 2004)

Cuairteoir (BÁC, Cois Life, 2004)

Duanaire Naithí: An Anthology of Poetry by Children from Scoil Naithí (BÁC, Coiscéim, 2005)

Fuadach (BÁC, Cois Life, 2005)

Duanaire na Camóige: Poetry by Children from Gaelscoil na Camóige (BÁC, Coiscéim 2006)

Hostanna (BÁC, Coiscéim, 2006)
Madra Meabhrach (BÁC, Cois Life, 2007)
Múinteoir Nua (BÁC, An Gúm, 2007)
Éasca Péasca (Dublin, O'Brien Press, 2008)
Brionglóidí & Aistir Eile (Cló Mhaigh Eo, 2008)
Tromluí (BÁC, Cois Life, 2009)
Thar an Trasnán (Dublin, O'Brien Press, 2010)
Úbalonga (BÁC, An Gúm, 2010)
Bronntanais & Féiríní Eile (Cló Mhaigh Eo, 2010)
An Guth Baineann (BÁC, *Leabhair*COMHAR, 2013)
Éaló ón Zú (Cló Mhaigh Eo, 2013)
Nílim ag Iarraidh Dul ar Scoil (BÁC, *Leabhair*COMHAR, 2013)
Comhar Óg (Editor, 2014–) creative writing magazine for
 teenage writers in Irish
Daideo (BÁC, Cois Life, 2014)
Hata Zú Mhamó (BÁC, Cois Life, 2015)
Cinnín Óir agus Na Trí Bhéar (BÁC, An Gúm, 2016)
Hata Oisín (BÁC, *Leabhair*COMHAR, 2017)
Boscadán (BÁC, Cois Life, 2018)
Fadó Riamh (BÁC, *Leabhair*Comhar, 2019)

Catherine Dunne

WRITING FOR MY LIFE

Summer 1979, Toronto

From where I sit, I can hear the steady tick-tick-tick of the lawn sprinkler. Inside the library the air is dry, cool, even chilly. It's late afternoon and I've had enough of mid-July Toronto. The sun smells of hot earth; it prickles across my Irish skin and makes me dream of books. I can't read in temperatures that force the humidex up to forty degrees.

Most days at this time, I dive into the clear waters of the Gladstone public library on Bloor Street. Its calm, sea-green interior is welcome after hours of painting and decorating. I stay there, floating, soothed, until the librarian murmurs that it's time to close.

On the new acquisitions trolley, just inside the door, I've picked up a book called *Life Before Man* by someone called Margaret Atwood. I've never heard of her before, but she is Canadian. I've already spent time with Margaret Laurence's *The Diviners*, with Alice Munro's *Dance of the Happy Shades* and with Carol Shields's *Small Ceremonies*. They've all made me hold my breath and so I decide to give Margaret Atwood a try.

Summer 1965, Dublin

My mother is darning socks. We're sitting in our back garden, in twin deckchairs. I can smell the new paint on the garage door, the one that's been left open for months

now. A blackbird built its nest in the abandoned speaker that sits on the top shelf: its concave shape the perfect foundation for a new and feathery household.

My mother and I are sharing the weak rectangle of sunlight that warms the concrete flags. I'm useless at darning and I still haven't managed to turn the heel of a sock. All the other girls in fifth class have smooth, obedient knitting, spreading evenly across the four thin needles. I keep dropping stitches. My wool is always grubby.

My mother tells me she had to be good at things like that. Her education finished in 1930, when she was just fourteen and her years at primary school were over. She went to work in Cassidy's department store on South Great George's Street, along with her younger sister, sewing, cutting patterns, making alterations.

She'd like to have gone on to secondary school, she says. But there was no money to spare in the two-room North County Dublin cottage that she shared with her mother and three siblings.

Her father, a much-loved merchant seaman, was an infrequent visitor, away for long stretches at a time.

Summer 1979, Toronto

I fish my brand-new Canadian notebook out of my rucksack. I've always been a notebook addict. Cool, lined pages offer up an invitation that is irresistible. When the notebook itself is beautiful, that's even better.

Today, I make notes as I read *Life Before Man*. The novel explores three characters, imprisoned in a triangular relationship. It digs deep into their disappointed lives. The prose fizzes and crackles; there are laugh-out-loud moments.

The author's voice is clear and resonant, somehow instantly recognisable. But meeting her characters means entering a new language, learning a new alphabet. The

words they hurl at each other are sharp, crystalline, exact. The wounds they inflict are different from the ones I expect. Their hurts are thrilling, energising, somehow up-to-date: emotion is revealed, rather than repressed.

I have so many questions. I've several notebooks filled with them: with ideas, observations, lines that grow into poems from time to time. I'm in my element now but I wonder how anybody ever writes a novel. I seem to start a lot, but never finish. I'm struggling to find my voice, and it feels important to keep on struggling.

I no longer remember when I started keeping notebooks. As a child, I believe that if you love reading, then you write your own stories, too.

Of course you do.

Once I discover that of course you do *not*, I keep my mouth shut.

Home again after Toronto, back at the day job in Dublin, I send stories to David Marcus for his 'New Irish Writing' page in *The Irish Press*. I write poems, too, but somehow never send them. The short stories all come back, but with encouraging, handwritten notes.

It feels like a conversation, one that sustains me. My voice no longer feels like its own echo.

When I win my first prize in 1990 – a tiny one, for poetry, at the Gerard Manley Hopkins Summer School – it feels as though others might be listening, too.

It's also the first time I learn that writers aren't in it for the money. Years later, my agent remarks, with a sigh, as she discusses her negotiations with a publisher: 'That's not an advance: that's a *retreat*.'

Winter 1969, Dublin
My father runs away from school so many times that my grandparents give up sending him. I don't blame them: my grandfather is already an older parent, with seven other

children. Exasperated by his son's unruly behaviour, he apprentices him to an electrician. But Belfast in the mid-1930s is an unfriendly place to be a Catholic.

Some three decades later, around our Dublin table, I hear story after story of those early teenage years. I soak them up. Later, I come across something that Margaret Yourcenar says about the 'emotional storage' that writers do, 'very early on'. I'm not aware of the concept at the time, but it's happening: the laying down of layer after layer of sedimentary memory.

Once, while my child-father is still a raw apprentice, the woman of the house asks this wee boy what school he went to. When my father tells her, she shrieks that she has the Antichrist under her roof and runs out into the street, flapping her apron, still screaming.

He learns quickly after that. And not just about what's neutral and what's live.

When Northern Ireland explodes at Burntollet Bridge in January 1969, nobody in our house feels surprised. But my adolescent self rebels, in time. Rushing home, all of us, one winter evening to catch the news on television, I'm less than polite. I want to watch something else, not the same old, same old.

But it's 30 January 1972. It's Bloody Sunday in Derry. And nothing is ever the same old, same old, again.

A few months later, as an apology, I buy my father the pamphlet of Thomas Kinsella's poem, *Butcher's Dozen*.

Winter 1987, Dublin

We are thinking of emigrating. Almost every young person we know has left the country. Although we don't yet realise it, this is the decade of Charvet shirts, of wholesale hypocrisy, both Church and State, of toxic collusions among the rich and powerful. What we do know about, though, is the economic black hole.

We're paying for it. That year, the mortgage interest rate soars to 12.5%.

The same year, unemployment stands at 17.5%. Teaching in a disadvantaged area, we all feel we're educating our students only to swell the dole queues. Deep in the shadows of recession and morally bankrupt institutions, we're told that we're all 'living beyond our means', that the national belt must be tightened.

If we had a belt, we'd tighten it.

There is political and social turmoil all around us. Ten men die on hunger strike in Northern Ireland.[1] Margaret Thatcher's intransigence transforms her into the most effective recruiting sergeant the Provisional IRA has ever had. A spurious new category of 'national security' means that respected journalists such as Geraldine Kennedy and Bruce Arnold have their phones tapped.

But probably the most bitter and divisive debate of all revolves around the abortion referendum of 1983. 'Vote No for No Change' is the slogan that galvanises resistance to the proposed new wording of the Constitution: a wording that gives an equal right to life to the foetus and to the mother.

I spend weeks shoving leaflets into letter boxes, meeting hostility on the doorsteps, thinking of my own lovely baby boy asleep at home: and how lucky I am.

But we lose. Women will continue to pay the price for another thirty-five years. And in 1986, the Divorce Referendum also fails.

The old Chinese curse that we might 'live in interesting times' feels particularly relevant. I know that Ireland is not a good place to be a woman. I don't want to be here anymore.

But Canada turns us down. With a four-year-old child and an increasing sense of restlessness, I write.

My energy feels limited. It's as though it, too, is pouring

itself into a black hole. Work helps: I love teaching, love my students. But I wonder what their lives will be, and I worry for all of us.

A popular bumper sticker of the times reads: 'Last person to leave Ireland please switch off the light'.

Writing remains a private activity during the dismal eighties: its very secrecy a necessary armour in the face of 'Who do you think you are?'

But annual visits to Listowel Writers' Week, the occasional writing workshop and a growing pile of notebooks all help me hold onto who I am, or at least, to who I might become.

For more than a decade I've absorbed stories of failure, of grief, of abandonment. Everywhere, there is the cultural absence of forgiveness: the cruel impossibility of a second chance.

And yet, I grow to understand that we Irish seem to forgive success even less readily than we forgive failure.

But something is happening to all these narrative webs that are spinning inside my head: they cease to be disparate. They are beginning to feel like fragile filaments of something that might coalesce into a whole.

I struggle to find coherence. Or, as Joan Didion says: I try to find out 'what is going on in these pictures in my mind'.

I have by then written forty thousand words about four women friends, 1980s Ireland, all their life experiences intersecting during the course of that grim decade. I know it's no longer a short story. But I don't know what else it might become.

I also don't know, at that early stage, that I'll have to kill off three of my characters. I can't handle such four-sided complexities of a narrative circle, not yet.

But Rose, my main character, remains: tenacious, often downright intrusive.

She won't go away, she tells me, until I listen, really listen, to her. She has a story to tell.

Summer 1970, Dublin

Clontarf, where I spend my childhood and adolescence, has no library. But nearby Marino does. My mother and father, both great readers, hand over their blue adult tickets and I borrow the maximum number of books allowed every week.

The smell of new books as they rest on those long, polished wooden shelves is intoxicating. Back then, libraries are quiet places. A glare from the librarian is enough to gather whole handfuls of silence out of the shufflings and behind-the-hand whisperings.

I like that. I like the hum of traffic outside, too, the way the library becomes a refuge, the way it offers everything and demands nothing in return.

I will experience this feeling all over again, with a similar intensity, some thirty years later. This time as a writer in the Linen Hall Library in Belfast. I'm engaged in research, and it has become compulsive. I'm writing *Another Kind of Life* (2003), a novel based on the history of my Northern Irish family.

I'm doing what I once heard Frank McGuinness suggest: I'm reading everything I can get my hands on about Belfast in the 1900s, in order to forget it. I don't want my new learning to sit upon the page.

I want it to disappear, priming the canvas: like the slow, deliberate work of the underpainter.

But that long-ago summer, the summer I turn sixteen, I make my way through the drama shelves in Marino library, alphabetically.

Of course, I don't understand everything I read of Chekhov. Or Ibsen. Or even O'Casey, even though his Dublin feels close enough to mine. But something inside

me understands, from that mysterious place that lies underneath all the levels of language.

Something that is recognisable is pushing its way to the surface.

All I have to do is breathe.

Summer 1991, Dublin

I am making my way through the wreckage, step by excruciating step. I cannot bear to look at the baby clothes, folded in a small, expectant pile in the corner of my bedroom. Or at the overnight bag, casually retrieved from the top of the wardrobe only days beforehand.

Afterwards, my life will remain divided into two parts: the part before the stillbirth of my second child, a boy, and the shards of living that I piece together afterwards.

Something has to be done to fill all those empty spaces. All those nights when sleep won't come. The days when picking my way through grief is like stepping from one half-submerged island to the next.

And so I write. Writing becomes my craft, easing me through the turbulent, watery journey from one piece of dry land to the next. I gather up my notebooks along the way. Sometime towards the end of that year, an opening sentence comes to me. 'In the beginning,' I write, 'there is a family.'

For the next four years, I live a life of imaginative empathy with Rose and her children. I write and rewrite so many drafts I lose count.

But it's exhilarating, endlessly-absorbing work, watching a narrative take shape. I never get tired of it. I may feel sad, but I never feel lonely in that creative zone.

It's my second chance. The life I never dreamt I'd have. And now I'm writing for it: writing for my life.

I've been doing it ever since.

I realise subsequently, of course, that many people all over Ireland are doing something similar. It never strikes me at the time that I should seek them out. That will come later. In the early nineties, my privacy feels as important as ever – but it is a privacy laced with something that feels almost as toxic as shame.

'Who do you think you are?'

'Writers are ten a penny.'

'Ah, sure, everybody has a book in them.'

And so, knowing who I am, I stay silent.

I take a career break from teaching. I need to know if I can make my story live. I need to know if writing is something I can do.

I have just turned forty-one.

A quick straw poll shows me now that women in those days emerge into writing careers much later than our male counterparts.

Mary Beard might have something to say about that: about how women work under the cultural constraints of silencings that are so pervasive we have almost ceased to notice them.

My first novel, *In the Beginning*, is published in 1997, although I complete it in 1995. Published by Jonathan Cape in London, it makes a respectable splash. Foreign rights are acquired by several countries, including Italy. There, it touches the Zeitgeist. A tale of betrayal, of sexual infidelity, of 'divorce Irish style' – before we had divorce legislation here – finds its way into the hearts of Italian readers, where it has since remained. The following year, it takes its place on the list of finalists for the Bancarella, the Italian Booksellers' Prize.

I have to pinch myself.

Italian readers will continue, over the next twenty-odd years, to keep me close. January 2018 sees a brand new

edition of *In the Beginning* for its twentieth anniversary in translation. In 2013, I am awarded the Giovanni Boccaccio International Prize for Fiction for *The Things We Know Now*.

With a teenage boy as my central character, I explore the devastating impact of cyberbullying on him and on his family. My novel also goes on to be shortlisted for the Novel of the Year at the Irish Book Awards.

Summer 1996, Dublin

Back in June 1996, Ireland's legislation permitting divorce for the first time is signed into law. Someone here hails *In the Beginning* as the 'first post-divorce novel'.

But I'm wondering: is this it? Is this the one book I've had inside me for all this time, the one that everyone talks about? Has the writing well now run dry? Somehow, the question makes me feel cheated.

I extend my career break for another year in order to find the answer.

Spring 1998, Dublin

I haven't been idle.

In June 1995, the day I finish *In the Beginning*, I write the opening sentence to a new novel. I'm supersititous that way: I feel that if I let any time elapse between finishing one piece of work and starting the next, the gods of writing might desert me. I write like a demon for the next three years.

I am aware of the tick-tick-tick of the career-break clock.

I have an idea that has been scratching away at me for months, that won't leave me alone. Reading a distressing newspaper report about a murder-suicide, something begins to stir in the darker reaches of my imagination. A character appears to me; his story feels almost fully-formed. It is an idea that grows, that seems to settle inside

me into stillness, into a space that has been long prepared for it.

A Name for Himself (1998) becomes a dark psychological thriller. It tells the story of Farrell, a damaged individual from a violent family background. He's a man in search of himself, his own identity. When he falls in love with Grace, he does so obsessively, destructively.

The following June, it is shortlisted for the Novel of the Year Award at Listowel Writers' Week. It is reviewed well; it, too, travels abroad and acquires several new covers in several different languages.

But, twenty or so years ago, I am puzzled at some of the questions that people in Ireland ask me. Many of them are similar to those asked about my first novel – although the two couldn't be more different.

Is this chick lit? Is it autobiographical? Is a lot of it based on your own personal experience?

These are questions I don't hear my male contemporaries being asked. It's as though the questions reveal a particular gendered conundrum: are women really gifted with the same sort of creativity as men? Doesn't what we write stem from our private lives? Isn't it all about personal experience?

It's a view that is at best ignorant; at worst, insulting. It's as though our words have managed to reach the page without any real process of transformation: so that rather than making art, when women write, it becomes therapy, or unfiltered autobiography.

For me, though, all those years ago, the real significance of the critical response to *A Name for Himself* is that I finally begin to believe I can become a writer. Not that I am a fully-formed one, yet, but that I am in the process of becoming one, raising the bar higher each time I write. It is a measure of self-belief that comes from the process of

writing itself and from the reviewers' reaction to this, my second novel.

No, say the reviews, it's not 'chick lit' or light romantic fiction, the apparent preserve of women writers. (Although around the same time, Tony Parsons, Mike Gayle, Nick Hornby, Matt Dunn and Jonathan Tropper are all writing light, humorous romantic fiction, from a male point of view, but somehow, the label 'lad lit' never sticks. And if it does, it doesn't carry the same disparaging undertones).

A Name for Himself is received as what it is. It is a novel. A work of fiction. A work of the imagination.

I finally feel like a grown up.

Over more than two decades as a published writer, I've experienced the accusation many times that women work on too narrow a canvas: that of the 'domestic'. The wider world, that of big issues and important causes, belongs to men. It's an argument that might also be familiar to Jane Austen.

In *The Odyssey*, Telemachus tells his mother, Penelope, to be quiet. He tells her: 'talking must be the concern of men'.

In this version of the tale, she obeys; we don't know how she feels, but she obeys.

He means, of course, that *talking* – all the public, the weighty, significant discourse – must be carried out by men. The chatter can belong to women, tidied away into their domestic spheres among the dishes and the brushes.

Spring 2018, Dublin
It's different now, though, in this well-aired twenty-first century. Some things have changed, for the better, haven't they?

Have they?

In 2015, the novelist Catherine Nichols, disappointed at the silence from agents that greeted her latest manuscript, decided to send it out under a pseudonym. She says the decision made her feel 'dishonest and creepy', but she was becoming more and more aware, the deeper she dug, of the unconscious bias of which she seemed to be a victim. And so, for her submissions to fifty agents, Catherine Nichols became George Leyer. In an essay for Jezebel.com, she describes what happened next:

> George sent out 50 queries, and had his manuscript requested 17 times. He is eight and a half times better than me at writing the same book. Fully a third of the agents who saw his query wanted to see more, where my numbers never did shift from one in 25.[2]

She goes on to say:

> One [agent] who sent me a form rejection as Catherine not only wanted to read George's book, but instead of rejecting it asked if he could send it along to a more senior agent. Even George's rejections were polite and warm on a level that would have meant everything to me, except that they weren't to the real me. George's work was 'clever', it's 'well-constructed' and 'exciting'. No one mentioned his sentences being lyrical or whether his main characters were feisty.

We might well ask: What is going on here? This is *now*, not thirty years ago.

Thirty years ago, we had the infamous *Field Day Anthology of Irish Writing* (1991) which arrogantly excluded the writings of most women: but that was *then*.[3]

Anne Enright, in the *London Review of Books* in September 2017, writes that in her examination of literary reviews in our major newspapers for the year 2013, only 29% of the books reviewed in *The Irish Times* are written by women. In *The Irish Independent*, the figure rises to just 37%: and that is *now*.[4]

If we're talking about literary visibility here – and we

are – we must look, too, at the choices made for 'One City One Book', Dublin's annual celebration of literature that takes place during the month of April.

Since it began, back in 2006, all the selections, except for one, were of books written by men. *Fallen*, by Lia Mills (Penguin Ireland, 2014) was the choice for 2016 'Two Cities One Book', twinned for the first time with Belfast's celebrations.

Since 2018, however, there are signs that the imbalance is being redressed. The featured book that year was *The Long Gaze Back* (New Island, 2015) an anthology of short stories written by women, edited by Sinéad Gleeson, herself a fine writer. In 2019, Edna O'Brien's *The Country Girls Trilogy* (Faber) was finally celebrated, and in 2020, Christine Dwyer-Hickey's *Tatty* (New Island, 2004) was the chosen work.

However, we must not forget that, in 2015, our national theatre, the Abbey, chose to stage works written almost exclusively by men during the centenary celebrations for the 1916 Rising, the following year.

'Them's the breaks,' observed the then Director of the Abbey, Fiach Mac Conghail.

Waking the Feminists was born, in an explosion of anger, to highlight and to challenge the inequalities in Irish theatre. A report commissioned by Waking the Feminists and funded by the Arts Council, *Gender Counts: An Analysis of Gender in Irish Theatre 2006–2015*, concluded:

> Looking at the first eight sampled organisations, there is a general pattern of an inverse relationship between levels of funding and female representation ... In other words, the higher the funding an organisation receives, the lower the female presence in these roles.

But change is in the air. In June 2017 *The Irish Times* observes:

> The Abbey is now measuring gender equality in its programme in five-year periods. It has stated that, while there will be ongoing flexibility within programming for a given

year, the artistic programme 'will achieve gender balance' over the course of those five years.[5]

And this is now.

Back in the 1990s, Dublin sees the birth of the Irish Writers Centre, an invaluable resource for writers and students of writing. In addition, there are several Irish houses publishing fiction, among them Poolbeg, Lilliput, Brandon, New Island Books, Wolfhound Press, Mercier Press, O'Brien Press, Town House and Attic Press. Arlen House, with its reputation since 1975 as a vibrant feminist publishing house, was revitalised by Alan Hayes in 2000.

But UK publishing companies begin to open branches in Ireland in the nineties. Their advances – such as they are – are still better than those offered by their smaller Irish rivals. Most literary agents back in the nineties are also based in London and so several Irish writers – myself included – publish fiction with UK imprints.

Now, some twenty years later, Ireland has new and vibrant publishing companies of its own. The stalwarts have, mostly, gone from strength to strength, despite economic challenges, and newcomers such as Tramp Press publish some of the best of contemporary Irish fiction – by both men and women.

But the publishing landscape has changed out of all recognition. Sometime around 2009, book sales drop dramatically. Publishing houses everywhere 'rationalise' staff numbers. The worldwide recession bites. The ebook comes to stay.

And although sales of print books have improved in the last few years they have done so from a very low base.

One exception to this is crime fiction. It is a genre in which women are particularly dominant. Back in 2016, *The Irish Independent* notes that along with Liz Nugent, Alex Barclay, Tana French and Jo Spain:

Today's writing climate is also changing, as climate will. But one thing is certainly changing for the worse: it has become increasingly difficult to make anything like a living out of writing.

The Irish writing community is small enough: most of us run into each other at festivals and literary events all around the country. With one or two exceptions, I know of no writers who make their living purely from writing. All of us have at least one more string to our bow. Teaching creative writing; mentoring; visiting schools and libraries. And there is still a widespread belief that needs to be challenged: that writers should do things for free. They should be willing to work for nothing, in return for 'exposure'. The British novelist Nick Cohen wrote a piece for *The Spectator* a few years ago, in which he noted: 'Such a strange word to use in these circumstances, I've always thought, when people die of exposure.'[7]

In February 2017, *The Irish Times* has this to say:

The most recent survey of Irish authors' incomes – published by the Irish Copyright Licencing Agency in 2010 – found that in 2008–09 over half the writers consulted (58.7 per cent) earned less than €5,000 from writing-related income. Indeed, the commonest response – given by more than a quarter, or 27.9 per cent of respondents – was that they earned less than €500 a year.[8]

Advances (retreats?) are now smaller than they ever were. The market is more and more competitive. When a trend takes hold, it seems that books that don't fit neatly into a category or a genre are sidelined by publishers for those that do. In addition, the debut is now the most highly-sought after work of fiction. Publishers, often while

rejecting a submitted manuscript, admit that they would look upon it with a different eye if it were a debut. Great for new writers – and I'm all for supporting new voices, I always have been – but for older writers, particularly women, it may contribute to the 'invisibility factor'.

'Spice it up,' a writing colleague was advised recently by the publisher who rejected her manuscript. 'Can't your main character cheat on her husband?' another was asked.

Catherine Nichols observes: 'Women in particular seem vulnerable in that middle stretch to having our work pruned back until it's compact enough to fit inside a pink cover.'[9]

I accept that such evidence is purely anecdotal: it comes from agents; from the experience of other writers; from publishers themselves; from personal experience.

I have no scientific study to back up my growing belief that women writers, as we become older and usually better with the passing of years, also become more invisible.

Spring 2018, Dublin

March 2016 sees the publication of my tenth novel, *The Years That Followed*. It goes on to be longlisted for the Dublin International Literary Award, 2018.

It's always a thrill to have responses to the books that we write. They are, after all, conversations with readers: a novel is just a text until somebody engages with it. It's fascinating to see the wildly-differing responses to the same piece of writing: to see how much of their own lives readers bring to each book they read. Book clubs have grown exponentially over the years: it's fun to visit and observe people disagree over what you, the author, must have intended by this scene or that.

Twenty-five years, several novels and one work of

nonfiction later – *An Unconsidered People* (2003) dealing with the experiences of Irish immigrants in London in the 1950s – I'm still at my desk.

So why do I do it?

Because I can't not do it. The creative urge is stronger than ever. Each new book poses different challenges. Meeting them is exhilarating: sometimes frustrating, sometimes frightening, but never, ever dull.

Margaret Atwood once observed: 'Writing a novel is like the opening of a door onto a completely unknown space ... it's just as terrifying every time.'[10]

In the last few years I completed my eleventh novel, *The Way the Light Falls*. Like its predecessor, *The Years That Followed*, it gives a contemporary twist to a Greek myth – this time, that of Phaedra – and the process of writing it has been all absorbing. I've learned a lot. I'm still learning.

I think, above everything, that's what keeps me at my desk. Curiosity. The teasing out of all those 'What if?' questions. The feeling of belonging to what Doris Lessing once called 'the noble and ancient tribe of storytellers'.

Nonetheless, imagining the future poses some uncomfortable realities.

I write the stories that grip my imagination. Those that come to me in a visceral moment of inspiration: a heart-stilling response to something I observe, or imagine, or visualise. They arrive with an impact that cannot be ignored.

I follow those moments; I engage with the narrative that always seems to have chosen me – rather than the other way around.

But there is the economic imperative to be reckoned with – a driver for writers since time immemorial. 'No

man but a blockhead ever wrote except for money', says Samuel Johnson, back in the 1700s. Exaggeration for the sake of effect, perhaps, but its kernel holds true. He doesn't consider women, clearly, but that doesn't change the truth of his observation: that writers, like everyone else, still need to earn money.

There will always be works of fiction that cannot be shoehorned into recognisable categories. Those that are not crime; or fantasy; or experimental; or cutting edge; or romantic happy-ever-afters.

But my growing sense is that there is less and less room for them.

It would be good to face the future with optimism. But, in reality, it may mean that in order to survive, a writer – this writer – will have to adapt.

I'm not sure what such 'adapting' might involve.

I'm not sure whether I have the courage to do it – whatever 'it' is – particularly if I can't follow my heart, or take it with me.

But I can't imagine a life without writing. The darkness would be unbearable.

As Margaret Atwood had, in many ways, the first word about my writing life, all those years ago, I'll leave the last one to her also. In her book *Negotiating with the Dead: A Writer on Writing*, she says:

> Possibly, then, writing has to do with darkness, and a desire or perhaps a compulsion to enter it, and, with luck, to illuminate it, and to bring something back out to the light.[11]

From darkness to light: now that's worth writing home about.

NOTES

* Author photograph by Noel Hillis.

1 In 1981, Bobby Sands and nine other republican prisoners died on hunger strike.

2 Catherine Nichols, 'Homme de Plume: What I learned by Sending My Novel Out under a Male Name', https://jezebel.com/homme-de-plume-what-i-learned-send ing-my-novel-out-und-1720637627)

3 *The Field Day Anthology of Irish Writing, Vols 1–3* (Derry, Field Day, 1991), eds Seamus Deane *et al*. Women writers were under-represented in some sections of the anthology, particularly that dealing with contemporary poetry. In 2002, *The Field Day Anthology of Irish Writing, Vols IV–V: Irish Women's Writing and Traditions* (Cork, Cork University Press), eds Angela Bourke *et al* was published. These volumes were exclusively devoted to the writing of Irish women.

4 Anne Enright, 'Call Yourself George: Gender Representation in the Irish Literary Landscape', in Anne Enright, *No Authority: Writings from the Laureateship* (Dublin, UCD Press, 2019). First published in *The London Review of Books*, September 2017.

5 10 June 2017, article by Hugh Linehan https://www.irishtimes.com/culture/stage/waking-the-feminists-report-gets-the-measure-of-irish-theatre-1.3112309

6 25 September 2016, Myles McWeeney https://www.independent.ie/entertainment/books/book-reviews/queens -of-irish-crime-writing-35072138.html

7 Nick Cohen, *The Spectator*, 17 January 2016.

8 Martin Doyle and Freya McClements, *The Irish Times*, 6 February 2017. https://www.irishtimes.com/culture/books /the-500-a-year-career-do-irish-writers-get-paid-enough-1. 2965310

9 Catherine Nichols, *art. cit.*

10 Margaret Atwood, *Negotiating with the Dead: A Writer on Writing* (Cambridge, Cambridge University Press, 2002), p. 44.

11 Atwood, *op. cit.*, 44.

Catherine Dunne, born in 1954, is the author of eleven novels. Her one work of nonfiction, *An Unconsidered People*, is a social history that explores the lives of Irish immigrants in London in the 1950s. Among her novels are: *The Things We Know Now*, which won the Giovanni Boccaccio International Prize for Fiction in 2013 and was shortlisted for Novel of the Year at the Irish Book Awards. *The Years That Followed* was longlisted for the International Dublin Literary Award. She was the recipient of the Irish PEN Award for Outstanding Contribution to Irish Literature (2018). And in 2019, her novel *Come cade la luce* (*The Way the Light Falls*) was shortlisted for the European Strega Prize.

BIBLIOGRAPHY

In the Beginning (London, Jonathan Cape, 1997)
A Name for Himself (London, Jonathan Cape, 1998)
The Walled Garden (London, Pan, 2000)
Another Kind of Life (London, Picador, 2003)
An Unconsidered People (Dublin, New Island, 2003)
Something Like Love (London, Macmillan, 2006)
At a Time Like This (London, Pan, 2008)
Set in Stone (London, Pan, 2009)
Missing Julia (London, Pan, 2010)
The Things We Know Now (London, Pan. 2013)
Heart of Gold/La grande amica (Italy, Novella, 2013)
Heart of Gold (Dublin, New Island, 2015)
The Years That Followed (London, Macmillan, 2016)
The Way the Light Falls/Come cade la luce (Italy, 2018)

1985

Ruth Hooley/Ruth Carr's anthology *The Female Line: Northern Irish Women Writers* was published by the Northern Ireland Women's Rights Movement.

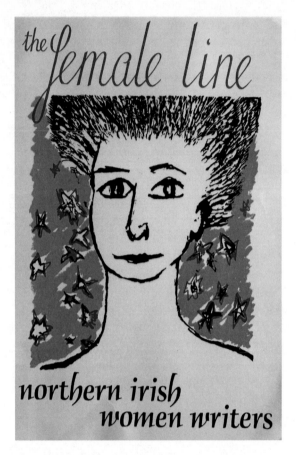

This was the first multi-genre anthology of women writers from Northern Ireland and it was a groundbreaking demonstration of the vitality of creative expression by women. Contributors include Medbh McGuckian, Anne Devlin, Jennifer Johnston, Marie Jones, Polly Devlin, Janet McNeill, Frances Molloy, Christina Reid, Fiona Barr, Mary Beckett, Anne Tannahill, Una Woods, Stella Mahon, Christine Hammond, Maura Johnston, Janet Shepperson and Blanaid McKinney. It was also a bestseller and went into a number of editions, most recently digital.

Éilís Ní Dhuibhne

IT WAS THE DREAM ITSELF
ENCHANTED ME

In Fourth Class, at the age of eight or nine, I wrote an essay about 'The Famous Person I Want to Be When I Grow Up' – Enid Blyton. I admired her more than anyone in the world.

So by the time I did the Leaving in 1971, although I was no longer in love with the works of Enid Blyton, I still wanted to be a writer and believed I knew exactly what to do next in order to become one – study English. Literature enchanted me. Although, at school, we read fiction and poetry in Irish and French, the focus in those classes was mainly on language, but in the English classes we discussed, with passion and delight, poems, plays, novels and short stories. Augustine Martin's anthology for the Inter Cert, *Exploring English Part One* (Gill and Macmillan, 1967), was a great favourite of mine. I knew some of the stories almost off by heart. I was bilingual in Irish and English, and now write in both languages. But back then English was the language of literature as far as I was concerned, and I longed to write it myself.

My teachers were always very encouraging. Confirmation that I was on the right path appeared to come in the form of the English Prize in the UCD entrance scholarship. I anticipated some sort of special attention thanks to this, but to my disappointment, nobody

appeared to know or care about my amazing achievement! (Plenty of students win prizes in the greater scheme of things, I suppose). In Belfield I was just one more anonymous student among the hundreds flocking into the biggest lecture theatre, Theatre L, to hear all about English literature. Not famous!

In school I had been encouraged to consider myself a future writer; in college there was apparently no expectation that anyone would have the slightest interest in such a career. I know now that several of those who perched on the seats of Theatre L in October 1971 had 'the bug', as my old English teacher had put it (to my disapproval – wasn't that expression disrespectful to my serious and burning ambition to be a great artist?) Maev Kennedy, Frank McGuinness, Harry Clifton and Ronan Sheehan, for instance, to name a few, were in the big crowd gathered for the opening English lecture, by Terry Dolan, on 'The Nonne's Preeste's Tale', in October 1971. But whatever our dreams, in college we were taught to read and analyse, not to write. Nevertheless, it was great fun. I enjoyed studying English, and writing the opinionated, rather gentlemanly, essays (no footnotes required) which were the staples of the English programme in those days.

We were, however, offered one analytical tool which was very useful for an aspiring writer, namely 'practical criticism'. This method of literary criticism, also known as 'new criticism', had been developed by I.A. Richards in his *Practical Criticism* (Kegan Paul, 1929/1930).

It was central to the UCD English curriculum in the 1970s. We pulled poems apart as if they were toads in a lab. The general idea was that there was always at least one subtext in any piece of writing and if you dug deep enough you would find out what it was. I loved these investigations. And now I believe that this insight into how texts work, although it was designed to help us

uncover meaning, was helpful to me as a creative writer. By learning how to read between the lines I figured out how to write between them, to create a surface and a subtext at the same time. We always carried out our 'practical criticism' on poems – probably because they are conveniently short – but it suits short stories very well too.

One aspect of the English syllabus which deserves comment is that while it aimed, nobly, to provide students with an overview of the most important works of literature in English from Beowulf to the twentieth century, it included hardly any works by female authors. Jane Austen, Emily Brontë and Emily Dickinson were indeed read at various stages during the three years of the BA, but, apart from these, women were absent. As the curriculum, so the staff: the female component thereof was miniscule. If my memory serves me correctly, there was one woman lecturer in the Department of Old and Middle English, and two or three in Modern English – out of thirty or so. In later years, I have often commented on these conveniently dramatic statistics. At the time, however, I didn't notice anything peculiar in the lack of gender balance so I can't claim that I was put off the notion of writing by the lack of 'female role models'. It's extraordinary how what we see is conditioned by expectations and habit. That most of the students of English were girls and most of the teachers men seemed entirely natural. If I was in danger of being put off, it was by the lack of any sort of role model, male or female, and by the apparent lack of recognition that Shakespeare and Swift and D.H. Lawrence had been human beings, once, even young apprentice writers. Students of a kind, just like us. But to us students, it was almost as if all the texts we read, even those with an author's name on the cover, novels and plays and poems (we seldom, if ever, encountered a short story, for some reason which I don't quite understand) had been created by some process of

spontaneous genesis or miraculous conception. Moreover, we were encouraged to regard the books we studied as the creations of geniuses, perfect in every way. If a work was on our list, it was clearly there because it was flawless. Who decided this divine canon? We didn't ask. One didn't. And we didn't know about 'the canon'. Like 'gender balance', it wasn't a term in our vocabulary.

Needless to say, there was some life outside the classroom, even where literature was concerned: societies, groups, where young writers gathered. These were loosely affiliated to the English Lit Society; as far as I remember, these young writers were male – only a very confident and assertive girl, a cool and beautiful girl, would have broken into the club. I wasn't that person.

The Irish Writers' Co-operative, founded in 1975, was almost exclusively male.[1] I am quite sure it was not deliberately designed to exclude women. It wouldn't have had to. They excluded themselves.

Still, I had decided that I was going to be Enid Blyton and I clung to my ambition to be a writer. Nothing ever dislodged that sense of myself.

Not even the fact that I hardly ever wrote anything.

'A woman can't be a good writer,' a boyfriend told me. I can remember very well the moment. We were sitting on the banks of the Grand Canal under a hawthorn tree, one balmy summer night.

'Why not?'

'They can't be frank enough.'

About emotion, love, and sex, is what he meant, I surmise.

I thought 'You're wrong.' (I was very given to not saying, out loud, what I thought – perhaps it is a writer's habit?) But I had no arguments to defend my literary ambitions. It hadn't occurred to me that the female cautiousness which would protect me from what we

perceived as the greatest danger a young woman could face in 1970s Ireland – pregnancy – could also prevent me from being a writer. With the gift of hindsight, I realise that the young man had put his finger on something significant. Women in Ireland were expected to be modest, retiring, lady-like. A writer reveals too much, she reveals her heart and her soul, and, even worse, secrets to do with her body. It's ok for a man to do that, but how could a decent Irish girl possibly consider such a thing? Goodness! She might as well go off and hang around the Burlington Road or Harcourt Street, selling her body to men in big motor cars. She'd be a scandalous woman, like Edna O'Brien or something.

Moreover, she would break another very strong, and related, taboo. She'd be showing off. This was absolutely forbidden by the whispered constitution of the time. And it is one reason why there were very few Irish women writers. In the Irish language, for instance, they were to all intents and purposes non-existent. Of almost 300 novels written in Irish in the twentieth century, about ten are by women, and all the rest by male authors. This is a much more extreme statistic than that relating to literature in English, but it's telling. Nice Irish women didn't write fiction. They read it. Then they covered their heads with lace mantillas and bowed them to the male gods of the country – not a few of whom were prancing about the slopes of Mount Parnassus.

But when my relationship with that particular person ended I wrote about it. I sent the short autobiographical story, handwritten, to *The Irish Press*, which published a short story once a week in the page called 'New Irish Writing'. David Marcus, the editor of the page, accepted and published it and sent me a cheque for five guineas. So, as a second year undergraduate student, I was a published writer. The story, called 'Green Fuse', was driven by sexual desire, the hand that through the flower the green fuse

drives. Decades later David included it in an anthology entitled *The Irish Eros*. It expressed its desire in symbols and metaphor – all that 'practical criticism' had taught me the art of the hint. My purpose was artistic but writing between the lines protected my female modesty from the social police – much as the Irish language writers of *aislings* hid their political messages in romantic images.

I hid in another time-honoured way too. I used a pseudonym. Nobody could link my story to the shy student who was traipsing around the corridors of Belfield.

That was the start.

Of course it started earlier.

Almost all children love stories, books, plays and films, if given the chance. So why do some 'become' writers and others not? Is there a natural talent or inclination, some compulsion which drives one individual in the direction of literary invention, as some are good singers or have a musical ear or can draw? What part do nurture and environment play?

I don't know.

As a child I was a voracious reader. I liked to escape from my real world into a world of fantasy, or at least into other people's worlds. The worlds of children's fiction, in the 1950s and 1960s, presented many territories which were more fun than my own – I loved Elinor M. Brent-Dyer's Chalet School series, and Drina Adams's days at the barre at Sadler's Wells. I enjoyed sleuthing around with Nancy Drew in her little roadster. The 'children's classics' offered worlds which were more nuanced by darkness than the relentlessly-cheerful life of Malory Towers – I cried with Heidi when she was homesick for the alp in grim Frankfurt (and my picture for Frankfurt is still based on the picture I drew in my head when I was seven or

eight). Katy's terrible fall from the swing wrung the heart strings, as did the cruelty of life for Mary in her *Secret Garden*. Like all bookish girls, I adored Jo in *Little Women*, although I suspected that Amy's declaration that 'Talent isn't genius' was a bit of a cop out. (Was I a genius? Would I have to be a 'genius' to be a writer? And what, anyway, is a genius?) I even empathised with William, in the books by Richmal Crompton which I adored and which I know coloured my writing style when I was a young teenager – no bad thing. So my explanation is that for no reason I can name I was naturally and spontaneously drawn to the world of fiction – thanks, of course, to the person who enabled me to get into it, namely my mother, who read to me and my siblings when we couldn't read ourselves, and recognised my appetite for stories early, and brought me to join my local library as soon as I was eligible for a reader's ticket – you had to be seven. That was fine. By then I could read books. I could walk on my own to and from the library, through the Corporation yard in Rathmines where the refuse collector trucks parked, and the dodgy wilds of Mountpleasant Buildings, something I did almost every day while I was in primary school.

I should say something about my family background. Not literary. My father was a carpenter, and my mother had worked in a shop, then stayed at home to look after me and my brother and sister. We lived on a redbrick terrace in Ranelagh, which was far from fashionable at the time. Everyone who was anyone wanted to be in the new white houses with picture windows out in the suburbs – Templeogue, Stillorgan, Ballinteer, places like that. We could only afford a Ranelagh redbrick. But my mother was quite ambitious for her children. She and my father had left school at fourteen; she did not intend that we would do the same, although money was going to be the issue. We were, in other words, socially upwardly mobile. Living in Ranelagh possibly encouraged this – it wasn't

fashionable, but nor was it a working-class ghetto. We were sent to what was a mainly middle-class school, Scoil Bhríde on Earlsfort Terrace. Most of the parents were civil servants or teachers or shopkeepers. Some were tradesmen. There were few or no solicitors or doctors or businessmen – their kids went elsewhere. But it was an academic school and the expectation there was that you would go on to secondary school, so almost everyone in my class did.

In 1965, which is when I did the Primary Certificate, it was not a foregone conclusion. Free education had not been introduced and only children whose parents could pay the fees, as well as the additional and substantial costs of uniforms, books, sports equipment, not to mention bus fares and living expenses, would go on to secondary. I took a scholarship exam, like everyone in my school, when I was in sixth class. Indeed I sat for more than one: the Dublin Corporation Scholarship, as well as a scholarship exam offered by a school, Holy Faith Haddington Road. I was by no means outstanding. But I got both scholarships – the Corporation one was means-tested so if your father earned below some amount you had a better chance of getting it than if he had enough money to pay your fees, basically. (My best friend got higher marks than I, but she didn't get 'The Scholarship', because her father had more money. This annoyed her, and struck her as unfair, quite rightly). The Scholarship meant secondary school was open to me. A year later 'free education' was introduced by Donogh O'Malley. Fees were abolished in most secondary schools. It would no longer be necessary for poor twelve year olds to win scholarships in order to stay at school. And the democratisation of Irish education continued. By the time I was ready for college, in 1971, means-tested grants for third level education had been introduced. So for me there would be no fees – my entire education, up to and including my Ph.D (as far as I recall)

was free, something for which I am eternally grateful to the Irish state.

In short, I was lucky, historically and geographically. I was born at the right time to benefit from 'free education', and I lived in a place which made it possible to avail myself of opportunities. And I was also lucky as far as publishing was concerned. The best encouragement any writer can receive is publication. Already as a teenager I had published letters, and got paid for them, in *The Evening Press* – five shillings per letter. I'd published a letter in *An tUltach* in 1967, and an article in our school yearbook, *The Lanthorn*, in 1970 or 1971. So I was used to the idea of publication. And in 1973 my first story was published in *The Irish Press*, as I have mentioned above. For a decade, or longer, I sent all my stories to David Marcus and only to him. He published about half of them. Anything he rejected I dumped unceremoniously, trusting his judgment totally. Usually it was spot on. Some stories he didn't take because they were corny. I didn't figure out how to write a story about my country forbears until I read Alice Munro, in the 1980s. Others he didn't like because they were too quirky, or too heavily under the influence of the writer I loved when I was in my early twenties, Samuel Beckett. Beckett the novelist, I mean. They were arch, smart, ironic stories, in the mode of Murphy or Watt. Also dumped.

Although I never abandoned the writing of fiction, I was far from single-minded about it. 'All things can tempt me from this craft of verse',[2] Yeats wrote, and with me that was definitely the case. I was, of course, tempted from the craft by men, as Yeats was tempted by women's faces. A great deal of time and energy during these important years is inevitably concentrated on love, seeking it, enjoying it, getting over it, getting on with it. For me there was another temptation – as a final year BA student I had fallen in love with a subject other than literature, and that was folklore –

specifically, oral narrative.

'Folklore' is a word which conjures up a plethora of ideas, most of them ghastly: fancy costumes, superstitions, old-fashioned outmoded ideas. The old days. The sort of folklore which I was introduced to in UCD in 1973 was something else entirely. I had studied Old English and Medieval English in order to get to the roots of literature. I believed the earliest writing – which in my Anglophone mind meant *Beowulf* – was the start of the story. What a revelation it was to discover that there was a much earlier layer to poetry and story. Before people could write, they told stories, composed poems, sang songs. There are as many genres of folktale or oral tale as there are of literature: fantasy, faction, crime stories, comic stories, romances and so on and so forth. I became entranced by the whole world of oral story, and by the methodology of folklore research. Most of my twenties were absorbed in writing a doctoral thesis on an international folktale. I carried out this work while also working full-time as an assistant keeper in the National Library, and other jobs. One year I spent abroad in Denmark as a research scholar, during which I spent a good bit of time learning Danish.

In 1981 I finally finished my Ph.D. In 1982 I married. That's the time I picked to start writing my first book. Very practical!

I wrote it in the evenings, after work, just as I had written my thesis in my spare time. The first novel I wrote was autobiographical – I called it *A Yellow Wood*, after the phrase in Robert Frost's poem about roads diverging, and its theme was the choices that a young person must make on the road to adulthood. This novel was not published initially, although I must have sent it out to a few publishers. (It was published in 1994 with a title I hated, *Singles*, and under the pseudonym Elizabeth O'Hara).

In June 1983 I had my first child. I looked forward to the baby, of course, but also to the maternity leave. In those

days I was always short of time, time to write. Back then, maternity leave consisted of three months' paid leave, and one month unpaid. I took the four months. You were supposed to take a month off before the birth. Most women didn't, saving the valuable time for the baby, but – selfishly? – I stopped working three weeks before mine was due. I planned to write all day long during those precious three weeks. I was also looking forward to being able to concentrate on my book after the baby was born, because babies sleep a lot, as everyone knows.

On the day I started my maternity leave my husband was diagnosed with severe angina. He was immediately hospitalised, and spent those three weeks preparing for a major bypass operation, which happened a few days after our son was born. June 1983. In 1983, a bypass involved major surgery and was a serious procedure. I spent the three weeks sitting in hospital with my husband – I couldn't bear to be apart from him. We spent the time reading – it was all quite cosy, until he had the operation, just a few days after I gave birth to our son.

So. No novel.

My husband recovered very quickly from the operation, and we spent August and part of September in our summer house in Kerry. While there I gathered up the short stories I had written over the previous decade and offered the collection to the local publisher, Brandon, in Dingle. I remember walking down to the publisher's office on the harbour carrying my baby in a red corduroy sling – the height of fashion, for babies, in 1983 – and dropping off the manuscript, feeling rather pleased with myself – baby and manuscript in my arms – as I pranced through Dingle on a sunny day, wearing a lovely flowery lilac skirt. My beginner's luck held. Brandon accepted the book and promised to publish it sometime the following year, 1984.

I went back to work in the National Library in October 1983, and my husband also returned to work. My mother

and father looked after the baby. We dropped him off in Ranelagh in the morning, then I cycled the rest of the way to the NLI, came back at lunchtime to breastfeed him. In the evenings, my husband came to collect both of us and we all drove home to Shankill on the old Bray Road in our rickety red station wagon.

I managed to write a little, for an hour or so, in the evenings after the baby went to bed – he was a great baby! I think I finished *The Yellow Wood* during that time. Sometime that year I applied for an Arts Council bursary, which, to my surprise and delight, I got – £2000. I used the money to buy a computer, an Amstrad. Of course I did! People told me this machine would transform my life. You had to buy the Amstrads in one shop – Mulvey's of Dundrum (if memory serves me correctly). The whole Arts Council grant went on it – £2000. To put this in perspective, you could buy a semi-detached house in Dublin then for £30,000 or less. I think I was earning about £10,000 per annum in the NLI.

The Amstrad operated on discs. Locoscript 1 and Locoscript 2. You inserted Locoscript 2 into the drive, the computer read the programme; then you took it out and inserted Locoscript 1 and that was the one you would write on. It was clumsy and time-consuming, but, indeed, it was easier to write on than on the typewriter I had been thumping away on for years. Life transforming? Well, sort of. The advent of computers would mean that the writer herself would now do a good deal of work that had previously been the job of publishers. My first story was submitted handwritten. For a decade I submitted typescripts. Soon after the advent of Amstrads, and its successors, publishers asked for floppy discs, then electronic copy. Only the first one or two of my books were sent to publishers in manuscript, then typeset by them. The way books were produced was changing radically just at the start of my book-producing life.

In 1985 a peculiar thing happened. I sent a story called 'Fulfilment' to David Marcus. At this stage, he published almost everything I sent, but he rejected 'Fulfilment', saying he recognised its merits, but that it was 'too zany' for him. For some reason I didn't dump it, as I usually did when he sent back anything, but sent it to an English magazine, *Panurge*, based in Newcastle upon Tyne. They published the story, and in 1986 it was selected for an English anthology, *Best Short Stories 1986* (Heinemann, 1986), edited by Giles Gordon and David Hughes.

What happened next was that I received letters from several literary agents in England asking if I had anything else, and if they could represent me. Some of these people came over to meet me in Dublin. I didn't know anything about literary agents, but I signed up with Curtis Brown – I had never heard of them.

Brandon, in the meantime, had written to tell me that they were not going to publish my short stories after all. They cited financial difficulties and suggested they were about to close down, although that did not happen. I sent the stories to my new agent in Curtis Brown. But he wanted a novel first.

At this stage I had had my second child, who was born in 1985. Much in the news was Windscale, the nuclear power plant in Cumbria; it was feared that an accident in Windscale – subsequently renamed Sellafield – would cause great problems in Ireland. The plant is only a short distance from us, across the Irish Sea, and fallout could affect us catastrophically. There was such fear of Windscale that the Irish government held a referendum on the nuclear power issue, the outcome of which was that all nuclear power is banned by the Irish constitution. I was very affected by the possible nuclear threat, not least because I had tiny children. I began to write a novel, envisaging an Ireland which had been destroyed by fallout from a nuclear accident. I told it from the point of view of

an archaeologist who came to Ireland to do a dig, and who excavated a house in Bray.

This novel was not finished, however. It was 1988. And I was getting impatient. I wanted to publish a book. Bypassing my agent, I sent my collection of stories to Attic Press, a new feminist publisher based in Dublin. Attic accepted by return of post, and published it within a few months.

That was my first book, *Blood and Water*. It was followed two years later by the nuclear fallout novel, *The Bray House*, which Attic also published. I retained my agent but he wasn't doing anything for me – neither the short stories nor *The Bray House* were what they were looking for, although in the event *The Bray House* made a reasonably-strong impact in Ireland. Complete strangers from the literary world contacted me to say how much they admired it; it was shortlisted for the Irish Book Awards. I took all this for granted and assumed it was just the sort of thing that happened when you published a novel.

I was also introduced to another phenomenon: the bad review. Although *The Bray House* was generally very well received, in *The Irish Times* it got a scathing review from a young woman writer whom I shall not name, and who at that time seemed to specialise in demolishing the reputations of other young women writers. (The sisterhood was not entirely loyal).

Attic Press was a feminist publishing house. It was established in 1984; its early mission statement:

> For too long Ireland has ignored the full potential of women's writings which have been lost to anonymity and foreign publishing. Our aim is to reclaim this material and fill the gap.

I published three books with Attic (and one with their Basement imprint), and all were fairly successful and attracted attention, reviews and readers here and abroad. And I went on to publish with other publishers, in Ireland

and abroad, to write in other genres (plays, for instance, and books for young people). In 1996, I began to write in Irish, as well as English.

I was a writer before I was a feminist, and before I had any sense of the importance of the feminist movement for Irish literature, and Irish life in general. Until the 1980s I was totally blind to the comparative absence of women's voices in Irish literature. I perceived myself as a thinker, writer, and person, who operated independently of any movement. This was very stupid. We are all bound by the nets of history, if not trapped in them. It is possible that I would have continued to write and publish even if the feminist movement had never occurred. I'd written and published before it had existed to any meaningful extent in Ireland. But I think it is unlikely. I believe it is much more likely that I would have focused on other aspects of my life – my family, my job, and, especially, my scholarly writing – that I would have given up creative writing. I am sure that many women who nurtured literary or artistic ambitions when they were girls, abandoned these aims when life got in the way, given that there was no expectation that they would produce artistic work anyway. My guess is that there were lots of Amy Marches, who said 'Talent isn't genius', and threw in the towel before they had really tested themselves. Yes, I was a writer from the age of eight or nine. But when my eyes were opened by feminism in the 1980s I understood the importance of sticking to the last. It was no longer just about me and my compulsions. I had a cause.

Because I had been writing since I was a child, before I was a feminist or even a woman, I was initially mildly disgruntled to find myself classified as a woman writer. For instance, when I was being interviewed by Mike Murphy on *The Arts Show* on RTÉ Radio One in connection with the publication of *The Bray House*, he opened by

saying, in his warm booming voice, 'Éilís, you write books about women and for women.' 'Hum, yes', I said, while thinking, 'Hold on. That's rubbish'. But I have often had a male friend say to me, 'My wife likes your stories' or 'Will you sign this for my wife?'

I did not know, then, that whatever the writer's imagined readership is, that most readers of fiction are women. But these statistics were not known, or acknowledged, in the 1980s. Everyone was writing for women, whether they knew it or not! And soon, in the late 1980s, everyone seemed to be writing about women – including Irish male writers. Women were now popular and, I daresay, sometimes profitable. If the woman's voice had been absent from Irish literature, men were lining up to play the ventriloquist and provide it. John McGahern, whose previous focus had been fathers and sons, turned his attention to women in what was to be his most successful novel, *Amongst Women*, which was published in 1990. Brian Friel remembered that he had grown up in a family of women, and wrote what is probably his most well-known and successful play, *Dancing at Lughnasa*, also in 1990. *Dancing at Lughnasa* is all about women. In Colm Tóibín's first novel, *The South*, the main protagonist is a woman. This book, too, came out in 1990.

1990. The year of the woman. They were all over the place.

Attic Press was in full swing. Poolbeg, Attic, Blackstaff, Brandon, Wolfhound and other Irish presses were publishing more and more books by women.

And the famous men writers were on the women's bandwagon.

But that is not to criticise them, of course, merely to make an observation. Men writers are as entitled as women to write about anything that interests them. Like women, they too are ensnared in the nets of history. And fashion. In this instance, the history was the 1980s and

1990s, when women's voices came to the fore and Irish scholars, historians, politicians and the media, observed that there had been a gap in our literature. Women were largely absent. Everyone was eager to fill the gap, now – even if they hadn't noticed there was a gap, until Arlen House and the feminist movement pointed it out to them. Oh yes, it is remarkable how (most) human beings only see what they have been trained to see.

My first books were published towards the end of the 1980s and in the early 1990s. By the time I compiled my third adult book, a collection of short stories entitled *Eating Women is Not Recommended*, I was very consciously giving voice to women's issues. I no longer considered writing from a male point of view – as I had done in some of my early stories. By now I had read Whitney Otto's *How to Make an American Quilt* (Random House, 1991), *How to Suppress Women's Writing* by Joanna Russ (Women's Press, 1984) and Virginia Woolf's *A Room of One's Own* (Hogarth, 1929). I had stopped perceiving myself as an individual writer without gender affiliation, and saw myself in a historical context, as part of a movement, or a school. It did not affect my style or my attitude in my writing, but it affected, deeply, two things: the raw material, and the level of production. I wanted to write about women, and Irish women in particular. And I was determined to keep writing and producing books. By now my literary ambition was not only personal, it was political.

From then on when asked if I resented being categorised as a 'woman writer' – this being a stock question in any interview in the 1990s – I always answered, 'No. I am a woman writer.' It was not the expected answer. Usually women – especially women who were getting anywhere with their writing – said something like, 'No, I am a writer, first and foremost. It doesn't matter if the writer is a man or a woman. It's all about excellence.' This is the writer's version of 'I'm not a feminist but ...' It is as if the

appendage of 'woman' to 'writer' diminishes the latter. Lady driver. *Bangharda*. Woman doctor. The word 'woman' cancels out 'excellent' in many people's minds.

I knew this. But I didn't care. People often describe me as modest, but secretly I am a little bit arrogant – all writers are, and have to be. Now I am proud to call myself a woman writer. I consider it a badge of honour, for reasons which I hope will be clear to readers of this volume. In addition, although nobody can predict the future, and the fate of most writers, male or female, is to fade into total obscurity, I suspect that the group of women who began writing from the 1970s and who persevered, have a strong chance of surviving the test of time, if we are good writers – and partly precisely because we are women writers.

NOTES

* Author photo by Lee Pelegrini is reproduced courtesy of the Burns Library at Boston College.

1 The Irish Writers' Co-Op was founded in 1975 and included among its members Neil Jordan, Ronan Sheehan, Peter Sheridan, Desmond Hogan, Fred Johnston, John Feeney, Leland Bardwell and Steve MacDonogh (later publisher at Brandon).

2 W.B. Yeats, 'All Things Can Tempt Me', *W.B. Yeats: Selected Poetry*, edited by Norman Jeffares (London, Macmillan, 1968).

Born in Dublin in 1954 she was educated at UCD and has a BA in English, M.Phil in Medieval Studies, and a Ph.D in Irish Folklore. A former curator at the National Library of Ireland, and writer fellow and lecturer in Creative Writing at UCD and Trinity, she is also a well-known literary critic. She writes short stories and novels, in English and Irish, and has published almost thirty books. Her work is widely translated and anthologised. Among her many awards are the Stewart Parker Award for drama, three Bisto awards for her children's books, several Oireachtas awards for novels in Irish, the Irish PEN Award for Outstanding Contribution to Irish Literature, and a Hennessy Hall of Fame Award. Her novel, *The Dancers Dancing*, was shortlisted for the Orange Prize for Fiction. She is a member of Aosdána.

BIBLIOGRAPHY

Blood and Water (Dublin, Attic Press, 1988)
The Bray House (Dublin, Attic Press, 1990)
The Uncommon Cormorant (Dublin, Poolbeg Press, 1990)
Eating Women is Not Recommended (Dublin, Attic Press, 1991)
Hugo and the Sunshine Girl (Dublin, Poolbeg Press, 1991)
The Viking Ale, edited with Séamas Ó Catháin, articles by Bo
 Almqvist (Aberystwyth, Boethius, 1991)
The Hiring Fair (Dublin, Poolbeg Press, 1993)
Blaeberry Sunday (Dublin, Poolbeg Press, 1994)
Singles (Dublin, Basement Press, 1994)
Penny Farthing Sally (Dublin, Poolbeg Press, 1996)
Voices on the Wind: Women Poets of the Celtic Twilight, editor
 (Dublin, New Island, 1996)
The Inland Ice (Belfast, Blackstaff Press, 1997)
Milseog an tSamhraidh (Baile Átha Cliath, Cois Life, 1997)
The Dancers Dancing (Belfast, Blackstaff Press, 1999; London,
 Hodder Headline, 2001)

The Pale Gold of Alaska (Belfast, Blackstaff Press, 2000;
 London, Hodder Headline, 2001)
Dúnmharú sa Daingean (Baile Átha Cliath, Cois Life, 2000)
Northern Lights: A Festschrift for Bo Almqvist, edited with
 Séamas Ó Catháin (Dublin, UCD Press, 2001)
Midwife to the Fairies: New and Selected Stories (Cork, Attic
 Press, 2002)
The Sparkling Rain (Dublin, Poolbeg Press, 2002)
Cailíní Beaga Ghleann na mBláth (Baile Átha Cliath, Cois Life,
 2003)
Hurlamaboc (Baile Átha Cliath, Cois Life, 2006)
*WB Yeats: Works and Days: A Book to Accompany the Yeats
 Exhibition at the National Library,* editor (Dublin, National
 Library of Ireland, 2006)
Fox, Swallow, Scarecrow (Belfast, Blackstaff Press, 2007)
*Mark My Words: Meditations Accompanying Alice Maher's
 Exhibition, The Night Garden* (Dublin, RHA, 2007)
Dún an Airgid (Baile Átha Cliath, Cois Life, 2008)
Dordán (Baile Átha Cliath, Cois Life, 2009)
The Shelter of Neighbours (Belfast, Blackstaff Press, 2012)
Aisling, no Inion A (Baile Átha Cliath, Cois Life, 2015)
Selected Stories (Illinois, Dalkey Archive Press, 2017)
Twelve Thousand Days: A Memoir of Love and Loss (Belfast,
 Blackstaff Press, 2018)
Little Red and Other Stories (Blackstaff, 2020)

CRITICAL APPRAISAL

Rebecca Pelan (ed), *Éilís Ní Dhuibhne: Perspectives* (Galway,
 Arlen House, 2009)

Mary O'Donnell

Bohemia, Bohemia – I Am Dancing ...

I'm sitting in the Small Injuries Clinic at Monaghan Hospital. My ninety-year-old mother sits in the single wheelchair I spotted and claimed quickly in the hospital foyer, before wheeling it to the car. Then comes the process of getting mother from car to wheelchair. She's not overweight, but helpless weight is dead weight and several complicated moves later, she is safely anchored. It turns out after the x-ray that the right foot is fractured. All afternoon, people are seen, mostly children, ferried in with minor sports injuries by their mothers. This is it, I'm thinking. This is what women do, no matter what their careers, Roland Barthes was right ... When you are a young woman with children, you are called a parent or a mother; when you're an older one with an aged mother, you're referred to as a 'carer'.

As we wait in the clinic, I'm thinking of the previous evening when I sit for a BBC4 radio link up in a Dublin studio with the writer John Boyne. I've been preparing for this interview all day, arguing the points surrounding the historical and sometimes contemporary exclusion of women from canonical literature. Then the phone rings as I park the car outside the studio, bringing news of my mother's fall. What do I feel, initially? To be honest, extreme agitation. No particular sympathy. You must come, I'm told in halting English by the Portuguese helper who comes to the house some days. *Feet is very sweeeled*

(sic). As I hang up, tears of frustration prickle up. But I mop up, enter the studios, meet John Boyne and the whole link up goes splendidly. Yet again, I've harnessed my energies to focus, focus. I've done this thing I've made a habit of, which is to visualise a golden cord rising from the top of my head to a higher consciousness. Corny, new-agey and, I realise, not for everybody, but I do whatever it takes to hold steady in situations such as this.

Later, I'm struck by Boyne's ease, his pleasure in the travel that comes with his highly-successful writing life, and the sense that he has many choices available to him. The next morning I head for Monaghan to make arrangements for my mother's recuperation. There are other things to consider: a part-time teaching position on the MA in Creative Writing at NUI Galway; questions about various meetings also arise and whether I'll be able to attend, an essay to complete, a reading to prepare for, and indeed the long-term fate of my writing life.

So how has it been, for me?

I remember how the roots of my life take hold with a gradually-increasing sense of the do-ability of art, without my realising until much, much later that this may be a difficult path to choose. For one thing, I'm rural, and everything happens in faraway places; for another, I'm Irish, and everything literary happens in England, even if we've had our own famous writers. I'm aware of Edna O'Brien, whose books are famously burned in her home place in County Clare, and am blessed with a younger mother very different from the one I'm about to encounter today, who presents me with a copy of *The Country Girls* when I'm twelve. She, anti-authoritarian by nature, also foists Patrick Kavanagh's *Tarry Flynn* on me, because it too is banned for a period. If something artistic is prohibited, it must therefore be of value to us in life – correct reasoning for the time.

Something of the atmosphere at home allows me to

experiment, to write, to paint, to play piano while my sister Margaret dances behind me. There are lots of books, from the literary to the medical. Both parents are readers. At the age of eight, I'm signed up by my father to join the Children's Book Club in London, which guarantees a monthly novel.

The sense that writing, drawing and composing are things one can do to pass the time (as I saw it) when bored or on one's own, is clear-cut. I can still play the piano piece I composed when I was about twelve, and to this day enjoy the possibilities of letting something flow freely. Behind the conventional carapace of my life, I'm a free spirit, always have been. I believe in Bohemia, once I discover what it is, realising that this is where my soul resides most happily, behind everything I have done and been.

At school in the St Louis Convent, Monaghan, education is quite academic, nourishing in some ways, less so in others. Music is brilliantly taught. I come under the wing of a couple of superb English teachers who help me to clarify my thoughts (sometimes disorganised) on that educational creature once called 'the discursive essay'.

Through my teens I privately dream about becoming a writer, of living in a commune with a group of like-minded creative types; but I yield easily enough to the other voices – of teachers, parents – trying to guide me towards a career of some kind, because everybody in my class is pushing, pushing, for results, high marks, achievement. Third level education is assumed. Away from school, I write poems and stories. I've read Seán Ó Faoláin, Brian Friel, Michael McLaverty, Frank O'Connor and Walter Macken. All these bright men with their tender stories, often of redemption in the face of the world's various trials, and how they also feed me the wonders of human tribulation, something that interests me greatly.

I also read Patrick Kavanagh, whom I love with a

fervour that has as much to do with the place he came from as it has with the poetry. I know his landscapes, desolately beautiful, and how such places can turn people to either madness or writing. The light in the reeds of poorly-drained fields before Ireland joined Europe, the ice edging a lake on a winter's morning, or the fields bulking up with oxeye daisies in July: all this provides an insight into some of the things I believe Kavanagh responded to.

Growing up in the countryside just two miles outside Monaghan town, I'm often overwhelmed by the fact of beauty, yet critically aware that nobody else from the outside world knows anything about it, and cares less. One automatically feels marooned, islanded and cut-off from 'important' things in an elsewhere that could be a city like Dublin or Los Angeles. When I travel to Germany in 1970 on a student exchange, the feeling of having come from a remote outpost increases. Germany is not the country I've anticipated, with romantic castles like Neuschwanstein and Linderhof – although, of course, I visit these with my very modern German family – but rushes forwards into the future, crazily, in a way Ireland can't possibly emulate pre our joining the EEC. A young victim of cultural inferiority, I am occasionally crushed by a feeling that nothing Irish is quite as good as things elsewhere, especially in England.

In my fourth year in secondary school, I am hospitalised for months in Dublin. A lonely time. I dig deep for resources as life and friendships rupture, as well as secondary education. My parents are poorly directed by the consultant to encourage me to do a 'commercial course' as it was called then. I've never regretted the skills it taught me, but I'm not really secretary material, and harbour dreams which are being thwarted at every direction. The secretarial school is on Haddington Road, Dublin, and sometimes before returning there after lunch I call into the big church and just sit. I am aware of

loneliness and of being an ill-fitted joist in a confused plan. I remember seeing Francis Stuart crossing Baggot Street Bridge and admiring him from a distance – rangy, tousle-haired, different. Yes, I think, he has it. He lives in Bohemia.

But things change. It happens in a random enough way. One day, I'm on a bus in Dawson Street and bump into a girl from school. When she tells me she now attends UCD doing Philosophy and English, I prickle inwardly with resentment and thwarted ambition, mainly because she was in one of the non A streams in our school and I was in the A group. But I press on and enquire about Philosophy. What is it, really? Well, she replies slowly, it's really about trying to find the meaning of life, and asking if there's a God, and where are we going and all that, and what's the point of everything ...

An inner light begins to glow. That evening, I phone my mother and inform her I plan on abandoning life as a secretary (by then I was in An Foras Forbartha on Baggot Street) and will return to full-time education regardless of health issues. Both parents are actually delighted. In the end, by going to Maynooth, and by studying German and Philosophy in my degree, I discover a range of interests and avenues which made all the difference to my life. Those German language writers – Hesse, Grass, Döblin, Mann, von Kleist, Lessing, Canetti – transformed me.

I continue to write through the university years at Maynooth – poems, the occasional play and a few stories. After university, and after getting married, I set to the task of writing and re-writing. I feel alone. I feel the work is useless and who'd ever read it. How can I know when it's any good? Who is going to tell me? But that is the nature of our work as artists. It's a solo voyage during which we instruct ourselves, or life instructs us, about the nuances and distortions, the revisions and the different levels of paying attention necessary to our work. But nothing is

published until 1982 when my individual poems and stories do find first release, like excited young pheasants let loose in a first field, with David Marcus in *The Irish Press*'s 'New Irish Writing' page. The belief such outings gave me in the possibilities of my work can't be overestimated.

Getting individual poems and stories published in the likes of *The Irish Press, Cyphers, Poetry Ireland Review* and other outlets such as *Oxford Poetry* and *The Oklahoma Review* is one thing. Getting a collection of poems into print is quite another. For the first time, I am seriously challenged by the fact that I am a woman in a woman's body, and that that is what prospective editors are seeing and thinking, rather than a writer with an actual voice.

What is it about so many of the male writers of my generation that they have been so unable or deliberately obtuse, or have inherited an intellectual patriarchy which prevents them from hearing voice in a woman? I don't think younger women today need any advice on how to get their work published. Thankfully, the world has changed. But for me, and for other women I know, it took time to receive recognition as a writer, and not as a woman (therefore sub-category) writer.

In the 1980s, male publishers tend to sniff around our collections in a slightly unpleasant way. Old habits of flirting with young women authors are alive and well in Dublin, and I have first-hand experience of several whose main interest in inviting me to lunch has little to do with my mind. Fragile male egos abound, too many alcoholics, and too many pompous men used to being listened to.

Eventually, after a few disappointments, I've been assured publication by one publisher, then replaced by a male poet when the Arts Council sanctions a grant for one book only; then a chapbook is promised but never materialises.

I bump into Jessie Lendennie in Books Upstairs on

Dame Street. In an instant, she proclaims 'I'll publish you!' She follows through and in 1990 my first collection, *Reading the Sunflowers in September,* appears to largely positive reviews, and it actually sells well.

I've never felt able to stick to one genre of writing though. Seven collections of poetry later, two short story collections on, four novels, one collaboration, one book of translated poems and a few other projects, generally speaking, reviewers have played a welcome enough part in signalling something about my work which pleased me. Generally speaking. I have not experienced any great unfairness on that level. Even so, it's true that neither good nor negative reviews matter in the end. You discover that when the negative ones don't stop you writing, and I've had a few. Because a writer's life occurs outside the limitations of dotted i's and crossed t's, outside the mores of what ought to be culturally 'good' or otherwise. The process is what counts for me, the work of redrafting, the silence, the work of making art.

The gender issue features in the lives of most women who write professionally. A few deny this, but by and large it's a common experience. Now, let's plunge a little deeper …

The gendered perspective creates this: an obscuring or ignoring of the written work of older female authors, either by exclusion from anthologies, or by a failure to interview them when a book is published, or indeed by finding prominent men more important in print media.

The gendered perspective ensures that no matter how mediocre the work of a male author, his work is more likely to be included in a prominent anthology than that of a mediocre female author.

The gendered perspective also creates a sneaking question in the minds of some people: but is women's writing any good? – invoking the perennial doubt about the mere possibility of female genius. And too many men,

who consider themselves readers, simply can't be bothered reading what women write. If then, such people end up editing a literary anthology, how can they possibly know what to select if they have made no fair attempt to read as widely as possible? That there is a glut of successful female authors now does not automatically translate into a made career, unless the authors are under forty.

From my UNGENDERED PERSPECTIVE, this is how it seems. I BELIEVE in a world of EQUAL OPPORTUNITY which includes opportunity of intellect and creativity.

That being said, I occasionally allow myself space to be critical of some women writers. A few in prominent positions have been careful. Possibly, if a woman sounds off explicitly, as I am now doing, about perceived absence of parity, it emits an unwelcome signal: she may be difficult, 'too feisty', 'strident'. So some women choose to write and publish, but do not speak out unless a groundswell of reasonably 'safe' consensus develops. Some would call it quite savvy of them.

I never describe myself as a feminist writer, although ideologically I am a feminist. I am a writer first and foremost. My voice is a writer's voice. Have I made money from it? Hardly. A modest income, bulked out by teaching, lecturing, journalism and essay writing. I am, however, a member of the multi-disciplinary artistic affiliation Aosdána. I'm proud to have been elected back in 2001, to have been enfolded by this group of peers from the world of art. Nor am I complacent about the position of the artist in our society. I work hard to ensure that the spirit of creation is transferable from person to person. Creativity comes in many forms, and it's not even necessary to be an artist to be creative. The problem though, for many, is a failure to recognise what creativity and inventiveness is.

I'm happy to have been able to pursue the life I dreamed of in the vaguest of ways as a child. Little did I know that the pull of the natural world around and above me, of its

colours and beauty, of its light and darkness, would gradually do its work on me, initially through poetry, then gradually through fiction. This multifarious world made me believe in possibilities that didn't seem quite logical: the invention of things, the making of new things through language. I hope to continue to do this till the day I drop. I pray that my mind will remain clear, because with age comes a lessening of fears – one isn't so easily intimidated by anything really, as time shortens – and there's still work to be done. Behind me, behind the things which I still feel the need to challenge, is this wall of inspiration, and it sometimes guides me.

But practically speaking, and as a woman, there is this other work I can't ignore: of ensuring that space is made for creators of all sexes, that gender is not viewed as a problem, and that the writer's voice is all that really matters. Once upon a time in Ireland, the problem wasn't that you were a woman writing – there weren't enough of them visible for anyone to view them as more than talented eccentrics or 'bohemians' – but that you might mention sex. But that sort of writing wasn't confined to women, and at one point all the good writers had their work banned. Meanwhile though, our censorship laws masked the invisibility-making ink that was gradually erasing the achievement of women of the Modernist period from our knowing.

So that work remains to be done: the work of restoration. And yet ... and yet ... I, Mary O'Donnell proclaim yet more work and it has to do with my mother as her time diminishes. I will continue to be challenged in that work, for as long as it takes, however it goes, and I accept now that – for many women – the outwardly-compromised role of artist is an element to be factored in.

I accept the deep fracture of the divided mind that I found so difficult to accept as a young mother. Somehow, I work through fragmentation. I am experienced, I know

how. Now, as an ageing daughter, I am able to accept that if art enhances humanity, we cannot desert kin for the sake of art and more art. And so, my other role as a working writer, is not just to write books, but to carry on living within my conventional carapace, my free spirit dancing like a dervish as I inscribe the words, Bohemia, Bohemia, within my dreamlife.

CRITICAL APPRAISAL

María Elena Jaime de Pabos (editor), *Giving Shape to the Moment: The Art of Mary O'Donnell, Poet, Novelist and Short Story Writer* (Bern, Peter Lang, 2018)

Mary O'Donnell was born in Monaghan in 1954. She attended the St Louis Convent before going to Maynooth University to study German and Philosophy, graduating in 1977. She began to publish her writing, both poetry and prose, from 1982.

She writes essays and cultural commentary and contributes to both acdemic journals and popular reading matter. Adjudication panels she has served on include the Strokestown International Poetry Festival, *The Irish Times* Poetry Award, and the New Irish Writing Award, as well as on the Board of the Irish Writers Centre.

Currently a member of the Toscaireacht with Aosdána, she holds a Ph.D. in Creative Writing from UCC and teaches writing and literature in Ireland and internationally.

BIBLIOGRAPHY

Reading the Sunflowers in September (Galway, Salmon Publishing, 1990)

Strong Pagans (Dublin, Poolbeg Press, 1991)

The Light Maker (Dublin, Poolbeg Press, 1992/1993; new edition with 451 Editions, 2018)

Spiderwoman's Third Avenue Rhapsody (Dublin, Salmon Poetry/Poolbeg Press, 1993)

Virgin and the Boy (Dublin, Poolbeg Press, 1996)

Unlegendary Heroes (Cliffs of Moher, Salmon, 1998)

The Elysium Testament (Clifden, Trident Press, 1999)

September Elegies (Belfast, Lapwing, 2003)

The Place of Miracles: New and Selected Poems (Dublin, New Island, 2005)

Storm Over Belfast (Dublin, New Island, 2008)

The Ark Builders (Todmoren, Arc Publications, 2009)

Where They Lie (Dublin, New Island, 2014)

Those April Fevers (Todmoren, Arc Publications, 2015)

Empire (Dublin, Arlen House, 2018)

Massacre of the Birds (Cliffs of Moher, Salmon Poetry, 2020)

FAIRYTALES FOR FEMINISTS

In 1985 Attic Press published *Rapunzel's Revenge*, the first Fairytales for Feminists (which went in its 6th printing in 1991), followed by *Ms Muffet and Others* (1986), *Mad and Bad Fairies* (1987), *Sweeping Beauties* (1989), *Cinderella on the Ball* (1991), and Maeve Kelly's *Alice in Thunderland* (1993), with retrospective anthologies *Ride on Rapunzel* (1992) and *Rapunzel's Revenge* (1995).

Contributors include Celia de Fréine, Evelyn Conlon, Mary Dorcey, Ivy Bannister, Liz McManus, Máiríde Woods, Maeve Binchy, Róisín Conroy, Mary Paul Keane, Gráinne Healy, Mary Maher, Clodagh Corcoran, Joni Crone, Máirín Johnston, Melissa Murray, Clairr O'Connor, Roz Cowman, Leland Bardwell.

The Fairytales for Feminists series, illustrated by contemporary artists, was hugely successful for Attic, and the books were enthusiastically welcomed for their originality, wit and verve.

'A funny, sassy, heretical collection of feminist fairytales'
– *The Irish Times*

Mary O'Malley

Notes on the Early Days

I should, I suppose, supply a few facts about how and when I started publishing poems. I came back from Lisbon with my husband and two young children in 1986. We had been lecturing at a university in Lisbon and been given a year's leave. We found a place to rent in Galway and discovered a changed place. Mostly, our old university friends were now respectable professionals and this was the first time I realised they were reaping what they had been raised to expect. Very few of them had family members living illegally in Chicago or San Francisco as I had. Very few of them were unemployed, as we were.

Connemara, where I'm from, was devastated, emptied out of hope and youth. Everyone that could go had left. It was the time of the illegals. Families were split, funerals, in some cases of parents, were missed because of the danger of being caught returning to the US and sent back, leaving a family in limbo 'over beyond'.

If I was serious about writing I knew it had to be now. Ten years out of Ireland had not banished the need, so I decided to write for a year, and see whether I could. There was never a question of what form. Poetry had gripped me early, and refused to let go. The real apprenticeship began then.

I started going to a writing workshop run by Jessie Lendennie of Salmon Publishing. Jessie was open,

generous and had an American sense of 'can do'. She praised some of my efforts, and gave advice. I found the poets intimidating, for the most part, and some of the most astute critics were prose writers. I didn't bring many poems to read out, and always ones I knew were flawed. The help I got was very useful. One writer made me get a stamped addressed envelope, enclose it in another envelope along with five poems, told me what a biographical note should read like. A number of those poems were shortlisted for *The Sunday Tribune* Hennessy Awards. Along with many Irish writers, I owe a great debt to Ciaran Carty, who edited 'New Irish Writing' after David Marcus.[1] I didn't get a Hennessy Award that year, but one of the judges took me aside and said 'You must submit again next year.' Such unsought kindnesses graced my early writing life. Jessie, Eavan Boland, whose felt support meant a great deal to me, John Montague, with whom I had robust discussions about 'who would you have on your book shelves?' Then there was the work of Michael Hartnett, which spoke to me with quiet authority, as it still does, and became a kind of tuning fork.

Those were the years of initial excitement. I was learning judgement in my reading, moving back from Europe to familiarise myself with the current Irish poets. I was in love with language and song, rhythm and blues. I continued to read the Spanish language poets, but in response to Eavan's early advice to 'read the Americans', I broadened and deepened my reading in English. She also pointed me to the letters of Lowell and Bishop by posting me the gift of a book, and through conversations with her I discovered the essays and critical writing of Sontag, Joan Didion and the essential Elizabeth Hardwick.

Did I think about being a woman writer? Of course I did, but I distrusted the diminishing power of the label. Nobody thought to describe Seamus Heaney, Thomas Kinsella or Derek Mahon as 'men writers'. That did not

mean I thought there was a level playing field. There wasn't, particularly in literary criticism, which then, as now, left much to be desired. The tropes were mostly manly, and dead animals at road sides abounded; there was enough metaphorical distance to contain a fair-sized ocean. Nor did it escape my notice that women had mostly been the 'objects' of poems, and were not, as Eavan Boland pointed out, expected to be the authors of them.

Jessie offered to publish my first book. I was pleased, but not sure it was ready. She said it was, so off we went. I wasn't very interested in it. I knew it was slight, and reading a few of the poems recently, I am inclined to be more forgiving of it now than I was then. My second collection was important to me, and I was already onto it before the first book came out. That was published two and a half years later in 1993 and it contains a sequence of poems about linguistic colonisation and the shame that comes with it:

> What is to be done with the millions of facts that bear witness that men, consciously, that is fully understanding their real interests, have left them in the background and have rushed headlong on another path, to meet peril and danger, compelled to this course by nobody and by nothing, but, as it were, simply disliking the beaten track, and have obstinately, wilfully, struck out another difficult, absurd way, seeking it almost in the darkness. So, I suppose, this obstinacy and perversity were pleasanter to them than any advantage ...[2]

No, Mr Dostoevsky, it was not 'pleasanter'.

I did things the only way I could. I was, like Hartnett, 'flung back on the gravel of Anglo-Saxon' and had to do with it what I could, but like Hartnett, the urge to poetry, or at least the permission to write it, came first from Irish, not English. Máire Mhac an tSaoi was described as a scholar and a poet, and 'Caoineadh Airt Uí Laoghaire' was composed by his wife, Eibhlín Dubh Ní Chonaill, and they both kept their own names. Perhaps that is why it never

occurred to me to feel that being a woman made me less entitled to be a poet. The only poets I knew of from my own place and background composed in Irish and the fact of not being from Dublin or Northern Ireland was a far greater obstacle than womanhood.

I was elected to Aosdána sometime between my third and fourth books, and that single fact has made a great difference to my life as a writer. I felt admitted, not to some special club – certainly there is no elitism – but it was a quiet recognition by other artists that I belonged in their company. I was also able, with difficulty, to hold onto my house when the economy fell apart. There are many other facts and details, such as the eight years I spent programming and organising the Cúirt Festival, alongside Charlie McBride and Trish Fitzpatrick, times full of discovery of new writers from across the globe, full of fun and energy and very low budgets, when Galway was buzzing and the arts had not yet become 'an industry'. Very often the conversations after readings were enlightening, challenging, delighting. Sometimes they were, of course, well lubricated.

Yet for the poet, the real influences are elsewhere: the music in the house, Eugene Lambe's uileann pipes, Frankie Gavin's fiddle among them, but also my uncles' fiddle and accordion, my mother's quiet singing, poems said naturally for the pleasure of hearing them, the repetition of verses and rhythms and lines, the endless lift of Raifteiri: 'Anois teacht an Earraigh' ... long 'recimatations' such as 'The Little Yellow God of Kathmandu' and comic songs where big words were spoken for the sheer joy of it, and rhythm lifted the heart, or soothed it. There were few books in villages like ours, but there was respect for learning and there was enough poetry.

'The pots are set out beyond Carraig Scoilte'

In the chart of the bay it is marked, but in no way remarkable. Neither is Sciard, though that rock seems to

float above the surface of the sea like a lost island and so real is this illusion that it calls to mind HyBrasil and other islands said to have appeared mysteriously, and just as mysteriously disappeared again, trailing their mystical implications like seaweed.

Carraig Scoilte, the Split Rock, once whole, was struck by a mighty bolt of lightning that sent the smell of cordite into the surrounding air and set the sea boiling down, five fathoms down or more, to the root of the now cleft shoulder of granite, or so I, my head rent by violent migraine colours, would later grow to believe. The sea pounded it in winter, and the water forced through its impressive cleft spouted into the air, or in kinder weather, foamed like Persil detergent on either side. Inside this rock the boats were safe, outside it they could still be lost if the weather or the sea turned, which they often did. I was convinced of this, although nobody had ever told me such a thing.

At three minutes to six every evening the house was silenced and the volume turned up on the radio. From Belfast Lough, the forecaster made his dangerous way down the East coast, along the southwest past Fastnet, Carraig Aonar, the lone rock, which I would sail past many years later on the *Celtic Explorer* and which would give me the centre of the long poem in *Valparaiso*. 'Tháinig long ó Valparaiso'. When there was disagreement between my father and the radio, I knew he would be right. The litany continued, Dogger Bank, Plymouth, Biscay, Fastnet and Cape Finisterre, the borders of the world swivelling outwards like a pod of dolphins. That was the backing track of my days, that and the commentary the fishermen made, weighing up tide and wind direction and phase of the moon, listening to the sea area and long range forecast to get the bigger picture of promised gales or fine spells, for news of Highs and Lows. Timing they decided for themselves by reading the sea and the sky and the

nearness of rocks to the eye.

The only weather I could predict unerringly was thunder. I knew days in advance by the weight in my head and the wired prickling of my skin. A slow heavy headache descended and I felt nauseous. The forecaster talked of a steady wave of low pressure over Ireland. He had the voice of a man born to announce bad weather. Any mention of bright sunshine was sure to be closely followed by showers and deepening to rain in the West. The West was where the rain lived, making regular forays out and across to torment Dublin, and when each storm abated I felt relief as clean and sharp as a knife blade. Some heavy substance had been washed away and only the good separated air was left. For a while the breath entered my lungs as cleansed and aerated as champagne and there was no struggle in the night, no fear in me at all.

Some fish were caught in English: mackerel and salmon and pollock. Others were in Irish: *gliomach* (lobster) and *fiogach* (dogfish). Nobody remarked on this, and I would only learn later that I had to separate them and learn the 'correct' word. The same was true of bushes and flowers. The words I had were accurate enough for my own internal map – I knew every wort and flower on the open area of commonage known as 'the beach' – but over thirty years later I would be sharply reminded of my ignorance of the proper names of most of those flowers. Even now, I know what I will see if I go there, to a small area between a tarred road full of D and G Reg cars, whose passengers have in their houses shelves full of books classifying what grows on the machair, and helping them identify one small plant from another. I will know if even one is missing, but I missed out on the hunger for classification, and I have never quite believed in its borders.

In the imagination, plants wander a little from their appointed place, and islands do not stay where they are put. Thus the snowdrop turns up in Book 10 of Homer's

Odyssey, and HyBrasil cruises around quite widely before being struck off once and for all by the cartographers sometime around the 1860s. I learned the plants by walking across the machair to the shore. Even then I thought some of them shone like jewels, with their pure colours and sculpted shapes. I have never learned all their names.

> God bless the Ground! I shall walk softly there,
> And learn by going where I have to go.[3]

Roethke's words chimed immediately with my child's wanderings when I first read them in my early thirties, although the ground never really held my attention for long.

It was the shore that drew me, with its beauty and freedom and possibility. There, most of the words for things were in Irish still, all the seaweed, the little fish and creatures in the rock pools, most of the life under the sea, and all the rocks and marks that jutted and shouldered out of it. I didn't distinguish which were in English, which in Irish until much later. The small child doesn't care. The shore is a playground, full of wonder and mess. The seaweeds and mermaids' purses and the odd horse's skull predisposed me towards an adult fascination with Gaudi's buildings, which have something of a child's wonder and audacity about them.

Great seeds sometimes came ashore. They were, I was assured, from Tasmania or Abyssinia. Abyssinia! Coleridge has a lot to answer for.

We had no trees, though great logs sometimes escaped their chains in ships and were washed up as windfall. We called them rollers, and I had a chair carved from one. Sometimes, as with poetry, there was enough material for a roof beam, sometimes only for a stool.

Words mattered to me always, and a day would come

when shame would lie in not remembering the exact word people had used when I was small, words neglected through misuse, or overlain with the corrected term, the necessary hand of linguistic authority. The new, correct words were like shiny pictures, attractive and interesting as pictures of New York or Hong Kong. The dictionary definitions are easily pursued but the sound in the mouth, between the tongue and the lips and the teeth is a different matter, not easily snared in letters and print and paper; these new words were not the picture the mind held when you said your own word, nor the precise sonic tint of it.

'*A stór*' would never become 'my dear'. It would always mean something closer to beloved, usually spoken by my grandmother, whose stories transported me early to another country.

A small girl goes out on Sunday to walk the hill. The corncrake is *krrk*ing in the field across the road. She doesn't like the sound but she loves the cuckoo, his accompanist. There's a pet jackdaw in the kitchen one year. He flew into the kitchen on an injured wing. All the sins of his kind are forgiven, his wing is splinted, and he eats out of the children's hands. Another winter, a tamed injured swan is tended on the turlough nearby. He waddles around outside the house like a transformed duck. Her small sister sits on its back for a photograph. In spring the swan will go. 'Back to his people.'

This fine Sunday, they are climbing Dun Hill. They take the path by the Seven Sisters' Well. The roses are out, their almost-purple flowers lovely, the scent strong. They are the only roses she knows. She wants to pick some on the way home. They walk on. Her father stops to show them how to look for the wren's nest in the furze.

'Listen. He isn't far away.'

Then there is a flittering in the undergrowth and a small

bird rises into the air close to her.

'*Dreoilín, dreoilín Rí na n-Éan*', her father says and she continues the rhyme. Or he might have said 'The wren, the wren, the king of all birds' and she 'St Stephen's Day was caught in the furze ...'

Later they see crows nesting in the castle and the kestrel's slow flight across the slope of Dun Hill. They sit content and watch the village spread out below them. Then the next village, and the one after that, then the sea and all the way to Slyne Head. When I came to read Yeats's 'He wishes for the cloths of heaven' that was the picture that went with the poem.

The birds' calls and their shapes have stayed with me, as has that picture to accompany the poem, but because I was that thin short-sighted child, I could only see what was very close to me and had to guess, rather than identify the birds I saw and heard. Over fifty years later, waiting for a traffic light to change, that wren will rise again, and quickly insert itself into a short poem, challenging me to capture its aerial grace.

NOTES
* Author photograph is by Bobbie Hanvey.
1 When *The Irish Press* ceased publication in 1995, the 'New Irish Writing' page was transferred to another newspaper, *The Sunday Tribune*, and after the demise of that newspaper, to *The Irish Times*. It was edited for many years by Ciaran Carty.
2 Dostoevsky.
3 Roethke.

MARY O'MALLEY

Mary O'Malley was born in Connemara in 1954. She was educated at University College, Galway. She spent many years living in Portugal before returning to Ireland in the late 1980s, and beginning a poetry career in 1990. She lives near the village of Moycullen. She teaches on the MA in Writing at NUI Galway and was Arts Council Writer in Residence at the University of Limerick in 2016. Widely anthologised, her prizes include the Hennessy Award (1990) and the 13th annual Lawrence O'Shaughnessy Award (2009). She is a member of Aosdána.

BIBLIOGRAPHY

A Consideration of Silk (Galway, Salmon Publishing, 1990)
Where the Rocks Float (Dublin, Salmon Poetry/Poolbeg, 1993)
The Knife in the Wave (Cliffs of Moher, Salmon Poetry, 1997)
Asylum Road (Cliffs of Moher, Salmon Poetry, 2001)
The Boning Hall: New and Selected Poems (Manchester,
 Carcanet Press, 2002)
A Perfect V (Manchester, Carcanet Press, 2006)
Valparaiso (Manchester, Carcanet Press, 2012)
Playing the Octopus (Manchester, Carcanet Press, 2016)
Gaudent Angeli (Manchester, Carcanet Press, 2019)

Ruth Carr

There is a House
Ruth Carr

Ruth Carr
FEATHER AND BONE

HER OTHER LANGUAGE
Northern Irish Women Writers
Address Domestic Violence and Abuse

Ruth Carr and Natasha Cuddington
Editors

The Airing Cupboard

Ruth Carr

The Female Line

An Anthology of
Northern Irish Women Writers

WORD OF MOUTH

Ruth Carr
Margaret Curran
Elaine Gaston
Pos Gora
Ann McKay
Eilish Martin
Joan Newmann
Kate Newmann
Gráinne Tobin
Mary Twomey
Sally Wheeler
Ann Zell

poems

I MAY BE SILENT, BUT

I may be silent, but
I'm thinking.
I may not talk, but
Don't mistake me for a wall.

> – Tsuboi Shigeji (*translated by*
> *Geoffrey Bownas and Anthony Thwaite*)

Writing was part and parcel of growing up for me. Words brought the naming of things, stories, rhymes, songs, tellings off, imperatives, all through the voice. But writing was the making of words, stringing them together, making a translation, transporting what was 'inner' into the 'outer' world. What could come out of the mouth could also come onto the page. Exhilarating to convey, or to try at least, to translate the feelings, the pictures, the sounds, the perceptions which I was experiencing and imagining, into a form that might exist as a thing in its own right, but in secret. At this point it was the excitement of making something for myself that mattered; of giving form to (not yet processing) my relationship to myself and the world.

As I grew into my teens it became a talisman. I felt the power (or a faint whiff of the power) of the seer, the fool, the witch. A poem could be an incantation, an amulet of words, or a spell, a curse, a comfort, a rant. There was a clarity and a mystery to writing poetry that I embraced as the gift of language. It was like dropping a pebble into a

still pool, but getting to shape the pebble for yourself, weighting it to make certain resonances. And when a friend might have caught sight of a poem and gave it the time of day, or a teacher might have encouraged me to send something in for a competition, it became something for other eyes and ears.

This would change things, of course. It would introduce other aspects: the managing of ego, the see-saw of self-confidence and self-doubt, the discipline of writing itself and later reading in public. But in that first instance, nothing much happened. It was 1969 and, due to the state of unrest, the award ceremony at the New University of Ulster (as it was then called) was cancelled. I received a letter with a cheque in the post. I remember also that when the poem was later published in the school magazine, it was a sobering experience. The subject was my father and our struggle to communicate with one another. This difficulty was confirmed by the fact that he was very proud of my success but ignored what the poem was asking of us both.

Throughout my life there have been periods of silence. Tillie Olsen in her book *Silences* points out that this is not unusual for women, or 'working class' men, due to cultural restraints and the demands of childcare and work. I have found the rewarding roles of tutor and editor to make heavy demands on my time and limit headspace for my own work. But I am not complaining, rather explaining that my choices have only intermittently given priority to my own writing. During those periods of silence, it is not that I do not write, just that I do not take writing to a final state. It remains in drafts, notes, or written on the wind when I am walking the dog. Worse if it remains in my head. For I find that writing brings clarity and a kind of meaning.

I have been lucky to have three collections of poetry published as I did not seek fervently to find a publisher. I

am particularly grateful to Joan and Kate Newmann who launched Summer Palace Press with my first collection. If anything, I have lacked ambition for myself; and that may be something to do with social conditioning which I have yet to address!

However, I do not hold with the notion that one is only an artist if published, exhibited, or award-winning. I would encourage everyone to pursue publication, and take their work seriously (and also with humility). But more crucially I would urge everyone to pursue writing, painting, singing, dancing or making music – whatever is part and parcel of your creative self. At certain points in my life it has been the return to writing that has never failed to be a resource upon which I can draw to find myself, but also to move beyond myself to create something independent, some making of art.

> I may be silent, but
> I'm writing
> – on the wind.

Ruth Carr was born in 1953 in Belfast where she still lives. She married Terri Hooley in 1974 and together they set up Good Vibrations record label. She was a joint winner of a bursary from Arlen House in 1981 which encouraged her as a writer and also spurred her on to raise the profile of Northern Irish women in literature. In 1985 she edited *The Female Line: Northern Irish Women Writers* (Northern Ireland Women's Rights Movement). Since then she has worked with community writing groups, and edited various publications of their writing. A founder member of Word Of Mouth Women's Poetry Collective, her work is included in their two anthologies: *Word of Mouth* (Blackstaff Press, 1996) and the bilingual *When the Neva Rushes Backwards, Five St Petersburg Poets* (Lagan Press, 2014). She compiled the section on contemporary women's fiction in *The Field Day Anthology of Irish Writing, Vols IV and V* (Cork University Press, 2001) and was a co-editor for *The Honest Ulsterman* poetry magazine for about 14 years. She co-curates the Of Mouth reading series with Natasha Cuddington and together they co-edited *Her Other Language: Northern Irish Women Writers Address Domestic Violence and Abuse* (Arlen House, 2020).

BIBLIOGRAPHY

The Female Line: Northern Irish Women Writers, editor
(Northern Ireland Women's Rights Movement, 1985)
There is a House (Kilcar, Summer Palace Press, 1999)
The Airing Cupboard (Kilcar, Summer Palace Press, 2008)
Feather and Bone (Dublin, Arlen House, 2018)
*Her Other Language: Northern Irish Women Writers Address
Domestic Violence and Abuse,* co-editor with Natasha
Cuddington (Dublin, Arlen House/Of Mouth, 2020)

Evelyn Conlon

LOOK! IT'S A WOMAN WRITER!

Writers can be a bit like children who have learned how to tie their shoelaces – all well and good, job done, delighted with themselves, and then someone asks how they did it. Things are not so happy now. I don't like writing about writing, but I'll dip my pen in the ink and see what happens.

I had two short stories published in a national newspaper, *The Irish Press*, written when I was 16/17 or so, quite young now that I look at it. The editor of this page was a man called David Marcus, a much-respected figure, a person who came to have a lot of say in how the Irish short story would look from the 1970s onwards. Or at least the ones that were published – not to mention lauded and prized. But somehow, after those two were written, my next endeavours were deemed not suitable, as we politely say. David's and my own paths had a serious divergence. My interests and subject matter changed. I wanted to write about how we – women, men, the entire country – were beginning to jump over the wall. I was affected, in the way that some writers are, by all that was happening around me. But those stories didn't fit on the national grid. Or on the manifest being compiled by men who could see the marketability of an Irish 'list'. The literary view of women was not keeping pace with the real lives that I was watching. No pageant was being made of our actual thoughts and of how we saw our world. Stereotyping

reigned supreme. (And in many ways still does, having crept back in, wearing different clothes). So I turned to writing bad poetry. I'm a great judge of bad poetry, having, in error, created some of it. I could not dare to write what I needed to, and thought to camouflage it by putting it in semi verse. I hadn't yet got the nerve to stand up to the consensus.

The process of realising that fiction could facilitate new truths came quite suddenly. I can still feel it. I am in a room at the National Writers' Workshop in the Atlanta Hotel in Galway. Eavan Boland, facilitating the poetry workshop, had apparently suggested to Bernard McLaverty that I join his short story group. And in the middle of the first day a faint sound slid in. Joy Williams once said that the short story made her think – 'assemble the ambulances; something is going to happen'. I felt myself gearing up for the something. I returned to the short story, having realised in that room that I could allow myself to paint whiffs of portraits through fiction, and that is all a writer can do.

I had already begun reading beyond my place, beyond the accepted canon, but now I did it in earnest. I don't consider that I re-educated myself, I consider that I added to what I already knew, blazed a bit of extra light, by first finding and then reading all these women who had been secretly kept locked down in the basement. The difficulties of the search itself told the story. And by my very reading, never mind my writing, I put myself outside the place intended for me. Briefly – with wonderful relief – I left aside all the male Irish writers who ought to have been ashamed of themselves for their myopia and the shadow dots of females they had created as background filler for their 'real' exploits – sub-airport-fiction characters, denuded of all life, nuance and brain matter.

Looking back now I imagine a picture of that time, as if it was taken unawares. I like the echo of photographs, the

standing still that Manuela Palacios González gets us to observe in *Ex-Sistere* (Cambridge Scholars, 2016). An image is snapped years ago, forgotten about, then found in a drawer. We look at it again. We're fascinated by that unseen thing that has turned up in the background. It catches our eye, and rivets our attention. Writers who are women, as opposed to writers who are men, speak always in front of that unseen thing. It's a flag saying *Look! It's a Woman Writer!* I wasn't a writer for long before I became aware of this pennant, fluttering away behind me no matter what part of the room I occupied. Eventually I had to acknowledge it. I did, by reading those writers whom I had never known existed, and boy did I have the time of my life. They gave me the right to be truthful. But they, and my own work, added another flag behind me: A writer who is not compliant with the view we have of Irish women.

If only I had a chapter for every time I've been asked if I'm a feminist writer. The answer is that no, I'm not. I'm a writer who is a feminist. It doesn't take hard work to understand why I have to be a feminist. Simply put, I must not be the opposite. Of course, the feminism that I espouse is not about being anti-man. How often have we had to say that with the stitched-on smile. Merciful hour it's not always about men. I'm all for men. I love some of them, like an awful lot of them, even though I've had reason to fall out with one or two. But I am also all for trying to understand women. I'm interested in the woman who is doing her best, the one who allows love to make her foolish, the one just barely holding on and the one who is trying to change the world, even in small ways, to make it a better place, for women and for men. It follows that a better world will benefit men. Well, some of them. Certainly it will not benefit those who have always had uncontested power, because they're about to lose some of it, aren't they?

I write about women, men and children, about Irish people and others. One of my novels, with the issue of capital punishment at its core, is about a man being wrongly executed for the murder of a woman. It's not about the woman, who deserves a tale all of her own. It journeys onto Death Row in the USA. I write, sympathetically enough I think, about men. But the reason I have to answer the question so often is that I also write about women who are alive, wide awake, who are more than what they look like, who have views about how they fit in the world.

'Surely that couldn't be a problem?' you say. But it is, because it upsets the script. The cries go up: 'but what about the ordinary woman?' And I say: 'there she is'. So the gender issue in my work is not that I write about women, but that I don't constrain them, I allow them to think in crooked lines. And be as unique as humans are. The issue is that there is an issue about that at all.

The dual standard is a worldwide one, not exclusively Irish, well described, for instance, by Alberto Manguel in his introduction to *Other Fires* (Picador, 1986), an anthology with one of my favourite stories of all time, 'The Fall' by Armonía Somers. I try to tell students about it, maybe making up extra bits around the fringes; it's hard not to. When I was attempting to write out from under the guilt inevitably bestowed upon us – Catholic in my case – this story was a shining light. Somers didn't just burrow her way out, she flew free in the first words, while at the same time having a thunderous respect for the poor captive's spiritual beliefs. Manguel understood the travesty of misrepresentation better than most. He had become frustrated by the academic shortchanging of Latin American literature. He set out in the 1980s to anthologise little-translated work. He was tired of the same three or four, and the magic realism trap, and the lazy term 'Latin American Literature', because there can be no such thing –

the continent is too vast and varied for that shorthand. He was bewildered by how translation choices were made, he had a copious list of neglected voices in his head. And became struck by the fact that there were so many women on it. Hence this jewel of an anthology, which opens up not just its own doors but a map to find other gems. I thought about it a lot as I chose work for *Cutting the Night in Two: Short Stories by Irish Women,* co-edited with Hans-Christian Oeser (New Island, 2001).

When I travel abroad as a writer I am continuously asked about male Irish writers, a situation that I suspect is not reciprocated. I often have to sew on that smile, yet again, when I say that work written by men about women is not the voice of women. You may find it odd that I should state such an obvious thing, but regretfully I must. No matter how good the writer, no matter how wonderful he is at getting into the heads of his women characters as well as his men, his is not a woman's voice. I get exhausted even having to think this truth. Of course, I'm not saying that men can't write about women, nor that white people can't write outside their colour, I am simply stating that I sometimes want to hear the original voice. And moreover, I want it to matter as much as the phantom one does. I want the unfiltered truth, not the one propped up by typically-lazy preconceptions or romanticised guff. I am, of course, very aware that women can write that too – often with the enthusiastic backing of publishing houses and men who really prefer that view.

In the 1970s we learned that when the woman in the story is always dumb and available, when her greatest task is to wipe the flour from her nose before setting the table, when the black man is always the janitor and the black woman always the maid, in other words when the only people who are equal to white men are white men, there is something wrong with Art. I said 'always'. And I said 'equal', meaning to be equally capable of being obnoxious,

human enough to be bad rather than a cliché. I'm a great one for the Lady Macbeths. I'd prefer to be horrible than to be a cardboard cutout.

I have on rare occasions tackled the gender issue head-on in my work. 'Taking Scarlet as a Real Colour', the title story of a collection published by Blackstaff Press in 1993, ends with the speaker writing to Henry Miller, suggesting to him that men writing about sex may have got it wrong, may have suffered from a misunderstanding. Again a title story, 'Telling' (Blackstaff, 2000/Books Upstairs, 2016), is about a great male writer telling a roomful of women how to write about domestic violence. I had form here, having once, in fury, published an article in response to the portrayal of a woman suffering domestic violence, and having expressed bafflement at the narrow view of what constituted a family. At the time I was myself a 'separated' mother of two young boys, living in a hostile environment. The factual pressure of that, and my watching the wonderful way my sons were negotiating their difference, dulled any pedestrian sense of humour I could have had around the issue. Initially I didn't have any intention of addressing the issue publicly (Why should I? No one else would). But then I could bear it no more. The reactions of women who had felt silenced and who contacted me in their droves to tell me of their relief might have suggested that I was right to do so. And yet, in some ways, I wish I had stayed silent. It's easier.

Of course, I would prefer not to be angry. Of course, I'd like to be considered polite. I once stood up to gently ask if a speaker, in his mentioning of twenty-two Irish writers, might consider that perhaps only one woman gracing his mouth was a bit minimalist. As I began to formulate the dry-throated words my brain said *Oh god, not me again*.

Currently, I'm working on a series of essays about my writing life, in its way a kind of memoir (but I don't like the word because of the presumption of the Me in it). In

this I've been writing about a quite shocking act of censorship performed on my second collection by the already mentioned man who was considered the arbiter of the Irish short story at the time. The shock is not about him as a reader exhorting that it should not be published (every reader has that right), it is about the reasons given. When I look at his report I realise that tackling gender issues within my work had a cost, a huge cost to me. I should say that the collection did get published, despite the obstacles thrown in its way.

The characters flaunting themselves, I hope, in my next collection are a variegated bunch of men and women. They include Violet Gibson, the Irish woman who almost succeeded in assassinating Mussolini; Mary Lee, the Irish woman at the forefront of getting the vote for women in South Australia; Sophie Brezeska who loved the French sculptor Henri Gaudier and rescued a considerable amount of his work after he was killed in the WW1 trenches. But it also includes a horrible woman who lies about the father of her child. And another who lies about herself. When I begin to write about a man or a woman I do not think of how the reader will see them. I simply run with what I know of the world, and a surprising enough place that is. I have three stories that could be in the voice of either gender, one from an academic who goes to interview the first woman to deliberately become pregnant after the atom bomb was dropped, one from a child who sits on the stairs listening to its sister lose the run of herself over her wedding. I've read both stories and it has been interesting, to say the least, listening to people explain why they know the characters are male or female.

I don't think about gender issues when I'm writing, I merely observe what happens between men and women, or what happens to women or men. But no doubt the shade of the things I see is affected by the colour code of my knowledge of the world.

EVELYN CONLON

Evelyn Conlon, described as 'one of Ireland's major truly creative writers' is a novelist, short story writer, radio essayist and compiler of anthologies. Born in 1952, her work has been described by turn as poetic, acerbic, spare and beautifully descriptive. 'She wears her attention to detail and research as the lightest of cloaks'. Her work often deals with people who are between places, crossing borders both real and imagined. It has been widely anthologised and translated, most recently into Tamil and Chinese. She is a member of Aosdána and lives in Dublin. www.evelynconlon.com

BIBLIOGRAPHY

Where Did I Come From? A Sex-Education Book for Young Children (Dublin, 1982/1983)
My Head is Opening (Dublin, Attic Press, 1987)
Stars in the Daytime (Dublin, Attic Press, 1989)
Taking Scarlet as a Real Colour (Belfast, Blackstaff Press. 1993)
A Glassful of Letters (Belfast, Blackstaff Press, 1998)
An Cloigeann is a Luach: What Worth the Head: County Limerick Anthology, editor (Limerick, 1998)
Telling: New and Selected Short Stories (Belfast, Blackstaff Press, 2000)
Cutting the Night in Two: Short Stories by Irish Women Writers, co-edited with Hans-Christian Oeser (New Island, 2001)
Skin of Dreams (Dingle, Brandon, 2003)
Later On: The Monaghan Bombing Memorial Anthology (Dingle, Brandon, 2004)
Annaghmakerrig, associate editor literature (Dublin, Lilliput Press, 2006)
Not the Same Sky (Adelaide, Wakefield Press, 2013/2015)

Anne Devlin

SWIMMING IN HISTORY

I grew up in a household where my grandmother remained emotionally engaged with the events of the French revolution. Her Catholicism was of the Roman variety with an Austrian tinge, in her attachment to Marie Antoinette. Lancashire born, she had been educated by French nuns at a convent there. So when I heard Brian Friel's character Gar utter the words of Edmund Burke, 'It is 20 years since I saw the Queen of France', I recognised this as the atmosphere of my grandmother's house in West Belfast where I lived for the first twelve years of my life. My father, the only man in a household of women, parked his republican history before I was born and became involved with the Labour Party (first Irish Labour and then Northern Irish Labour) and agnosticism. This was the 1950s, and the only thing that mocked this history was my name, Anne Devlin.

The books arriving at Christmas and on my birthday were from my mother's older sisters in England. Auntie May sent me Perrault's *Fairy Tales* with illustrated ballrooms and tiny swirling eighteenth century figures; the vanished French court, reconfigured as the interrupted lives of *Sleeping Beauty* and *Cinderella*. Whereas my father's gift and reward for passing my Eleven Plus was the *Junior World Encyclopaedia* with its illustrated classical world of Greek and Roman gods and goddesses. Another lost world. I could recite from memory the Seven Wonders of

the Ancient World, but I wasn't aware of the historical drama of Anne Devlin. It was as if the household had changed its tone and only at my grammar school, St Dominic's, was it of some concern. I was challenged in answering Present to the roll call, by a nun who asked: And who was Anne Devlin? Was? Surely, I am, I think. I couldn't answer. So she supplied the detail. She was Robert Emmett's housekeeper. And she was tortured by the British. If housekeeper and torture worried me, I learnt something more troubling from this exchange: that far from being present – I was standing in for someone else.

And it was this perhaps among other things that led me to pick up my pen to write out my complex sense of feeling about who I am. I felt that I did not fit the history that was being projected onto me. I do have a sense that history is something that falls on you – not like a guillotine, more like a wave; it crashes down and sends you away from where you originally stood; and you struggle to sink or swim within it. You become in fact a swimmer, which is what my mother was. She swam regularly in the 1940s, from Pickie Pool to the Pier and back at Bangor West; or up and down the clean waters of the Lagan from the Minnowburn, at Shaws Bridge in Belfast. An athlete who wanted to be an actress, she made as big a contribution as my father and grandmother to my becoming a playwright. She wanted to go on stage; not being allowed or encouraged by her father, she sent me to drama classes and accompanied me to every festival around the counties of Antrim and Down in the mid fifties, until in fact I was to prepare for grammar school. May Marrion's School of Speech and Drama was held in the Scottish Provident Building in Wellington Place on Saturday from 10.30 until 6. The legendary May was the sister of a painter: 'He painted the scenes and I made them move', she once said. Among us were the children of aspiring Catholic commercial classes – mostly publicans –

and also a good many Protestants, like my father's friend at Andrews Mill, a painter, who got his daughter to enrol me in the class. The one thing all three of the parental figures in my life agreed about was the stage.

We did monologues and duologues, and poetry, and extracts from Shakespeare's plays, by heart. And every year we did a pantomime at St Mary's Hall in Bank Place off Chapel Lane. May Marrion's version of *Babes in the Wood* and *Robin Hood* was performed in my last year before the grammar school entrance exam. The hall was used to host Joe Devlin's political rallies, right up to the 1930s. To have been there in a theatrical way, when I was 9, and then to return ten years later, October 1969, to end my association with the student movement, the PD, as it took out membership cards and became increasingly nationalist in its composition felt untimely. It was as if the earlier purpose of the site had reclaimed it, as a political history seemed to reclaim me from the theatre. It brought home to me that it is place, rather than time, that is subject to cosmic manipulation, in much the same way that analysts will say that trauma is the return of an event to a person who is unwilling to receive it. So I have found myself returned unintentionally, or beyond my control, to a place of whose significance I am unknowing, and the nature of the return will be as significant as the original event.

For example, during my Eleven Plus year, our teacher took us to Stormont; it was the day that the new prime minster was to be inaugurated. We were being hosted by Harry Diamond, the MP for Falls, the seat my father would later win from him. We were thirty or so little Catholic schoolgirls in navy gym slips and blue girdles. We were crowded into a small lobby between the pillars. In front of double doors I don't think I even managed to catch a glimpse of the new prime minister Terence O'Neill, but there was a procession in which a man in knee britches carried the mace towards the doors, there was a shout, the

doors opened and power passed. The next time I was in that building, seven years later, I arrived with a group of students and I sat down on the floor until midnight, calling the members from the chamber. We were sitting at the foot of the grand staircase. And we sang, and the power had passed again to us. It was Human Rights Day in 1968. In the same term I wrote a fourteen page essay on a Shakespeare sonnet, 'When in disgrace with fortune and men's eyes', for my homework.

The cycle began on Human Rights Day 1968 when I stepped blindly outside that building into the flash of cameras, onto the front page of a newspaper whose readership saw me as a troublemaker, but with a sense that my own history had begun. It will carry me through the dreadful year of 1969 beginning with the ambush at Burntollet when the student march is attacked by a loyalist mob and ends with the IRA split into Official and Provisionals in December. I will have already retreated in September, as a companion from my group of left wing political friends – I had no others – directs me to the library. He's a History undergraduate at Cambridge. And I lay the self who was an activist aside and learn to live without Anne Devlin for a while.

To get to university, and because the nuns think I have outgrown the school, I have to go to a Further Education College, Rupert Stanley in East Belfast, to sit my A's in a year. I run out of time in the English paper and don't answer the Chaucer question, 3 out of 4 awards me a C, but I am able to make up to B in the other subjects, Politics and Economics. I qualify for the University of Ulster Education Department but transfer to Single English by the end of the first year and this saves my life. If I had stayed in politics in Belfast I would be dead. And I wouldn't be a writer.

I even managed to change my name in the years I was living without her. Anne Devlin. Every time she surfaces I

am traumatised. I was teaching in north Antrim when someone wrote that name in an essay. I didn't stay in north Antrim, but moved to Germany where I began to write in the library in Freiburg. It took me from 1976 to 1979 to begin to recover my history. They say the most painful things must be kept very far away from us, at first. We edge towards them. I do this with language. I'm helped by an Arvon Foundation week in Devon which Olivia Manning and her husband Reggie Smith attend. He was based at Magee College in Derry and taught at Coleraine for a while. A friend of Walter Allen's, the head of English. The Arvon tutors were Colin Spencer and Alan Sheridan Smyth (a translator of Foucault). I have read Foucault's *Les Mots et les Choses*. In English of course. So that books then became the place to live. I didn't even read the newspapers anymore. I read the books pages. I could not bear Any Questions. I listened to Alistair Cooke's 'Letters from America' because it was storytelling not argument. So I begin writing stories under the name I have assumed when I married; it's a courtly Elizabethan name. I send the stories to David Marcus and Michael Longley. And then I realise I'm about to publish, and now divorced, I must be brave enough to take up the mantle of my own name again. And I do. And Longley writes back: that name is so resonant.

One day I go to Sweden, or the British Council sends me; they were once very generous to writers. It is 1990 and I am at Lund University, and naturally I'm thinking of Bergman and *Wild Strawberries*. Naturally? Because the journey in the film ends at Lund University – the cobbled square in front of the cathedral where my flat is located. One of my colleagues in the Comparative Literature Department invites me to join his family at Sandhammaren where they have a summer house. It is late May and we are walking across a wide moor towards evening. There is a long low house in the middle of the

landscape and the sun is going down, and everything is filled with light. And I have never been in such an idyll. My colleague tells me that the house belonged to Dag Hammarskjöld – a man who was a Secretary-General of the United Nations and a poet. He died in a plane crash in Africa, mysteriously, settling a dispute in the Congo. The house is now a writers' retreat, he adds. And I cannot for the life of me think why if this was your place would you ever go into the world and leave it. Why would you engage in the world of politics? It will take me the best part of twenty years to answer this question for myself. Here was a poet, he could have stayed at home and written poetry. This is what I thought every time I recalled myself to that place.

Forgetting that if we don't go to seek the world, the world will come for us, in many forms.

I left Sweden with a very clear sense that there's a place which is the objective correlative of the inside, and that dangerous attraction to the idyll led me to France. When I returned from teaching at Lund, I didn't return to my job at Birmingham University Drama Department. Instead I went to work for Paramount Pictures. To adapt *Wuthering Heights*. I had only ever been Visiting Tutor at Birmingham, and the attachments to Lund and later Trinity have always only been for two terms. I earned £59,000 for that screenplay work for Paramount. I had only ever earned £2,500 per script until then. With the money I earned I bought an idyll in the midi Pyrenees. The dream of living outside the mainstream stayed with me. And I went on to write my second big stage play at the French house. I didn't see a tax bill waiting round the corner for me, so I took on script doctor work – taking a structure and filling in the emotional blanks. And at the same time being asked to take myself out of things. I have acquired many skills, writing on location, writing to an edit, writing to the music. Writing in radio, in TV and in film. And if I

was never asked after Trinity to teach creative writing again, it may have been my own fault, it may have been that in a nuclear age my weapon of choice was seen to be the crossbow.

Just as my father's republican history returned to claim him under pressure of August 1969, so I returned in 2007 to the age of commemorations, first forty and then fifty years from the start of the Civil Rights Movement. The culmination of my engagement with the fiftieth anniversary committee resulted in an event at the Playhouse in Derry on 6 October (Ivy Day) 2018, where twelve women writers read for five minutes from the stance of generation. Inspired by *Female Lines*, and a conversation I had with Jean Bleakney, I said I thought Michael Longley (and Seamus Heaney) were brave to go on the Newry Civil Rights March following Bloody Sunday. I was too afraid, I told her. I was afraid too, she said. She was nine when she watched the marchers arrive in the town where her father was a customs officer on the border. We were not adversaries, Jean and I. We both knew that literature, in her case poetry, allows for total knowledge, unlike politics which is partial.

When I was away the distance to my subject matter was created by a sense that the past existed only as a dream. I took up writing plays because my dreams (nightmares) would not allow the events I had lived to pass into history. When I broke with my political friends all those years ago, it caused a great rendering. I used the plays to find my way back to live a whole self. It did not involve me in activism; the play was the activity. If I have inadvertently turned real people into ghosts then they have claims to demand recognition.

On 21 September 2019 I am invited to join a discussion group at the Irish Transport Union HQ in Belfast. I am not

invited because I'm a protagonist, or a writer. I'm invited because I'm Paddy Devlin's daughter. I resume the daughter mantle again. Erskine Holmes, my father's old Labour friend, has issued the invite. The discussion is being chaired by another member of the Civil Rights Commemoration Committee 50 – Deirdre McBride.

Living History Reflections on 1969 discussions are recorded, published by Island Books and complied by Michael Hall, who was a student in 1969, and is himself a writer. I am given a place at the table by Harry Donaghy, the convenor, whose father I recall from Falls Labour Party in 1969. The contributors are described in the first pamphlet as protagonists (loyalists, republicans and others) in the events under discussion. The aim to separate history from myth and build a meaningful peace.

In the second of the discussions on the barricades period, August 1969, I record that my writing comes from eyewitness testimony and research. I explain that I went to the Transcripts of Evidence to Scarman in the British Museum Library to fill in what I did not witness. But the research was 'overhearing' because it is spoken even though I am reading the papers. I have always been very retentive of things said. To begin these discussions at a fifty years' distance among the protagonists is to become cognisant of what it is to engage in that transcendence we are all seeking through language.

Yet there are difficulties which reveal the original fractures. When I compared my memory with the published account of the discussion on the barricades I came across a discrepancy. I recall that I asked how much the 'May Events' in Paris impacted on our reaching for barricades. I remember that Seamus Lynch replied 'there were barricades in the thirties', to which I answered 'I didn't know that.' Yet when I read the published pamphlet two people replied. One whom I'd forgotten, Jim McDermot, a historian, said, 'there were barricades in 64'.

But Seamus Lynch's reply was attributed to Martin Lynch, who wasn't even in the room.

Memories diverge, where fact is concerned. Yet there is an emotional truth in this, for while I was sitting down among the students in Linenhall Street in 1968, Martin once told me he was on a bus that night, in blocked traffic, trying to get home from work, thinking 'effing students'.

Recently I was turned down by a very good producer when I tried to return to TV to work on a four-part series, *The Telling*, an opus I began and had to abandon in 2004, after my term as Writer Fellow in Trinity. She said: 'we will only pull your work out of shape; you have to find another outlet for this'. The chief broadcaster to whom she had hoped to go had just emphatically announced that there would be no more 'Troubles' drama. They had moved on. It's the crossbow effect again.

In my most recent short stories, two published in anthologies, the collection a work in progress, and a necessary prelude to a play, the returning histories emerge as interruptions in the visual sphere: apparitions that are sometimes manifest.

If I falter in giving language to this inconvenient history I will have no peace. And this quest for the idyll, where I think peace is to be found, for place, is a quest for understanding which in my view is more vital than the pursuit of justice, which understanding must always precede.

CRITICAL APPRAISAL

Brenda Josephine Liddy, *The Drama of War in the Theatre of Anne Devlin, Marie Jones, and Christina Reid, Three Irish Playwrights* (Lewiston, NY, Edwin Mellen Press, 2010)

Anne Devlin is a short story writer, playwright and screenwriter born in Belfast in 1951. She was a teacher from 1974 to 1978, and started writing fiction in 1976 in Germany. Having lived in London for a decade, she returned to Belfast in 2007. She is the daughter of Paddy Devlin, a Member of the Parliament of Northern Ireland and a founding member of the Social Democratic and Labour Party (SDLP). She was raised in Belfast.

In January 1969, while a student at the New University of Ulster, Devlin joined a civil rights march from Belfast to Derry. At Burntollet Bridge, a few miles from Derry, the march was attacked by loyalists. Devlin was struck on the head, knocked unconscious, fell into the river, and was brought to hospital suffering from concussion. The march was echoed in her 1994 play *After Easter*.

Devlin subsequently left Northern Ireland for England. She was visiting lecturer in playwriting at the University of Birmingham in 1987, and a writer in residence at Lund University, Sweden, in 1990.

In 1982, she won the Hennessy Literary Award for her short story 'Passages', which was adapted for television as *A Woman Calling*. She received the Samuel Beckett Award in 1984, and won the Susan Smith Blackburn Prize in 1986. *The Forgotten*, a major radio play by Devlin, was first broadcast on BBC Radio 4 in January 2009.

BIBLIOGRAPHY

Ourselves Alone (Faber, 1986)
The Way-Paver (Faber, 1986/1987)
Heartlanders (Nick Hern, 1989), with Stephen Bill & David Edgar
After Easter (Faber, 1994)
Titanic Town (Faber, 1999)

Ivy Bannister

DUBLIN MADE ME A WRITER

You could see the bottles from the street, four storeys below ...

1970 was the glory day of Mateus Rosé in its oval bottles; and when the pink fizz had been drained by me and my new friends, I stuck candles into the empties and arranged them round my window – an art installation, although the term was as unknown to me then as Quantum Physics.

Fitzwilliam Square was a posh address. I had taken the flat because it was cheap, and within walking distance of Trinity College where I was studying; and because there was no landlady – or other Cerberus – on site. What did it matter that the interior of the Georgian townhouse had long left the Enlightenment behind? The bottom floors were occupied by a couple of dodgy medical services rarely visited by anyone; and as I climbed the stairs, punching a button on each landing to elicit a few seconds of dust-peppered light from a naked lightbulb, the surroundings grew dingier and dirtier.

My flat was at the top. Once upon a time, it had been a room for servants. Now it was mine alone, the first roof that I'd put over my own head, and its grottiness didn't faze me. After all, I had come to Ireland to study and to write; and I knew from Puccini's *La Bohème* that writers lived in garrets and suffered for their art. There was an

oozing sink, a two-ring burner, and 1940s wallpaper with roses afflicted by black spot and powdery mildew. The two beds were wire mesh with pads on top. But there was a table for my typewriter, a few creaky chairs for friends, and a single-bar electric fire that reluctantly released heat.

The loo was in the hall outside, to be shared with Miss O'Shea, a gentle, elderly madwoman with flowing white hair. 'Eily, lovely Eily,' she'd sing at the sight of me. The cavernous bath itself was icy, and the water supply, a drip. So I bought a plastic baby bath and squeezed my backside into it, fearlessly washing within inches of the electric fire. My resourcefulness delighted me.

I was developing a new way of looking at things, catnip for a writer.

I'd grown up in New York City, and by comparison, Dublin was a house of mirrors, where everything had a new slant. Buses, for example, had two floors, their conductors came to you, fares were complicated, and you could smoke *anywhere*, not only on buses, but even at the theatre, where you watched the show through a blue-grey miasma that floated towards the proscenium. Around me, people spoke English, but it wasn't the English that I knew. So much required translation, words like *baluba*, *stocious*, *jacks*, *yoke* and *holy hour*, which, for months, I believed was an arrangement for barmen to pursue their religious obligations.

However there was one familiar-but-unfamiliar word that I got at once. If I opened my mouth, people replied, 'You're a Yank.' *Yank* as a noun sounded uneuphonious and rude. More than a reference to my birth place, it held mixed messages: a grudging admiration of the glamour and city lights of me; and a fascinated revulsion at my presumed wealth and sophistication. Attributes, I might

add, which were in short supply in my nineteen-year-old self.

Sometimes complete strangers would stop me: 'Aren't you a Yank?' It was unsettling. How could they tell? I had no idea that my status as an outsider was so obvious. I didn't understand that my skin was missing the pale Irish pallor that encourages the absorption of vitamin D. Or that my coat looked American, as did my shoes. Then there were the tights: red, green, blue, violet, a rainbow for legs; and the fabric was different too: sleek, opaque, wrinkle proof.

I bought a large map of Dublin, and plunged into its streets, eyes wide open. Dubliners weren't in the least like New Yorkers. They weren't in such a hurry. They noticed each other. They milled about in a ferment of awareness, observing and remembering. Everyone was writing, acting, painting or dreaming; and if you were on the street, likely as not, you wanted to talk.

The absence of phones, by which I mean landlines, made all the difference. Like me, most of my friends had no reliable access to a telephone, which infused everything with a sense of now-or-never. Friendships sealed themselves swiftly with a leap into verbal intimacy, as if the participants had known one another for years. It was essential to talk *now*, because who knew when the opportunity would arise again.

Talk was everything. Every encounter glowed with possibility. When I ran into someone familiar on Grafton Street, often as not, we'd disappear into Bewley's, perhaps collecting another acquaintance or two on the way. There the talk over the welcome steam from a hot drink would be fast, furious and funny. As I soaked it all in, I'd wonder if my companions planned to write down everything we'd said, because I certainly did.

I'd arrived in Dublin knowing no one. Within weeks, my circle of friends was colossal, more people than I'd ever known in New York.

I was thirteen when Daphne du Maurier's noir novel, *Rebecca*, convinced me that I wanted to write. As I raced through its exciting pages, a particular sentence stopped me in my tracks. 'You thought I loved Rebecca,' the brooding Max de Winter mutters, 'I hated her.' He *hated* her? Why that changed everything! Tears of relief spilled down my cheeks for the nameless heroine. Then the left side of my brain kicked in. How was it possible? How could a few words thrill me and make me cry at the one time? If that's what writers did, then I wanted to be one.

Then and there, I scribbled a short story about a boy and his guitar. The story won my school's annual writing competition, although I was the youngest in the senior school. Now who wouldn't opt for writing after a lucky start like that?

But thinking of myself as a writer was one thing. Actually writing was another; and I wasn't yet ready for the blood, sweat and tears of sustained word-spinning.

December 1970. 'Why Ireland?' one of my Dublin friends inquired, as we knocked back the Mateus Rosé. 'Why Trinity?' Funnily enough, my mother had posed similar questions, the assumption being that Oxbridge (or even Edinburgh) would better inspire a wannabe writer. The answer was rooted in my childhood. The answer was Mr Higgins. I was six when my father hired him, a Corkman, to do some serious work at our summer cottage in Connecticut. Mr Higgins was a man-mountain: tall, wide and larger-than-life in every way. From a distance I saw him build a wall, the stones floating like feathers in his massive hands. Watching him was mesmerising, but

listening to him was even better. Stories flooded from his mouth, stories enhanced by the wild energy with which he slung his words together.

If Ireland was a country where builders were so eloquent, then what must the literati sound like?

After a few weeks of living in Dublin, I wanted to *be* Irish. I cultivated an Irish accent, cantering in a breath from Kerry to Cavan, and I started to write: stories of Ireland.

I wrote in longhand, under the impression that serious stories were written in longhand. How I laboured over these dark, convoluted works, seasoned by the writings of Dead White Men, each word instinct with meaning. I put aside the drafts for future scholars, so they might trace the growth of my artistry with ease. My brain thumped from the exertion, and the pages piled up; but to my chagrin, these masterpieces earned the most vigorous rejections.

At this point my writing career might have ground to a halt forever, had the Fates not intervened. By chance I discovered that a popular Irish women's weekly paid twelve guineas for every story that they published. Twelve guineas! A fortune. Of course, I knew that the women's weekly wouldn't fancy my unrecognised masterpieces. But a quick read of some back issues was enough to suss the necessary formula: girl meets boy; an impediment to romance is discovered; said impediment is overcome; girl and boy ride off into the sunset. A simplified take, in fact, on classical comedy as described by Northrup Frye in *The Anatomy of Criticism*.

I sat down at my typewriter and had a go. I was an excellent typist, having cut my teeth back in America in the typing pool of *The New Yorker*. In a few hours I produced a clean first draft, which I delivered by hand to the offices of the women's magazine. When the story duly appeared, I shared it with a clatter of my college friends.

We read it out loud, howling with laughter at the cliché-ridden text. Much encouraged, I wrote another in the same vein, this time hitting upon the amusing expedient of drawing my characters from life: well, if James Joyce could do it, why shouldn't I? Needless to say, this new story went down even better with my pals, but soon I got bored. Pulp fiction, especially when ladylike, had its limits.

What I didn't understand then was how these silly stories were a step forward for me. Because deep beneath their coy surface, these new stories were about sex, something that I, like any other young adult, was trying to fathom; and that – however superficially – I was writing about relationships as I saw them myself.

It was a useful lesson. To write successfully, you have to start with what Yeats called the rag and boneshop. If I was going to write at all, the world on my pages needed to be filtered through my own sensibilities. I had to know and trust myself. And Dublin was bringing me on.

Ars longa, vita brevis, or to paraphrase Grace Paley, art is too long and life is too short.

As a writer, I've chanced my arm at almost everything: articles, radio work, plays, fiction, poetry, memoir. Early on, I was fortunate enough to participate in the seminal Arlen House National Women Writers' Workshop, chaired by Eavan Boland, where the writing friends that I made would last a lifetime. Welcome support came from the Arts Council, and the Abbey optioned one of my plays for a generous sum, although they never performed it. I won a Hennessy and the Francis MacManus awards for fiction, the O.Z. Whitehead for playwrighting, two Maxwell House poetry awards from Arlen House, amid a raft of other awards. And I published three volumes, one each of fiction, memoir and poetry.

I've always been easily distracted: by babies and personal disaster; by teaching, travelling, friends and art; by growing veggies, and even simply by soaking up the blessed gift of sunshine. I've never been driven by a need to make my mark on the world. I write because I want to, because finishing a piece that works, brings with it some feeling of accomplishment. For me, writing is a gift, something to get on with come hell, high water or lockdown. *Retirement* has always struck me as a bad word.

February 1971. I've been living in Dublin for four months. A friend with a car – a car! – wants to show me the Irish countryside. 'Where would you like to go?' he asks. The car is a Morris Minor, a vehicle that resembles a box on wheels. Its indicators pop out from the car's sides and flap.

'Moone,' is what I say to my friend. 'Moone Abbey.' *He is taking me to the moon in his Morris Minor*. The Irish countryside is vast, fresh, beautiful and empty. We park in the middle of nowhere, and clamber through the undergrowth towards the ruins of a church. There's no sign that anyone's been here for ages. We pass a patch of blue speedwell, then something yellow, which may – or may not – be coltsfoot. The cold air burns in my lungs. The High Cross rises before me. My eyes settle on the apostles, twelve of them, carved with impeccable simplicity into the stone. I stand and stare and wonder as the apostles return my gaze. Then I feel the presence of the hand that carved them. My eyes close, as I acknowledge that Ireland, past and present, is my forever home, that I am in Ireland for the distance.

IVY BANNISTER

Ivy Bannister was born in New York City in 1951. In 1970, she came to Ireland to study at Trinity College, Dublin, where she earned her Ph.D. Her books are: *Blunt Trauma*, a memoir; *Vinegar and Spit*, poetry; and *Magician*, short stories. Several plays have been broadcast by RTÉ radio, and she has written more than fifty pieces for *Sunday Miscellany* and *The Living Word*.

Awards include the Francis MacManus and Hennessy for fiction, and the O.Z. Whitehead, Listowel, and Mobil Ireland for stage plays. Amongst her poetry awards are Best Small Collection Listowel, the Kilkenny Prize and the Kent and Sussex.

BIBLIOGRAPHY

Magician (Dublin, Poolbeg Press, 1996)
Blunt Trauma: After the Fall of Flight 111 (Dublin, Ashfield Press, 2005)
Vinegar and Spit (Dublin, Astrolabe Press, 2008)

Sophia Hillan

APOSTROPHE

In the night ward all is quiet. Soft shadows, soft whispers; outside in the street a Christmas carol, badly, drunkenly sung. Someone coughs: a sudden bright light and a hovering silhouette. It is 1975: I am twenty-five-years-old, in hospital, in a city I don't know well enough to know where I am. Am I near to the new-smelling, unfamiliar, barely-furnished house where I have been living these five months since I got married? Am I at all close to the equally new-smelling, unfamiliar, barely-furnished school where I have been teaching for those few months? I have no idea. A sudden, breathtaking pain, severe enough to pitch me bent double onto the floor, has brought me here, two days before Christmas. Above my head is a sign: 'Sylvia King: Fluid's only'. I can read upside down, and back to front for that matter: Lewis Carroll taught me how. What use that is I no longer know: all I know is that my name is not Sylvia King but Sophia Hillan, and that I did not put that apostrophe there.

This strange period in Dublin's Jervis Street Hospital stands out in my mind as the time when I decided a number of things. One was that, whatever convention dictated about the taking of a husband's name, I needed to reclaim my own, a process which proved harder than I imagined; the other that I must get on and write if I was ever going to do it. I don't mean I hadn't ever been doing

it: like many another, I grew up intending to be Jo March, scribbled in exercise books all through childhood, and had a reputation in school for two things: one, not good, for looking out the window when I should have been listening, and the other, for having the ability to write, which probably saved me from most of the consequences of the first. When bored or, just as often, distracted by whatever was outside – the flight of a bird, the shape of a cloud, a drifting leaf – I could not stay in the room. The windows in my handsome convent school were long and elegant; it was all too easy to take my wandering mind through them, easy as passing through the mirror in the hall of the house where I grew up. For that, also, I must thank or blame Lewis Carroll: once I encountered the strangeness and magic of his looking-glass world, I could never be unaware of it. Coming home each afternoon, putting down the schoolbag, it was the first thing I saw to my left: a whole other house, everything so like home, yet not. It was the not-world, where the not-people, who looked almost like us, but not, lived their parallel mysterious lives. It was never possible to see those people in their rooms so nearly like ours, but I knew they were in there: sometimes they would be glimpsed, running through like my siblings but not; like my parents but, unnervingly, not. Yet that strange mirror-world, not always pleasant to observe or easy to inhabit, has drawn me ever since.

As a child, reading everything I could get my hands on in a house full of books, I was much given to nightmares so vivid, so powerful that they stay with me still: I was so certain of the cold hand at the window, the grisly head that could be looked at only by reflection, that the wondrous terrifying books giving rise to them were taken away from me. I found them later, of course, as a reading child will, and I go back to them still, just as I still check out the not-world in every mirror I encounter: and though it would be

years before I encountered Frank O'Connor's *The Mirror in the Roadway: A Study of the Modern Novel* (Knopf, 1964), its title an echo of Stendhal's idea of the novel as 'a mirror carried along a roadway', it would be a matter of immediate recognition when I did. The experience of sudden transportation into another world would stay, and the sense of paralysing fear as much as the glimpse of bright joy would eventually find its place in my writing; but not yet.

I've described elsewhere the heady experience of finding myself in the momentous years of 1968–72 in Queen's University Belfast, a time famous for the resurgence of our euphemistically-termed Troubles. For those of us who were there, however, it was also the glorious period when Seamus Heaney was on the university staff, teaching and inspiring such distinguished contemporaries as Medbh McGuckian, Paul Muldoon and Ciaran Carson, as well as myself. Bliss was it in that dawn; though, as I've also written elsewhere, my feeling of utter unreadiness in such company and in such unpredictable times to write, made youth a time of uncertainty rather than clarity. Yet, I recall a bright morning in late September 1972, a new graduate, sitting on a grassy slope in Donegal, and a sudden sense of eager readiness. I had a copy on my knees of Heaney's *Death of a Naturalist*, the first book I had ever asked an author to sign, and, reading it, stirred and disturbed by its visceral strangeness as much as by its familiarity, I knew, watching the drifting, shifting Lake of Shadows stretched out beneath, that something was waiting for me; but what that something was I did not know.

It took the utter displacement of finding myself three years later, that Christmas in Jervis Street, distant and divorced from everything I thought I was or knew, to focus my mind. Surrounded by a ring of grave-faced students not much younger than myself, I listened with

what I now consider a curious detachment as an elegant consultant, silver-haired, grey-suited, told the students, not me, that 'this girl' had a rare cancer, a tumour now removed by surgery; that she was lucky it hadn't spread; and that if it had, she wouldn't have seen thirty. I watched as they all trooped away, and there, in that long, ill-lit Victorian ward where people died in the night and had disappeared by morning, I left the room once more. They were not talking about me. They were talking about somebody called Sylvia King, who had a rare cancer: she was not I. In that quiet darkness I formulated my first five-year plan.

The five-year plan involved being published before I was thirty: an ambition which, thanks to two of the great editors of twentieth-century Irish literature, Sam Hanna Bell and David Marcus, was miraculously achieved. I was teaching at the time in the remarkable and, later, famous Greendale Community School in Kilbarrack. At the outset, when it opened in September 1975, we were just ten teachers and one hundred students, many of whom had been repeatedly re-housed and shunted about from school to school; but they were young and we were eager, and we were all engaged in a new and heady experiment. Each staff member had several jobs and elevated titles – I found myself Head of English and Class Tutor and Librarian – and we could and often had to do anything and everything to make it all work. How that freed the imagination is almost impossible to describe: with a limited library budget, I could take the train home to Belfast and buy up stocks from the War on Want and Oxfam charity shops, and in so doing become again the child reader I had been, bringing back to our library as many as I could carry of the books I loved.

There were few windows in the classrooms of that ultra-modern design, the polar opposite of the graceful nineteenth-century convent rooms I had known: in my

room, there was just one accessible window, a long, narrow slit, like an arrow space in a castle wall. The walls were of blank and blandly-painted stone: so, for all our sakes, I decided to put up posters of windows, looking out on imagined worlds – a Flemish town, a rolling countryside – to give colour and life to the room and take away the starkness of the walls; and, perhaps, if any of the students desperately needed to escape and dream elsewhere, as I had done, they could. At the end of Friday afternoon I started to make a habit of reading aloud, remembering the comforting, steadying joy of the spoken word and, as a bonus, seeing the results of it in the classes' own responses, verbal as much as written. In the range and cadence of their speech and the quick sharpness of their wit, I began to have a sense of the Dublin Joyce and Beckett knew, heard and immortalised. Those children taught me far more than ever I taught them. And after school, like as not, I would take the rattling pre-Dart train in from Kilbarrack to town, go somewhere like Bewley's and read myself away from all the day's concerns.

That was how I came, so comparatively late in life, to the novels of C.S. Lewis. I knew who he was: on the shelves at home had been *The Screwtape Letters* and *The Problem of Pain*; and at university his *Allegory of Love*, like his study of *Paradise Lost*, had illuminated texts for me with a beautiful clarity; yet, I thought of him as a philosopher rather than as a writer of fiction. The Narnia chronicles were a revelation. I forgot O'Connell Street and Grafton Street, forgot Kilbarrack and Malahide, forgot entirely that I was married and a wife and made my way, not through the mirror this time, but through the wardrobe. I didn't yet know that Narnia had its origin in the Mourne mountains, or that Lewis's Cair Paravel took its origin in the spare and ascetic ruin of Dunluce Castle near Portstewart, where we had spent our childhood summers; but I knew that these novels reminded me, inexplicably, of home, just as surely

as the Enterprise gliding, red-lanterned, over the estuary in the winter night.

From my time in Jervis Street, where it was always for me, that year, winter and never Christmas, I found my way not only into writing but also into reclaiming the person lost in the loss of my name. I had, of course, been conscious of that loss of identity before: I saw it in the bank manager who refused me a chequebook when he saw that I was a married woman; I saw it in my salary, not only substantially less than my husband's,[1] despite our parallel and equal academic achievements, but also, as I recall, less than those of my male colleagues: tax laws of the time meant that, as a married woman, I was not a person in my own right, with my own tax-free allowance, but merely an adjunct of my husband. Shortly after I started teaching in Kilbarrack, my monthly salary after emergency tax was £14, while a female colleague in the same situation received no salary that month, but a demand from the revenue for payment. The archaic tax law was eventually updated, but that it existed still in 1975 should have been an alarm bell; yet it was not loud enough to wake me. Nothing was, until my whole name, not just my surname, disappeared that night in Jervis Street.

So, exploring the world of books with the young boys and girls of Kilbarrack enabled me to remember myself, as well as to recall what it had been like to be a child; to be certain that I should be writing a story, yet battling with the unspoken but necessary language of caution. In the Belfast of my growing up, long before Civil Rights marches and baton charges woke everyone up, we knew there were things that must never be said, people with whom it was essential to be careful, questions which must be neither asked nor answered; like many others of my acquaintance I learned to maintain, as we were taught by example in my primary school, not only custody of the eyes but also government of the tongue.

Strong and conflicting emotions came back in Kilbarrack: the feeling of being a child, and the liberation of being able, finally, to address what that overpowering caution had been about. So when in the late 1970s I began again to write, I returned to that lost world of 1950s Belfast when, though trouble had not truly broken out, it hung round the edges, round the borders, lying in wait beneath a relatively-calm surface.

Reading begets reading and re-reading: hidden or buried impressions, things that would become part of the writing I would undertake later but hadn't yet sufficiently absorbed to know I needed, would begin to rise to the surface. The glory of rediscovering, of coming to understand what had been read years before was to know that it could be revisited or, as Eliot might have put it, known for the first time. Working among the Kilbarrack children, as in the hospital night, I could revisit all the experiences – sound, vision, the spoken as well as the written word – that made me want to write: all of these would help me find my way into fiction, just as the muted sense of doom and an unspoken grief that hung over the bombed-out buildings of Belfast, sad abandoned testaments to the lost lives of the 1941 blitz, shells of houses not yet demolished or rebuilt, would one day find their place in a novel.

A rediscovery of the power and liberation of the imagination is what five years in Kilbarrack gave me, as well as friends for life; but it was not until I left it in 1980 to go and work as a part-time tutor, at Carysfort College of Education in Dublin's Blackrock, that my name was restored to me. There, with Seamus Heaney as Head of Department, I came back through the mirror and was known again, professionally, as Sophia Hillan. Under his guidance I, as much as the young trainee teachers studying the tragedy of *Antigone*, and the surprising darkness of Iona and Peter Opie's *Classic Fairy Tales*, came to

understand something of the extent to which the grim origins of folktale and ancient myth, like nightmare, like the mirror-world, are necessary not only to the wonder of reading and the telling of stories, but also to the understanding of the individual self. In 1980, inspired, liberated, I made another five-year plan.

Yet all this heady reading, writing and planning was, I somewhere knew, based on the premise that I might not necessarily meet my self-imposed targets. I believed, or chose to believe, that the cancer found in 1975 was gone, dealt with, not to be thought about, obsessed over or even addressed: it helped that I moved house and that Jervis Street didn't catch up with me, that it was later closed, its records moved elsewhere and that my records were (as I later learned) destroyed in a fire at Beaumont hospital. I don't think I mentioned it even to the obstetrician who delivered my two children a few years later, though I probably should have done.

It was quite a shock when, in 2008, thirty-three years after it was first found, the cancer reappeared. This was after quite a number of five-year plans: after a Ph.D, thanks to my being blessed with unfettered access to the papers of another tireless and generous mentor, Michael McLaverty; after a moderately-successful university career with the requisite amount of publication (very little of it fiction, not then admissible in research output returns); after many baffling illnesses which always seemed to necessitate the removal of yet another bit of my inside workings. Now, like those sinister, barely-glimpsed people in the not-world of the hall mirror, the neuro-endocrine tumour, sly, elusive and deadly, was found out once more; and this time, it had migrated to lymph nodes. Hearing that, in another hospital, on a bright May morning; not twenty-five now but fifty-eight, no longer a wife but still and, with my whole heart, mother to two young people not yet established in their adult selves, I thought of Jervis

Street and was back in darkness, not a creative, helpful darkness this time, just darkness. Even though, in the meantime, a treatment had been found; even though my version of this insidious cancer is slow, and that the treatment can slow it further; even though.

Yet, darkness itself can't last: daylight always returns. There was a square of hazy blue just discernible in a distant window, high up on the hospital wall, and when my eyes found it I was suddenly nineteen again, on a May morning at Queen's, reading Paul Verlaine in his prison cell, the sky through the roof-high window *si bleu, si calme*. When it is not possible to sit up, it may still be possible to look up, and nothing, not pain or drips or tubes or pendant bags, can stop the light returning at the end of the night; and, where there is a window, there is an elsewhere. To picture that elsewhere; to find my way into it and make another five-year plan was the obvious, only thing to do. Not young any more with all of life still to look forward to, but suddenly time-limited, more years behind than before, how could it not be imperative to know what might yet be done, and to plan to achieve it?

It was after that second cancer diagnosis, not before, that I saw published my biography of Jane Austen's nieces in Ireland, followed over the next five years by two novels and most recently, to my delight, the book of short stories that had been quietly gathering up in the background, waiting all through the years in the university, all through academic articles and administrative meetings and budgetary cuts and conference presentations, all through the sudden disappearance via another euphemism ('restructuring') of the university job for life. I sometimes wonder if I would have written those books, or reclaimed a sense of myself, without the shock of the night ward in Jervis Street, or the sunlit May morning in Belfast's Royal Victoria.

That said, I don't like living with neuro-endocrine

cancer: it can make me ill when I least expect it and it requires regular treatment which, while I am most fortunate to have it, is beyond uncomfortable at times. I don't, however, regard myself as a victim of cancer, or as a person battling cancer. It is just there. I am also here. We co-exist. It's not nearly as aggressive in me as it was for, among others, Steve Jobs and Aretha Franklin, who died of it. I'm told if I'm unlucky I will die of it; but that if I'm lucky I will die with it. Naturally, I'm aiming for luck. In the meantime, to know that the fuel tank needs refilling every twenty-eight days, thirteen times a year, does help with the conservation of energy, with the planning of work and the managing of a workload. In effect, I suppose, it may be because the cancer manifested itself when it did, that I began to find what was necessary to my own creative life.

So, thinking back to that Jervis Street apostrophe under my not-name, this is what I conclude: it should not have been there, any more than the tumour in my body. Both constituted an unwelcome intrusion, distorting and disturbing. Yet, since 'apostrophe' comes from the Greek 'to turn away from', then I turn away from the idea that a chronic illness like this NET must be a disadvantage. I did not put that apostrophe there any more than I put the tumour there, and I turn away from the idea that the presence of either should diminish me. And if to 'apostrophise' means to address, I also address them both, acknowledge that they were there and am almost grateful to them for compelling me all those years ago to come back to myself, to organise my time and get on with the books – of which, come to think of it, I have at least two more I want to write in the next five years. Even the back-to-front clock in my hall mirror tells me it's time I started work on those.

SOPHIA HILLAN

Sophia Hillan was born in Belfast in 1950 and educated at Queen's University Belfast, where she took a BA (1972), MA (1974) and Ph.D (1987). After teaching English from 1974 until 1986 in Belfast and Dublin, she was appointed to a Research Fellowship at Queen's University Belfast's Institute of Irish Studies (1986–1988), becoming its Assistant Director (1993–2003), then first Academic Director of its International Summer School in Irish Studies (2003–2005). She was a prizewinner at Listowel Writers' Week (1980), shortlisted for a Hennessy Award (1981) and runner-up for the Royal Society of Literature's first V.S. Pritchett Short Story Award (1999).

BIBLIOGRAPHY

In Quiet Places: The Uncollected Stories, Letters and Critical Prose of Michael McLaverty, editor (Dublin, Poolbeg, 1989)
The Silken Twine: A Study of the Works of Michael McLaverty (Dublin, Poolbeg Press, 1992)
Hope and History: First Hand Accounts of Life in Twentieth-Century Ulster, ed, with Seán McMahon (Friars Bush Press, 1996)
The Edge of Dark: A Sense of Place in the Writings of Michael McLaverty and Sam Hanna Bell (Bethesda, Academica Press, 2000)
May, Lou and Cass: Jane Austen's Nieces in Ireland (Blackstaff, 2011)
The Friday Tree (Dublin, Ward River Press, 2014)
The Way We Danced (Dublin, Ward River Press, 2016)
The Cocktail Hour (Dublin, Arlen House, 2018)

NOTES
* Author's photograph by Bobbie Hanvey is reproduced from the Bobbie Hanvey Photographic Archives at JJ Burns Library, Boston College. With many thanks to Bobbie Hanvey and Boston College.
1 The EEC directed that member states apply the principle of equal pay for men and women on 10 February 1975 (75/117/EEC). It took some time for this directive to be implemented.

FROM THE PERSONAL TO THE POLITICAL

Éilean Ní Chuilleanáin (ed.), *Irish Women: Image and Achievement* (Arlen House, 1985) was the first book to explore the place women have occupied in the development of the Irish imagination, tracing images of women found in art, folklore, religion and law, and documenting women's artistic achievements. Contributors included Margaret Mac Curtain, Nuala O'Faolain, Nóirín Ní Riain, Helen Lanigan Wood and Miriam Daly (assassinated in 1980 in Belfast).

Out for Ourselves: The Lives of Irish Lesbians and Gay Men (Women's Community Press, 1986) was edited by the Dublin Lesbian and Gay Men's Collectives. Irish lesbians and gay men speak for the first time, by name and anonymously, describing their experiences, reflecting on their personal needs and their political demands. Unfortunately the book was banned by some shops and media outlets, and didn't receive the attention it deserved.

Ailbhe Smyth (ed.), *Wildish Things: An Anthology of New Irish Women's Writing* (Attic Press, 1989) is a collection of new fiction and poetry vividly conveying the rich complexity of the lives and visions of women in contemporary Ireland, celebrating imaginative power, freshness and diversity. Contributors include Medbh McGuckian, Mary Dorcey, Mary O'Donnell, Evelyn Conlon, Moya Cannon, Éilís Ní Dhuibhne, Áine Ní Ghlinn, Eavan Boland and Maeve Binchy.

Directory of Women Contributors to Radio and Television: A Guide for Programme Makers (RTÉ, 1990, literary editor, Áine Ní Ghlinn) was compiled to ensure more women would be engaged for programme making; to more accurately refect contemporary Irish society; and to convince Government that there was no shortage of women qualified to serve on public boards. Sadly, in 2021, the gender imbalance in public broadcasting remains. (For example, see Lucy Keaveney and Dolores Gibbons' media monitoring research).

Medbh McGuckian

ON
BALLYCASTLE
BEACH
MEDBH McGUCKIAN

HAD I
A THOUSAND
LIVES
Medbh McGuckian

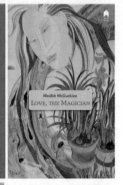

Medbh McGuckian
LOVE, THE MAGICIAN

Marconi's Cottage

MEDBH McGUCKIAN
POETRY IRELAND CHOICE

DRAWING
BALLERINAS
Medbh McGuckian

Selected Poems
Medbh
McGuckian

BLARIS
MOOR
Medbh McGuckian

MARINE CLOUD
BRIGHTENING
Medbh McGuckian

Medbh McGuckian
SHELMALIER

THE CURRACH REQUIRES
NO HARBOURS

Medbh McGuckian

Medbh
McGuckian
The
Unfixed
Horizon
NEW SELECTED POEMS

THE FLOWER
MASTER
AND OTHER POEMS
Medbh McGuckian

A Poet's Life

My father's people were County Antrim farmers but as the eldest he was educated to third level as a primary teacher, as were several of his aunts and sisters. There were books in the home and we also walked to various libraries to borrow mostly British fiction like *Five Children and It*. My mother had a deep love of poetry, mainly Victorian Tennysonian verse and Omar Khayyam. Her father had read Dickens aloud in their dark tenement house. The poet my father admired was Robert Burns and he also taught rebel songs and poems of action to the boys at school, calling me 'The Wreck of the Hesperus' because my hair was unruly long before I knew what those classical terms meant.

So in the 1950s I wrote endless compositions in a neat backhand they were always getting me to turn italic. They were as far away from real life as possible. I was a boarder at Malory Towers with my very own dressing gown (plaid), slippers and a tuck box for midnight feasts. I had a puppy called Shep whose adventures filled several exercise books which the principal appropriated to impress the inspector. I went to elocution lessons and entered competitions in the imposing Assembly Rooms downtown. I wore a limp hand-me-down midnight blue velvet dress with smocking on the bosom and a creased hem. My poem illustrated the long vowel 'A' in a very upper-class-English accent which was far from what I ever heard except on radio or television.

Past barges and wharves
Past harbours and cars
The stars go darting by
Till after dark their sparkling lights
Startle the starry sky.

Needless to say I did not win but I was highly commended and found it all fascinating, although we were concentrating on sound rather than meaning.

In the 1960s I began to comprehend the necessity and importance of a muse figure by falling in love, although I was not experienced enough to call it that, with a buxom blond named Angel, who composed poetry herself and edited the annual magazine. She encouraged my efforts till I was writing her a daily poem, or weekly. I came down to earth with a still-resonating bump when only one four-line verse about ducks or swans was chosen for publication. I imagine now that the build up of passion in the majority of the poems was too personal for her but I was still stung enough to shun her on the bus after she left. It was a lesson that remained always.

There were no men in my life save priests and cousins, pop station DJs whose voices were seductive, intellectuals like David Frost, or comedians. Of course, there were nothing but men on the English syllabus. T.S. Eliot, John Keats, Wordsworth, Gerard Manley Hopkins, Wilfrid Owen. Austen and the Brontës featured, but as novelists, not as poets. After several months' study a rather forward pupil put forward the query that we should perhaps be taking account of the sexuality of Owen, only to be categorically assured, with some iciness, that this was an irrelevant issue.

I attended my first poetry reading in St Malachy's College where we were beginning to get to know some boys. I was the only female present, except for tea makers. I could not follow any of the discussion and stood out

awkwardly in my emerald green military coat. In the 1970s the whole scene became militarised, while the literature course at Queen's was even more colonial, apart from Joyce and Yeats. Seamus Heaney introduced us to Kavanagh and McNeice, but the only women mentioned were the Americans Emily Dickinson and Sylvia Plath, both highly eccentric, while the Russians Akhmatova and Tsvetaeva were only heard of in graduate school.

All of these women were portrayed as weird or suicidal, but an American poet called Tess Gallagher began to read and offer advice on my budding, halting early attempts at poems. At the end of the 1970s I mustered courage to enter the British National Poetry Competition in its second year, and won it. I had figured out from the previous winners that the judges preferred dramatic monologues of under forty lines, so I sent in three under an English pseudonym. They were not recognisably Irish but very definitely by a woman. At this stage I was deluged with offers of publication, so it was a heady time.

In the 1990s I switched from a British to an Irish publisher, mostly because my work was accused of being cryptic, odd, indecipherable, precisely as were the prominent women I was being influenced by. I became aware of the other women of my generation – Eavan Boland, Eiléan Ní Chuilleanáin, Nuala Ní Dhomhnaill – like them, jostling international readings with being a mother (of four in my case) and a part-time teacher.

There was a ferment of literary activity in the North corresponding to the increase in political instability. Joan Newmann was the only woman poet to have a Festival pamphlet published in the 1960s, and subsequently she started her own poetry press, Summer Palace Press, which has had a long and very successful run. I worked for ten years teaching English in a school, then managed to become a writer in residence at different universities,

which was really ideal creatively and financially. Once I became a lecturer in poetry I found my own work suffered because of the amount of teaching each student needed, plus all the meetings and marking of papers and number of hours spent on computers. One's own poetry was half-hearted, less than fully committed; there was pressure always to keep publishing whether you believed in what you were producing or not. Poetry has been and still is turning into a consumer society post-industrial production line where winning prizes is all that seems to matter.

Although I have several books now dedicated to scholarly analysis of my work, reviews tend to be not so plentiful, perhaps because online magazines have eclipsed the role of the literary magazine. Things have naturally changed a lot for me. I used to earn a lot from teaching and poetry awards, from travelling to festivals abroad. Now I am mostly sedentary and depend on pensions. But I am still writing for the sheer and absolute pleasure of it. Like my grand-daughter, not yet two, who prefers scribbling with real biros rather than crayons, chalk or paint, digging, as Seamus Heaney would call it. I have been very well served by Gallery Press, and more recently have brought out a collection with the feminist press Arlen House, which was launched and toured together with three other highly-talented women poets.

I just read some poetry essays by Tony Harrison, for example, where no woman poet is mentioned, and women themselves only mentioned as muse or pornographically, which seems wrong to me. Are we any further than Mrs. Jane Carlyle's friend, the novelist Geraldine Jewsbury, mid nineteenth century, assuring Jane they were not failures:

> We are indications of a development of womanhood which is not yet recognized. It has so far no ready made channels to run in. There are women to come after us who will approach nearer to the fullness of the measure of the stature of women's nature.

She was the third of six children, as Maeve McCaughan, to Hugh and Margaret McCaughan in North Belfast in 1950. Her father was a school headmaster and her mother an influential art and music enthusiast. She was educated at Holy Family Primary School and Dominican College, Fortwilliam and earned a Bachelor of Arts degree in 1972 and a Master of Arts degree in 1974 from Queen's University, Belfast.

Maeve McCaughan adopted the Irish spelling of her name, Medbh, when her university teacher, Seamus Heaney, wrote her name that way when signing books for her. She married a teacher and poet, John McGuckian, in 1977. She has worked as a teacher in her native Belfast at St Patrick's College, Knock and an editor and is a former writer in residence at Queen's University, Belfast (1985–1988). She spent part of a term appointed as visiting poet and instructor in creative writing at the University of California, Berkeley (1991).

BIBLIOGRAPHY

Single Ladies: Sixteen Poems (Interim Press, 1980)

Portrait of Joanna (Belfast, Ulsterman, 1980)

Trio Poetry (Belfast, Blackstaff Press, 1981), with Damian Gorman and Douglas Marshall

The Flower Master (Oxford University Press, 1982), reprinted as *The Flower Master and Other Poems* (Oldcastle, Gallery Press, 1993)

Venus and the Rain (Oxford University Press, 1984, reprinted Gallery Press, 1994)

The Big Striped Golfing Umbrella: Poems by Young People from Northern Ireland, editor (Belfast, Arts Council of Northern Ireland, 1985)

On Ballycastle Beach (Oxford University Press, 1988/Wake Forest University Press, 1988; reprinted, Gallery Press, 1995)

Two Women, Two Shores (Baltimore, New Poets/Salmon Publishing, 1989), with Nuala Archer

Marconi's Cottage (Oldcastle, Gallery Press, 1991)
Captain Lavender (Oldcastle, Gallery Press, 1994)
Selected Poems, 1978–1994 (Oldcastle, Gallery Press, 1997)
Shelmalier (Oldcastle, Gallery Press, 1998)
*Horsepower Pass By! A Study of the Car in the Poetry of Seamus
Heaney* (University of Ulster, Coleraine, Cranagh Press,
1999)
Drawing Ballerinas (Oldcastle, Gallery Press, 2001)
The Face of the Earth (Oldcastle, Gallery Press, 2002)
Had I A Thousand Lives (Oldcastle, Gallery Press, 2003)
The Book of the Angel (Oldcastle, Gallery Press, 2004)
The Currach Requires No Harbours (Oldcastle, Gallery Press,
2006)
My Love Has Fared Inland (Oldcastle, Gallery Press, 2008)
The High Caul Cap (Oldcastle, Gallery Press, 2012)
The Unfixed Horizon: New Selected Poems, edited by Borbála
Faragó and Michaela Schrage-Frueh (Wake Forest
University Press, 2015)
Blaris Moor (Oldcastle, Gallery Press, 2015)
Love, the Magician (Dublin, Arlen House, 2018)
Marine Cloud Brightening (Oldcastle, Gallery Press, 2019)

CRITICAL APPRAISAL

Jolanta Burgoyne-Johnson, *Bleeding the Boundaries: The Poetry
of Medbh McGuckian* (Coleraine, Cranagh Press, 1999)
Shane Alcobia-Murphy and Richard Kirkland (eds), *The
Poetry of Medbh McGuckian* (Cork University Press, 2010)
Shane Alcobia-Murphy, *Medbh McGuckian: The Poetics of
Exemplarity* (Aberdeen, AHRC Centre for Irish and Scottish
Studies, 2012)
Borbála Faragó, *Medbh McGuckian* (Cork University Press,
2014)
Leontia Flynn, *Reading Medbh McGuckian* (Dublin, Irish
Academic Press, 2014)
Maureen E. Ruprecht Fadem, *Silence and Articulacy in the
Poetry of Medbh McGuckian* (New York, Rowman &
Littlefield, 2020)

Mary Dorcey

Moving into the Space Cleared by Our Mothers

Mary Dorcey

A NOISE FROM THE WOODSHED

Mary Dorcey

To Air the Soul, Throw All the Windows Wide

New & Selected Poems
Mary Dorcey

salmonpoetry

Biography of Desire
Mary Dorcey

POOLBEG

Like Joy In Season, Like Sorrow
MARY DORCEY

Kindling
Kindling
Kindling
Kindling Kindling
Kindling
Kindling
Kindling
Kindling

Poems by Mary Dorcey

Perhaps the Heart is Constant After All
MARY DORCEY

MARY DORCEY
The River That Carries Me

SALMON

IN AND OUT OF TIME
lesbian feminist fiction

edited by Patricia Duncker

Why?

Why Did You Become a Writer?

As soon as I learned to read I began to write. I can't remember a time when I was not fascinated and delighted by language. As a small child I was forever making up stories, songs and poems and exasperating any adult who would listen by reciting them.

I was enthralled by my mother's gift for storytelling from life. I followed her about upstairs and down while she prepared meals and did housework, asking for yet one more story from the trove of her childhood. I loved my father's dramatic talent for reading aloud. Every evening when we had finished tea, he would gather the three youngest onto his lap and begin to read to us, a favourite book for each. Like a magic lantern casting a light, his melodious voice filled the room and the everyday world was transformed. I perched precariously on his narrow thigh, held onto the lapel of his jacket and listened while my mother hovered by the door, tray in hand (I noted even then that she had the hard job) straining to catch a few crumbs that fell from the adventure-filled tales my father read to us from the classics of English and American literature – Dickens, Stevenson, Mark Twain, *Moby Dick*, Jules Verne, *et al*, and the one woman I remember from that period, E. Nesbit. I listened enchanted and never wanted the evening to end. At last my mother would carry

me to bed, and locked up alone in the dark with the raucous wind of the Irish sea rattling the window, I would find myself fiercely awake, my imagination on fire with the images stirred by these great books, the daring, the heroism, the romance, the beauty, the tragedies.

The protagonists of these nineteenth-century books inspired in me a lust for adventure and a passion for justice. What chance had I of avoiding this when they were drawn from a cast of explorers and pirates, warriors and highway men, thieves, and heroes: Jack Hawkins, Billy the Kid, D'artagnan, The Artful Dodger, Will Scarlett, Lancelot du Lac, The Man in the Iron Mask, Tom Sawyer?

But my growing pleasure and fascination with words existed long before I formed any political or social awareness. This idiosyncratic need to write seemed to spring from an impulse whose origin was hidden from me. But it was something more akin to spiritual sensibility than any concern for career or achievement. I experienced it as a need to make sense of existence through words and imagery. I wanted to match sight and sound, rhyme and rhythm to the mysteries of the natural world, and the conflicts of human personality to the incomparable sorcery of word and sentence.

My mother was widowed when I was seven and the eldest of us just sixteen. This sorrow marked us all. But we had many compensations. The greatest was my mother's strength and love of life and the next most significant blessing was that we lived surrounded by natural beauty in a house so close to the sea I could almost have jumped into it from my bedroom window. A house where every room had bookshelves. A mother who encouraged imagination and learning.

I grew up in the 1950s and 1960s, a period of profound social conservatism, silence, repression, superstition, guilt and fear. A Catholic State for a Catholic people. Long dark winters, poor food, drab clothes, all hospitals and schools

run by priests and nuns, censorship of books and films. An almost entirely homogenous society where the only differences were those of class. The contraceptive pill was unspeakable, condoms had to procured in Belfast, abortion was unheard of, except in one English film that no one was allowed to see.

But despite vicious bigotry and destructive repression I had a childhood and adolescence filled with adventure, affection, variety and freedom. All the local children spent more of their life in the water than out of it. We swam and rowed on the open sea from March to October. It was an open, welcoming household. Being the youngest of five, my elder brothers and sister brought all their friends to visit so I had the benefit of constant stimulation, new ideas and personalities.

I went to a convent school along with my sister until I was fifteen. I was then transferred to the only non-denominational school in Ireland – and in that thrilling phrase, also mixed sex! – because the nuns had accused me of seditious ideas and practices and my mother, though herself a devout Catholic, thought I might fare better in a secular system. She was wrong. I missed the tribal battles, the 'cops and robbers' atmosphere of living with two hundred rebel girls and twenty restraining nuns under the same roof. But that's another story.

At seventeen I skipped the Leaving Cert and studied for A levels, achieving an A in English and History. I started a three year Arts degree with the Open University. As a teenager I had read my way through the great nineteenth-century classics of French, English and Russian literature. I encountered the great writing of the first half of twentieth-century literature, much of which was then banned by the Irish 'Free State' and had to be smuggled through customs in suitcases from England. On completion I went to live with my French boyfriend in Paris where I studied at Paris Diderot University.

I must have been sixteen before I noticed whether the books I was reading were written by men or women. Gradually I began to be curious about their authors and to want to know what nationality they were, what class they came from, what kind of education they had had and so forth. It was only then that I stumbled upon the extraordinary fact that ninety percent of the books I was reading were written by men. I was familiar, needless to say, with the great women of the past: Austen, the Brontes and Eliot and the early twentieth century Colette, Woolf, Mansfield, but the post war period apart from a handful of English authors, Drabble and Murdoch, seemed to have returned women to kinder and kitchen.

It was not until my last year at school that I discovered first of all Edna O'Brien and Elizabeth Bowen, and a little later, the novels of Kate O'Brien, republished by Arlen House, that I was able to read my own countrywomen. The student politics of the 1960s and early 1970s in the UK and the US laid the foundations for my politics. I learned about civil rights, the women's liberation movement, the black power movement and went on anti-war marches. In Paris I became involved in excited discussions about left wing and anarchist groups and joined the almost weekly protest 'Manifestations.' I came home determined to find people who shared this politics: activists and free thinkers. I founded with five others the first gay rights group in Ireland, the Sexual Liberations Movement, and after a few visits to the early meetings of the Irish Women's Liberation Movement, I founded with others, Irishwomen United, the feminist campaigning and theoretical movement. We wrote our Charter with others listing our seven demands and took part every week for four years in its discussion/planning meetings and demos. There were just about two hundred of us in all; fiery, passionate, eloquent,

risk-takers, journalists, students, trade union activists, some artists.

Publication

My first book, *Kindling*, a collection of poetry, was published in 1982 by Onlywomen Press in London. The editor, an American living in London, had read poetry of mine in journals here and there and wrote to ask if I would allow her to bring out a book. I said yes and went to live in London for two years. When the book was published in Britain I gave readings from it around the country. The audiences were placid and appreciative. But when I came home to Dublin one or two mentions in the press alerted the society to scandal. No one had ever seen the word lesbian on the cover of a book of any kind before this, or poems that celebrated love between women. I was pleased by a thoughtful and encouraging review in the *Sunday Tribune* by Emily O'Reilly, but other than that most references concerned themselves only with the shock of the aberrant sexuality.

Because the social reaction was so intense and impacted so badly on my mother who was living alone in the wilds of the suburbs, I put off publishing the next book until seven years later. From the comparative safety of Kerry where everyone knew me and my partner Carole (a French chef) and patronised the restaurant we opened together where the local girls found work each summer, and writing in the winters, through the normality and welcome of everyday life there, I developed the resilience to publish again.

And so I was in my late thirties when my collection of short stories, *A Noise from the Woodshed*, was published in Britain in 1989. It was widely reviewed in England. In Ireland it was written about in hushed tones that skirted around the issue of the author's sexual preference. The

only openly homophobic review, written in a disparaging tone by a woman journalist, was published in *The Irish Times* headlined 'Dark Nights of Underground Love'. But a week later to my immense surprise and joy, *A Noise from the Woodshed* was awarded the Rooney Prize for Literature and suddenly everyone wanted to talk to me. It was reprinted three times and is still selling today and has been studied internationally since the year after it was published.

Salmon Poetry then asked to see my poetry and published my second collection, *Moving into the Space Cleared by Our Mothers*. After this I was accepted in Ireland as an 'Irish writer' and allowed into the fold. I am indebted to the foresight and courage of Jessie Lendennie who did not care a fig about which kind of sexuality a poet endorsed and who published each of my poetry books when every other male dominated Irish press was closed to me.

Critical Reception

I was fortunate from the start to be read widely outside Ireland. Over the next ten years I lived in England, France and America. My then two books of poetry and my short story collection were embraced almost immediately in academia and researched and taught especially in America and Canada and England. During the 1980s, 1990s and early twenty-first century I was, like so many Irish writers, continually on the move between countries and cities, bookshops and universities and conference halls giving readings, keynote speeches and workshops. I lived in Kerry for ten years and moved back to Dublin in the middle 1990s. Very soon after that I became a writer in residence at the Centre for Gender and Women's Studies at Trinity College. Later on I taught for five years in the UCD Women's Studies department leading outreach courses.

Income

I was also fortunate to be awarded an Arts Council grant for each book I published. Even more fortunate many years later, when close to sixty, I was honoured to be elected to Aosdána. Apart from my two books of fiction which sold extremely well, as can be imagined, I made little enough directly from my poetry books. My income derived almost entirely from the ancillary activities of these aforementioned readings and lecture tours, and from the sale of books at public events. Nine books later, and with a tenth on the way, I do not live in material luxury. But as my mother said to me many years ago, she considered a well-stocked mind was the best resource you could have in life and an enquiring mind was the greatest gift. I think I can say by that standard I have kept my head above water, and body and soul together.

Finding Our Voices

In the dark years of sexual repression, when books were banned and ideas repressed, when guilt about the body and all pleasure set the only recognised moral standard, 90% of women were official 'home makers'. I knew only one woman doctor, one woman vet and one woman solicitor until I was in my thirties. So it could be no surprise that a professional woman writer was something almost unheard of. There were, of course, a handful of Protestant writers from the old ascendancy, Somerville and Ross, Elizabeth Bowen, but being considered semi-pagan and known to be independently wealthy they were discounted. So to live in Ireland, to be raised as a Catholic, to be a female and to write and seek to publish books before the 1980s, was to be seen as eccentric if not actually an unfortunate, half-formed thing. This has been true in many other countries in the past but as with so much else in Ireland – misogynistic, church ridden, conservative

homophobic – until recently only a handful of women survived as writers and poets or visual artists.

As almost every writer who is also a woman will tell, our gender still works against us in many ways, blatant or covert. When I started out only a handful of books by women would be reviewed in our journals and newspapers in any one year. It is still more difficult for a woman writer to be published, more difficult to be reviewed. More difficult to get a well-placed review (above the fold), more difficult to be invited to take part in panel discussions on radio and TV. All these things are even more difficult if the central character in a novel written by a woman is female. Literary novels written by women about women are the hardest to place, to be fairly reviewed or to win prizes.

I started to write to break through this deliberate silencing. In the early years as a writer my chief interest was in sexual politics and the manner in which it shaped and misshaped women's lives. Perhaps my journey as a writer might best be defined as a desire to explore otherness: the ways in which societies construct castes of 'insiders' and 'outsiders'. Many accounts of 'otherness', whether of gender, sexual orientation, race or age are corralled, I believe, in a kind of quarantine, separated from 'normal people.' In my fiction and poetry, whether concerned with erotic/romantic same-sex relations, political oppression or the experience of ageing – this is especially true in my most recent work – I deliberately place my so-called 'out-siders' where they belong – within the mainstream of human experience. Both in poetry and prose I like to write from the subjective centre of each character so that the reader is drawn into the heart of their experience and jolted from the safe seat of detachment. I continue to write for these same reasons I began because it is at its best, the most enjoyable, satisfying, challenging process I know.

In Ireland the entire literary scene has changed dramatically. Until the 1980s it was rare to find more than one novel by a woman in an Irish bookshop. Now it's impossible to count them. There are so many new voices; an orchestra of rich and varied themes. A revolution has taken place – social, educational, cultural and certainly literary and artistic. An ever-increasing number of young women especially want to write. An increasing number are taking degrees in creative writing, attending workshops and writers' residencies. More and more are being published in small, great literary journals and also many are making a name for the first time online. More and more women are winning the major prizes.

If literature can make it into the next half of this century, I hope women will finally draw parallel to men as far as exposure and opportunity goes. But the world will change no doubt beyond our present recognition, and perhaps literature will have no part in it. Is the making of literature and the habit of reading it likely to survive in this ever-accelerating and fragmentary world controlled by social media? Will the new owners of our globe, Facebook, Google, Amazon and goodness knows who else in the near future, have any need for literature? Perhaps humans will always crave poetry and stories? Perhaps it really is embedded so deeply in the DNA of our being – we weirdly emotional, sensual, reflective animals, that it will survive as long as we do on earth. Or maybe not. But at least for the next twenty years I think we can assume people will still want to read and write. Women will be writing those books in ever greater numbers. And perhaps, before literature dies, there will come a day when no one notices an author's gender or race but says only 'I have just read an astonishing, unforgettable book by a fantastic new human writer.'

I plan to live to see this.

MARY DORCEY

Mary Dorcey is a critically-acclaimed fiction writer and poet. Her work is taught and researched in universities from North America to Europe, China and Africa. She won the Rooney Prize for Irish Literature in 1990 for her short fiction collection, *A Noise from the Woodshed*. Her novel, *Biography of Desire,* has been both a bestseller, having been reprinted three times, and achieved critical acclaim. She has published nine books, three of fiction and six of poetry. She was the first woman in Irish history to campaign publicly for LGBT rights and the first to address the subject openly in literature. A lifelong feminist and gay rights activist, she was a founder member of Irishwomen United in 1975 and Women for Radical Change in 1973. She is a Research Associate at Trinity College Dublin where she led seminars on women's literature and led creative writing workshops for many years. She is currently at work on a new novel. In 2010 Mary was elected to the Irish Academy of writers and artists, Aosdána.

BIBLIOGRAPHY

Kindling (London, Onlywomen Press, 1982)

A Noise from the Woodshed: Short Stories (Onlywomen, 1989)

Scarlett O'Hara, novella in *In and Out of Time: Lesbian Feminist Fiction* (Onlywomen Press, 1990)

Moving into the Space Cleared by Our Mothers (Salmon Poetry, 1991/1994/1995)

The River That Carries Me (Salmon Poetry, 1995)

Biography of Desire (Dublin, Poolbeg Press, 1997)

*Like Joy in Season, Like Sorrow (*Salmon Poetry, 2001*)*

Perhaps the Heart is Constant After All (Salmon Poetry, 2012)

To Air the Soul, Throw All the Windows Wide: New and Selected Poetry (Salmon Poetry, 2016)

Celia de Fréine

BECOMING THE WRITER I AM

Nothing in my childhood suggested I might become a writer. No single event or set of circumstances encouraged it. I was a child who had little thought for the future. I expected that one day I would grow up and become a shop assistant or hairdresser, occupations which my aunties enjoyed and which paid good money. Three of my grandparents had been born in Dublin, the fourth in Liverpool. They had settled in Donaghadee in Northern Ireland where they raised their families. My parents moved from Donaghadee to Dublin when I was a babe-in-arms but they never really put down roots here. Their sense of displacement was reflected in their lack of awareness as to how institutions, schools in particular, functioned. A fear and distrust of authority pervaded their lives and rubbed off on their children, especially their eldest, me.

Our local Carnegie library in Rathmines was one such institution and, though I managed to become a member when I was about eight years old, my membership was short-lived. A classmate who lived in the family quarters of the local army barracks followed me in one day. I had explained to her that inside the forbidding structure of the library were shelves filled with magic – books which could be borrowed for up to two weeks at a time. My companion was as excited as I had been on my first day. The librarian took one look at her and gave her an on-the-spot spelling

test. My classmate failed the test and was run out of the building. I left with her.

During the years that followed I succeeded in laying hands on reading material other than books. This included weekly comics and daily newspapers. An auntie would send me an annual at Christmas and sometimes the money to invest in a classic such as *Treasure Island* or *Ivanhoe*. However, in spite of limited access to books, my childhood was filled with stories. These unfolded on screen and on stage. The nearest cinema was the Stella, reputed to be the largest cinema in the country. Hordes of children, including myself, were dispatched to the weekend matinées. Much of the regular fare consisted of westerns. My younger self didn't like how women featured in these heroic tales. They either flounced about the saloon dressed in red feathers and lace or cowered by their wagon until scalped by a whooping 'Indian'. The Scotland Yard thriller was more satisfying: after two hours of investigation, the detectives would discover from whom the dismembered limb washed up on the banks of the Thames had been severed. Films based on *Bible* stories by Cecil B. DeMille and others featured regularly also.

Every July I was collected by an auntie and brought to my Granny's in Donaghadee where another world of excitement opened up for me. As well as the carnival and circus, which visited during the holiday season, I had the Pierrots to look forward to. Troupes of Pierrots had become popular during the Victorian era and would perform at the seaside during the summer months. Pavilions, such as the one in Brighton, were built to cater for their performances. In Donaghadee the Pierrots took up residence in a hut, not much bigger than a garden shed, on the pier. Two shows were performed daily and punters could sit on the steps of the pier wall for three pence or hire a fold-up chair for sixpence. It was advisable to bring a rug to keep warm.

The Pierrots took their cue from vaudeville and each show was made up of song-and-dance routines and sketches. Four performers usually took part: one banged out the tunes on a rickety piano while the others sang and danced and performed sketches. Each show included a talent competition. I entered once and came second for dancing a slip jig. What I remember most about these peripatetic performers is not the content of any particular show, but the way in which they made up much of their dialogue as they went along. Nothing fazed them: their clever repartee rebutted off-the-cuff remarks from the audience. It was from watching their performances that I developed my love of theatre and my conviction that anything was possible on stage.

One summer in Donaghadee an event occurred which helped me to develop a skill which would lead to my becoming involved in theatre. In 1959 Ruth Handler invented the Barbie doll and by the following year a knock-off version had made its way across the Atlantic. An auntie bought me one. For some reason I felt sorry for the strangely-shaped creature and, as she had only one outfit, decided to make more clothes for her. I bought a quarter of a yard of fabric in the local drapery and set to work on the front stoop of my Granny's house. All of the girls I used to play with during the summer were Protestant. They would sometimes ask if I were a Roman Catholic. I'd reply: 'No, I'm from Dublin'. The mother of one of these girls was a dressmaker and when she heard about me and my doll, she gave me a bag of leftover scraps. I discovered later that she was a Catholic who had raised her family as Protestant. It seems that when she visited the 'mission' priest one year to seek absolution he declared that she would be condemned to suffer the everlasting pain of hellfire. Her kind deed enabled me to cut and fashion a wardrobe for my knock-off doll such as none of my family, nor anyone I knew, would have occasion to wear. I

remember a purple satin strapless ballgown with a flowing train and an exquisite pink crêpe de chine negligée. Neighbours would pass by as I worked with my needle and thimble, muttering: 'It'll be well for the man that gets you.'

I had learned to sew in St Louis National School in Rathmines. When I was twelve I went into seventh class which prepared some children for scholarship exams and allowed others to mark time until they were old enough to start work in the local factory. I wasn't sure which stream I belonged to. Sewing was one of the subjects for the Dublin Corporation scholarship. I passed it and the other subjects with flying colours. My parents seemed surprised when I won this and two other scholarships. I ended up accepting one to the St Louis nuns' mother house in Monaghan.

While living in the suburbs and raising a family during the seventies and early eighties, I often asked myself whether I had learned anything while attending this school to prepare myself for life as a mother and homemaker. I knew nothing of how to raise children, run a household, balance accounts, plant a garden, wallpaper a room or change a plug. But I did know how to make clothes for the children and how to cut their hair. When I began to write in the mid-eighties, I realised I had learnt the vocabulary and grammatical ins-and-outs of four languages – Irish, English, French and Latin – and familiarised myself with texts in all four. I loved the poetry prescribed for the exams but had little interest in the prose. Though plays by Shakespeare were included in the curriculum, they were never performed. Dramatic productions staged in the school tended to be musicals – and I didn't sing. It was while in Monaghan that I developed an interest in the Irish language. It was an all-Irish school.

I continued to design and make clothes during my teens. My parents bought an electric sewing machine on hire

purchase so that I could tackle larger adult-size garments for my family. I also knitted Aran jumpers for all my relations. No one recognised my ability as anything out of the ordinary. There was little career guidance in school and when I broached the subject of fashion design with any of the nuns I was dissuaded from making my way along this career path: sewing was for girls who weren't smart. Smart girls did Latin and Science and went to college and became teachers. A similar attitude prevailed when it came to art: anyone could draw a picture and colour it in and scrape a pass in the Leaving Certificate exam.

My involvement in theatre began in 1974. I had drifted into the Dublin Shakespeare Society through some friends and designed and made the costumes for a production of Stoppard's *Rosencrantz and Guildenstern are Dead*. The title roles were played by Myles Dungan and Gabriel Byrne respectively. During the ten years that followed I designed and made costumes for most of the Society's productions. It was a convenient way of socialising as most rehearsals and performances happened in the evening and at weekends when the children could spend quality time with their father. By degrees I began to act in and direct plays, which led me to work on scripts. The first production I directed was Brian Merriman's *Cúirt an Mheán Oíche* which I translated and dramatised. This was published by Arlen House in 2012 as *Brian Merriman's The Midnight Court* and in 2017 as *Cúirt an Mheán Oíche le Brian Merriman* by LeabhairCOMHAR. After adapting some of the bard's plays I began to write my own and have them produced in fringe venues by fringe companies.

In 1985 I moved with my family from the suburbs and settled in Ranelagh. Once again I was walking the streets of my childhood and early adulthood. As a young adult I had joined the local branch of Conradh na Gaeilge and became a language activist. I now began to write poetry in

Irish. The following year I organised a series of workshops facilitated by Seán Mac Mathúna and Alan Titley, which were funded by the Arts Council. These were probably one of the first ever, if not the very first, Irish language creative writing workshops in the country. I kept on writing and enjoyed every minute of it.

Then I made a mistake: I decided I'd try to have my work published. I submitted some poems to an Irish language journal and entered others for an Oireachtas competition. Both submissions were unsuccessful. Both rejection letters arrived on the same day. The male editor of the journal pointed out that there were grammatical errors in my work which would have to be addressed if I wanted to be published in his journal. The male Oireachtas judge analysed my poems with care. One concerned the death of Ann Lovett, another involved bringing a sick child to hospital. While these were noble topics, he concluded, they were not suited to poetry. Thus ended my efforts to become a *file Gaeilge* at this time: what I had to say couldn't be said in poetry and even if it could, I didn't have the grammatical skills in which to convey it. I believed these two men: they were in positions of power; they knew what they were talking about.

Shortly afterwards I was invited to join the WEB writing group which had been formed some years earlier by women writers who had taken part in a workshop organised by Arlen House and facilitated by Eavan Boland. Everyone in the group seemed to be having a book published and winning awards. The emphasis was on prose and poetry. As I believed I couldn't write poetry I tried my hand at prose, but met with little success. I continued to write plays. It seemed, though, that plays counted for naught and that one became a writer only when one's name appeared on the cover of a book.

Around this time I began to work part-time for the Irish Writers Union. The union had been founded by my

husband, Jack Harte, who went on to found the Irish Writers Centre. I attended the inaugural meeting of the IWU in Buswell's Hotel in 1986 merely to support him, and watched as one man proposed another for different roles on the committee. I raised my hand. Was this going to be another boys' club or would there be a place in it for women? Established writers Carolyn Swift and Eithne Strong were proposed. They declined but, casting an eye in my direction, asked would I allow my name to go forward. My bluff had been called. That evening I became the only woman on the first committee of the IWU. In the years that followed I continued to be elected to subsequent committees.

At first the administrative work of the IWU involved taking minutes at meetings and sending welcome packs to new members. But as the organisation grew, so too did its administrative needs. In 1990 I was employed by the IWU for two days a week and paid a stipend which covered my expenses and included a small fee. The additional work involved attending and taking minutes at the weekly officers' meetings; attending and taking minutes in due course at the Irish Writers Centre board meetings. I was responsible for the paperwork associated with laying the groundwork for an agency to handle copyright licensing (now the Irish Copyright Licensing Association), and with establishing an international exchange programme for writers, not to mention the campaign against censorship and the administration involved in disputes between writers and publishers. A monthly newsletter had to be issued also. All within two working days. In June 1991 after eighteen months, in response to tensions, I resigned.

By this time my children were growing fast as was the cost of educating them. I needed a real job with a real salary and became employed by the County Dublin VEC as a teacher of literacy, numeracy and creative writing in a centre for early school leavers, all of whom were members

of the Travelling Community. I stayed in this job for seven years, the first year of which was spent studying in the evening for a diploma in adult education. When the academic year 1991–2 ended, I went on a family holiday to Galway, sat in the corner of the kitchen of a rented apartment and began to write poetry. In English. The poems kept coming. It was as though during the previous seven years they had been forming an orderly queue in my head and were now thronging to make their way into the world. Now that I was teaching I no longer had time to write plays. I wrote poems, not least because they fitted onto the backs of envelopes and grocery lists. Two years later I won the Patrick Kavanagh Award. At the time I had perhaps only two or three poems published in journals.

Being the recipient of this major accolade did not however guarantee publication of either a manuscript or of poems in individual journals. At the time I felt that the poetry scene in Ireland was not only dominated by men, but that nature formed the theme of many poems which were, naturally, celebrated within a rural setting. There seemed little place in the canon for my poems which had an urban setting and which were surreal in style. The rejection continued. I continued to write poems. During the summer of 1995 I entered the London-based Blue Nose Poetry Competition. My poems were highly commended. The Arts Council awarded me an 'arts flight' so that I could travel to London, pick up my award and read my work in an Indian restaurant off the Tottenham Court Road. As I queued in Dublin Airport to board my flight, An Taoiseach John Bruton waited in the VIP lounge to welcome home Seamus Heaney who had just won the Nobel Prize for Literature.

In London I met my friend, Bríd Ní Mhaoilmhíchíl, who welcomed me with a cry of 'Yourself and Heaney in the same week!' Bríd brought me over to the poetry library in the Southbank Centre where I could see displayed on

stands all the literary journals published in the UK. I was able to study them and see which published poems similar in style and content to my own. On my return to Dublin I began to send out and place poems in UK journals. I felt at the time that, unlike here, because English society was multicultural, there was recognition of and place for poems that were varied and represented the country's population. Through perseverance, I eventually began to place work in Irish journals. During my apprenticeship I kept a record of all submissions. For example, during the period from 29 April 1997 to 13 December 1997, I submitted poems to twelve journals, including *HU, Books Ireland, Poetry Ireland Review, Comhar* and *Feasta*. Eleven of the journals in question accepted and published my work.

At this time I'd often begin a poem in Irish but then change to English. As my previous efforts had been stonewalled I saw little point in completing a poem in Irish. However, in moving between Irish and English I now began to use the process of translation as an editing tool. Gradually I grew bold and began to complete poems in Irish: I submitted one such poem to Comórtas Filíochta Dhún Laoghaire Rath an Dúin and won the award. Success in other competitions followed. Still, the concept of the book eluded me. However, in 1999 I entered the competition, Gradam Litríochta Chló Iar-Chonnachta, funded by Údarás na Gaeltachta. Poetry was one of the genres eligible that year and my manuscript *Faoi Chabáistí is Ríonacha* was awarded the runner-up prize and published by Cló Iar-Chonnachta in 2001. The year is significant in that it means in some quarters I'm not regarded as a twentieth century poet. Often the criteria for being included in a poetry anthology is decided by the date of one's first collection or one's date of birth. I've been lucky to have been included in anthologies where the editor asks only for work which he or she likes. These are the editors who tend to come in for criticism when certain

poets are excluded: they have made their choice on artistic merit rather than allowing the constraints of a particular time frame dictate it to them.

My second collection of poetry, *Fiacha Fola,* appeared from Cló Iar-Chonnachta in 2004. This time I won Gradam Litríochta Chló Iar-Chonnachta. It was the final year of the competition and welcomed work in all genres. In addition to submitting my poetry manuscript, I submitted two plays. My three entries fetched up in the top six and *Fiacha Fola* won the award outright, thanks to judge Máire Mhac an tSaoi. In her foreword Máire writes of one of the poems:

> I don't think anything has yet been composed in modern Irish
> as powerful as those lines. That little poem is a faultless unit
> that rises to the height of perfection from the depths of terror.
> For me, the whole revival movement has been worth it so that
> its like could be provided (*translated*).

Fiacha Fola concerns the Anti-D scandal in which 1600 Irish women, including me, contracted Hepatitis C through contaminated Anti-D immunoglobulin. It is the only book in any language written on this scandal. As well as winning Gradam Litríochta Chló Iar-Chonnachta, *Fiacha Fola* received a commission and a grant from Bord na Leabhar Gaeilge; three of the poems in it also won individual awards in various competitions. Ten years later, in 2014, Scotus Press published *Blood Debts*, its translation into English. Reviews for the book in both languages were positive. Some critics described it as angry. No kidding.

During my years teaching I studied for an MA in Creative Writing which was awarded by Lancaster University. As with my BA from UCD, both these courses were slotted in around other activities and, though I sat the relevant exams and submitted the appropriate theses, I never experienced the luxury of college life. In 1998 I left my teaching job as I'd begun writing *Ros na Rún,* the TG4 soap opera. Éilís Ní Dhuibhne, who was on the team at the time, had put my name forward. My first episode was

shortlisted for the Pan Celtic Film and Television Festival (1998). I wrote one other significant episode. In 2016, when TG4 was celebrating twenty years in existence, various people were interviewed about its high points and the impact it had made on viewers. Among them was one of the actors from *Ros na Rún* who had participated in Ireland's first onscreen gay kiss. There was no mention of who had written the episode in question. Reader, I was responsible for this landmark in the history of Irish television.

To date I have published nine collections of poetry, two in Irish, three in English and four in both Irish and English. One of the bilingual collections sold out in hardback and is now republished in a new expanded paperback edition, and one in English sold out; the other three in English have done well enough. Reviews have, for the most part, been positive, though they tended to dry up after the first four books. It was as though I were producing too much too often. I rarely submit to literary journals now but give work when it is solicited from me.

Money for poetry is earned through awards, bursaries and advances, rather than from sales. Writing for *Ros na Rún* had paid well, though at the time the rates were lower than those paid to writers of RTÉ1 soaps. However, as the twentieth century drew to a close, after years of working flat out both inside and outside the home, my health deteriorated. The stress of deadlines was something I couldn't cope with and I had to withdraw from the *Ros na Rún* team. Since then I have co-written film scripts which netted no income but two of which picked up awards at the New York International Film Festival (*Marathon*, best script and cinematography, 2009; *Rian : Trace*, best international short, 2010).

I've often read at festivals and in universities in Europe and America and have enjoyed residencies on both continents also. It's worth noting that judges of

competitions who have given me awards, and editors who selected my work for journals and anthologies, have included both men and women. All of my books have been published by publishing houses owned by men.

It's hard not to be disappointed when work is turned down for bursaries or awards, but what causes me most grief is the question of plagiarism. As a former reviewer and sometime writer of academic papers I have a knack for recognising stray lines within a text and noting where different ideas emanate from. Influence is all around us. Georges Polti has identified thirty six dramatic situations. It is the way we approach these situations that makes our work unique. Down the years I have taken part in creative writing workshops and been involved in writing groups. Once, in response to raising the issue of plagiarism at a meeting of one of these groups, some members admitted they wouldn't realise had they inadvertently borrowed from another writer; others had the attitude that what has been published is in the public domain, in itself a huge supermarket through which anyone can wheel their trolley and help themselves to whatever takes their fancy.

In 2013 I became one of the co-founders of Umbrella Theatre Company which was established to present new work in an innovative manner. Since then I've had about a dozen or so plays produced. One of these was a full-length play, *Safe*; another, *Luíse*, was in Irish. The others were short plays produced within a larger show which included work by other writers. Sometimes in my plays I give voice to women whom history has forgotten, such as Elizabeth Fitzgerald (objectified in a sonnet by Henry Howard, Earl of Surrey) or Mary Duffy (killed in the Bachelors Walk Massacre in 1914). *Luíse* was based on the life of Louise Gavan Duffy who, though not quite forgotten, hasn't been given the attention she deserves. Louise, who spent Easter Week 1916 in the kitchen of the GPO and who co-founded Scoil Bhríde, Ireland's first gaelscoil, is the subject of my

biography, *Ceannródaí*, published by *Leabhair*COMHAR in 2018.

There has been much talk about how little work by women playwrights sees the light of day. I agree that, yes, it's hard to have one's work produced. A playwright needs to see her work staged so that she can learn the nuts and bolts of playwriting; when work is continuously rejected, there is little opportunity for development. As a playwright whose work is regularly produced in fringe venues, I find that the greatest challenge faced is in rounding up punters and reviewers to come and support new work. As well as writing for Umbrella, I sometimes co-ordinate the costumes for a show. Though I neither make clothes nor costumes now, I often whisk garments off the bargain rails of charity shops and adapt them to look as though the actors wearing them have stepped out of a Frederic William Burton painting, as in the production 'The Meeting'.

When asked to write this essay I gave some thought to free will and to how decisions made by myself in response to treatment by others have impacted on my development as a writer. I asked myself whether these decisions may have placed unnecessary obstacles in my path, but have come to the conclusion that they worked to my advantage and contributed in their own bizarre way to my becoming the writer I am. Had I not left Rathmines Library in terror of the harridan behind the counter and in solidarity with my classmate, I might not have had to seek out other ways of accessing stories. Had I not resisted writing poems in Irish, I might not have developed a method of moving between Irish and English when composing poetry and honed this system to a useful editing tool. Had I not left my job in the IWU, I might not have ended up teaching some of the most interesting and beautiful people I might ever meet.

These decisions form part of the 'how' I became that

writer. Today, though surrounded by books, I still enjoy reading newspapers. While influences on my work are varied, biblical and Shakespearean references regularly make their way into my poetry. Theatre continues to excite me but I prefer shows in smaller fringe venues to lavish mainstream productions. I am a regular cinemagoer and love watching thrillers on both large and small screen. I often give talks in libraries and am regularly in the manuscript and reading rooms of the National Library of Ireland.

I don't know 'how' I write or where the ability to write comes from. Nor does any writer, I suspect. One thing I can be sure of, though, is why I write. As with every writer, the impetus forms part of that quest for identity, that need to find out who we are. Being the child of parents from Northern Ireland who settled in the Republic of Ireland and granddaughter of grandparents from the south who settled in the north adds an extra dimension to my quest. I am the child who watched as buses and postboxes turned from green to red and from red back to green again as I crossed an invisible line on this small island. I am a writer who tries to make sense of it all.

Celia de Fréine, born in 1948, writes in many genres in both Irish and English. Awards for her poetry include the Patrick Kavanagh Award and Gradam Litríochta Chló Iar-Chonnachta. To date she has published nine collections. Her plays are performed regularly, have won numerous Oireachtas awards, and are studied at second and third level. Her film and television scripts have won awards in Ireland and in the US. *Ceannródaí*, her biography of Louise Gavan Duffy, was shortlisted for the Irish Book Awards (2018) and Gradam Uí Shuilleabháin (2019). It was awarded the ACIS Duais Leabhar Taighde na Bliana by the ACIS in Boston in 2019. celiadefreine.com

BIBLIOGRAPHY

Literacy, Language, Role-play, with Phyl Herbert (Sarsfield, 1991)
Faoi Chabáistí is Ríonacha (Indreabhán, Cló Iar-Chonnachta, 2000)
Fiacha Fola (Indreabhán, Cló Iar-Chonnachta, 2004)
Scarecrows at Newtownards (Dublin, Scotus Press, 2005)
Mná Dána (Galway/Dublin, Arlen House, 2009/2019)
imram : odyssey (Galway/Dublin, Arlen House, 2010/2019)
Aibítir Aoise : Alphabet of an Age (Dublin, Arlen House, 2011)
Desire : Meanmarc (Dublin, Arlen House, 2012)
Plight : Cruachás (Dublin, Arlen House, 2012)
Brian Merriman's The Midnight Court (Dublin, Arlen House, 2012)
cuir amach seo dom : riddle me this (Dublin, Arlen House, 2014)
Blood Debts (Dublin, Scotus Press, 2014)
A lesson in Can't (Dublin, Scotus Press, 2014)
Blúiríní: Sraith Drámaí mar áis 'Drámaíocht san Oideachas' do Mhic Léinn agus d'Fhoghlaimeoirí Gaeilge, with Fidelma Ní Ghallchobair (COGG, 2015)
Cúirt an Mheán Oíche le Brian Merriman: Cóirithe don Stáitse ag Celia de Fréine. In eagar le gluais ag Fidelma Ní Ghallchobhair (Baile Atha Cliath, Leabhar*COMHAR*, 2017)
Luíse Ghabhánach Ní Dhufaigh: Ceannródaí (Leabhair*COMHAR*, 2018)
Cur i gCéill (Baile Átha Cliath, Leabhair*COMHAR*, 2019)
I bhFreagairt ar Rilke : In Response to Rilke (Arlen House, 2020)

PLAYS PRODUCED

'Were Man But Constant' (from Shakespeare's comedies), The Studio, Dublin, 1982

'The Midnight Court', The Studio, Dublin, 1982

'The Courting of Emer' (produced by Meitheal), Temple Bar Studios, Dublin, 1985

'Diarmuid agus Gráinne' (produced by Meitheal), Halla Uí Dhonnabháin Rossa, Dublin, 1986

'Holloway 1918' (rehearsed reading), 'An Béal Bocht', Dublin, 1990

'I Have Seen the Stars' (produced by Rosna), Dublin Theatre Festival Fringe, 1988

'Two Girls in Silk Kimonos' (rehearsed reading as part of 'Women at the Peacock'), Dublin, Peacock Theatre, 1991

'Nára Turas é in Aistear' produced by Amharclann de hÍde, Dublin, The New Theatre/Galway, Town Hall Theatre, 2000

'Anraith Neantóige' produced by Aisling Ghéar at Theatre Space @ the Mint, Dublin Theatre Festival Fringe; toured nationwide, 2004

'The Midnight Court' produced by Dublin Shakespeare Society Theatre @ 36, 2007

'Casadh', commissioned by the Abbey Theatre (rehearsed reading), Dublin, Peacock Theatre/Belfast, An Chultúrlann, as part of 'Gach Áit Eile' series, 2009

'Seamstress', 'Stamen' and 'Beholden' part of the Umbrella Theatre Company show '8x10', National Gallery of Ireland, 2014/2015/2016

'Safe' produced by Umbrella Theatre Company, Mill Studio Dundrum, 2015

'Cúirt an Mheán Oíche' produced by Aisteoirí Bulfin, Scoil Bhríde, 2016

'Cruachás' produced by Aisteoirí Bulfin, Scoil Bhríde, 2016

'Beth' produced by Umbrella Theatre Company as part of 'Katie and Beth' ('Katie' by Lia Mills), Two Cities One Book Festival, Dalkey Book Festival and at the Mill Studio Dundrum, 2016

'Rose and Aoife Rua', part of the Umbrella Theatre Company show 'From Patrick to Pearse' (National Gallery of Ireland, 2016).

'Rose' part of the show 'Forgotten' (Rathfarnham Castle, Red Line Festival, 2017)

'Luíse' produced by Umbrella Theatre Company, Scoil Bhríde, Ranelagh, 2016 and 2017

'Laurels', 'What Only the Blind can See', 'Pearl of Great Price' and 'Veronica' produced as part of the Umbrella Theatre Company show 'The Meeting', National Gallery of Ireland and Dún Laoghaire, DLR LexIcon Studio, 2017

Máiríde Woods

A CONSTANT ELSEWHERE OF THE MIND

Máiríde Woods

MÁIRÍDE WOODS

UNOBSERVED MOMENTS OF CHANGE

Astrolabe Press

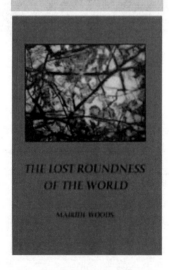

THE LOST ROUNDNESS OF THE WORLD

MÁIRÍDE WOODS

My Writing Life

How did I come to write? From the time I met stories, it was what I most wanted to do. My father filled our attic bedroom with his fantastical tales of leprechauns who inhabited the woods around Glencar, my mother told us 'moral' stories about the ups and downs of two little girls, coincidentally always the same age as we were. Once I learned to read, I discovered – à la Enid Blyton – adventure, which hooked me because there was so little of it in the real world of the 1950s. The first story I remember starting in a copybook was 'Michael and Fionnuala' and it was full of adventure. Almost at once I met the writer's main problem: how to keep going and bring it to a satisfying close. Vaguely I knew I hadn't quite succeeded.

I was a teacher's daughter and my parents encouraged my love of books. I read omnivorously – classics, comics, Patricia Lynch, Angela Brazil, as well as every Enid Blyton I could find. In a world where goodness was important I fell in love with *Little Women* and Jo. As a homesick boarder in Loreto, Coleraine I was consumed by *Jane Eyre*. English was my favourite subject and I had excellent English teachers who opened my eyes to literature. I wrote for the school magazine, dared to imagine becoming a journalist. But when I reached UCD in the 1960s I lost my way. The English syllabus was very different from the A Level one I had loved, and it seemed designed to put a young person off. Mainly we read minor texts by dead

authors. *Comus* (published by John Milton in 1637), was the one that evoked my greatest loathing. The student's feelings about these were deemed irrelevant. Many lecturers were lofty and immured in their own worlds, with little interest in undergraduates – apart from the exalted Group 4s who took 'pure' English unadulterated by another subject. (Honourable exceptions included Gus Martin, Thomas Kilroy, Alan Bliss and Sister Aideen). In the French Department things were a little more lively – lecturers presented works by Camus, Giraudoux and Maupassant with modern comparisons and – crucially – engaged in dialogue with us students.

UCD was, of course, a mixed world with a preponderance of male lecturers. Slowly, it dawned on me that being a woman might be a disadvantage – brilliance seeming male-slanted. Female over-achievement might interfere with the duties of beauty and finding a boyfriend. A girl's best bet was to become a competent teacher. And while earlier I had scorned such a view, now I wasn't so sure. My unsettledness affected my first writing attempts – I didn't know how to put form on my angst and was scared to come out as a writer. I toyed with the idea of sending something to *St Stephen's* (the UCD literary student journal of the time). It seemed to me impossibly obscure, though when I picked up a copy recently the writing seemed quite accessible. Back in those days of the late sixties, we configured the problem as a dinosaur – rather than a gender issue. Once the older generation disappeared, things would improve.

And so to graduation and the real world. I fell in love. I started a Master's. And guess what, the need for money led me into teaching. Then I married and a year later when my first child was a few months old, some of my poems were published in 'New Irish Writing' in *The Irish Press* and in *The Irish Times*, to my immense delight and that of my husband. 'Oh, that first fine careless rapture!' I had

sent them out a few months earlier in my best handwriting, not having a typewriter. It seemed too easy. I laughed when my father told me to be careful of copyright. Little did I know that it would be thirteen years before I had anything else published.

Some people manage to combine writing with babies; I didn't – producing only scraps, though I continued to read. There would be time, I told myself. Perhaps that has been my problem as a writer – partial rather than total commitment. I was reluctant to give up love, children and other interests to this demanding master. My mother's death in 1981 brought home to me the shortness of time. I invested in a portable typewriter and started writing stories as well as poems. As my children toddled onto the school stage, writing workshops appeared on my horizon, many of them run by Arlen House, then actively promoting women's writing. Some Saturday mornings I would rush off to sit in a room with women who talked seriously about the hieroglyphics on their pages – instead of cleaning, shopping or watching TV. The organisers and my comrades-in-ink were encouraging about my efforts, while suggesting possible alternatives.

For the unpublished writer the difficulty always lies in gauging your own worth. Are you unpublished because of a conspiracy against your age/gender/class/ background, because your work has gone missing … or because it isn't good enough? Those workshops built confidence and made us take our writing seriously. Eavan Boland was particularly strong on this. For me, the WEB writing group which grew out of one series of Arlen House workshops, became a long-term support and a testing ground. Reading your work aloud to others shows you firsthand whether the reader gets it or not. I also learned the art of close editing, the deceitful brilliance of first drafts, how to refashion and omit. At the same time, we women became more and more aware of the unequal nature of writing – so

many male mugshots on book covers. Many of us contributed to the Attic fairytales for feminists series and a broadsheet which appeared around 1990. Roald Dahl had competition.

Over the next decade I wrote stories, poems and a couple of radio plays. At first David Marcus (the editor of 'New Irish Writing') wrote me half-encouraging rejections; RTÉ accepted a first piece, I contributed to *Sunday Miscellany*. I moved from typewriter to Amstrad and admired my chic manuscripts. And then in 1987 my story 'The Better Part' got into 'New Irish Writing' and ended up winning a Hennessy Award. In 1991 another story won the Francis MacManus Award and a third 'Now and at the hour of our death' won a second Hennessy in 1992. I had found a voice and thought my brilliant career might be at hand.

This time I *did* realise how lucky I was. I even enjoyed all the razzmatazz of the second Hennessy in Kilmainham, a major contrast to my ordinary life. The surprise of winning the overall award, the praise of the adjudicators brought me pure joy, and the fact that the story related to my mother was a secret bonus. The kids on the road recognised me. 'Did you just win a grand, missus?' My literary sails would start to billow.

I didn't realise the need to go into marketing mode. If I was advising my younger self, I'd tell her to burn the midnight oil over a collection of stories, to bombard publishers with material, to winkle her way onto Gay Byrne *et al*, to send out decent photos. (It was pre-internet). But I wasn't publicity inclined and I had lots of responsibilities – a part-time job as well as the family. I found it hard to imagine another grand coming my way from writing. With four children, one of them disabled, money was always an issue. I knew there were mythical male writers who would starve in garrets for their art, but weren't they well – selfish?

Art is, after all, quite an enjoyable occupation. I was always trying to balance Elizabeth Cady Stanton's two imperatives – self-fulfilment and self-sacrifice. How strong is your need to write? How do you survive when you're an apprentice (or slow) writer of either gender? Do writers belong to the elite or the precariat? Should there be a general *cnuas*? And where would the bar be set and by whom? Most of the writers I knew eked out a living on bits of teaching and reviews; others felt such activities took too much of their time and headspace. Yet I turned out more work when pushed for time. Send me a deadline! I wasn't willing to give up the other (precious) things in my life for the legendary blank page – which I feared might remain that way. And didn't a writer need to engage with other parts of society? In the middle 1990s I undertook a Master's in Equality Studies – sociology being another interest – but perhaps I should have set myself to produce a novel. However, the paid work I later found in research and information was satisfying and included writing of a factual nature.

Despite my capacity for distraction I finished a respectable number of stories, some finding a home in reviews or anthologies or on RTÉ. With 'The Waiting Room Story' I won the PJ O'Connor Radio Drama Award. But short stories are not a saleable commodity. Neither is poetry which I continued to write, joining another group, Thornfield, mentored by Dorothy Carpenter. This was inspiring and brought a new clutch of poets into my life, while the WEB group remained a major support, particularly in fallow periods. By this time the profile of Irish women writers was rising and brought opportunities which were important in stitching together a career. Some of the WEB group appeared in an *Irish Times* short story series. Writers probably don't pay enough tribute to the selflessness of good editors! David Marcus, Anthony Glavin, Catherine Rose, Caroline Walsh, Declan Meade,

Seamus Hosey, Clairr O'Connor and others deserve my gratitude.

In the early 2000s I was struck by tragedy. My eldest daughter died suddenly. My husband left. In the face of such happenings, getting published seemed irrelevant. I continued to write obsessively, in this instance to hold back the darkness, and my work continues to reflect those losses. The novel I had started remains unfinished. The importance of the writing game began to fade and fewer of my stories were published. When I had to come to terms with the transitory nature of all things, the magic power I'd had seemed useless. Published or unpublished, one is soon forgotten. The secondhand bookshops are full of the bright young things of 30, 40, 50 years ago.

Yet when I got the chance to publish a collection of poetry with Astrolabe Press I was delighted. *The Lost Roundness of the World* appeared in 2006, *Unobserved Moments of Change* in 2011 and *A Constant Elsewhere of the Mind* in 2017. I am happy to have these three volumes bobbing around on the ocean of publications, because I'm thinking of what I'll leave after me – even on the back shelves of a secondhand bookshop!

Somehow, while I was looking elsewhere, I've slipped into the final stage of life – the one where having promise is not enough. And today's Zeitgeist sometimes seems alien. I like sentences to have full stops, characters to have names and stories to have something suggestive of resolution. Texting has promoted a curt allusive style and writing about sex often seems derivative or designed to shock ... And don't start me on typos ... Have I become a dinosaur?

It's probably easier to publish books now than it was in the 1980s. But it's not easier to get attention for those books – unless you've made the leap into the ranks of fame. It's almost as if many of us are working in burrows with limited connections. This means you can avoid what you

don't like; but it also means less cross-fertilisation, less sense of a general literary forum. There are lots of prizes but few regular openings for stories; lots of book-related events, but how much in-depth reading? It's almost as if we prefer the hype to the real thing. Successfully publishing a book now means a slightly rock-star-ish tour of venues where flatteries are exchanged. If you're a woman, it works better to be young and blonde – alas for the late maturing writer! Part of me thinks Elena Ferrante is right – a book should stand on its own merits, rather than on its author's talent as an actor/entertainer. Another part of me sympathises with the publisher who needs to entice readers. Chance plays a larger role in success than we admit and not all of an author's work will be of equal quality, particularly if their eminence means editors cannot easily turn them down. And success partly depends on capturing that 'shock of the new'.

I couldn't have survived on the income writing brought me. Yet I can't imagine retiring from the word, though inspiration and crafting come more slowly, and I can carry less in my head. Today I can see how my individual voice belongs to a generation and a place. I'm also conscious of the repetitive nature of my own work and its flaws. Perhaps I only have one story which I keep on telling in different guises. It never comes out quite as I intend. Our creations float beyond us taking their chances on the waters of fortune.

MÁIRÍDE WOODS

Máiríde Woods was born in 1948. She writes poetry and short stories. Her work has appeared in anthologies and reviews and has been broadcast on RTÉ radio.

She has won several prizes, including two Hennessy Awards and the PJ O'Connor and Francis MacManus Awards from RTÉ.

Máiríde was brought up in County Antrim but has lived most of her life in North Dublin.

BIBLIOGRAPHY

The Lost Roundness of the World (Dublin, Astrolabe Press, 2006)
Unobserved Moments of Change (Astrolabe Press, 2011)
A Constant Elsewhere of the Mind (Astolabe Press, 2017)

Liz McManus

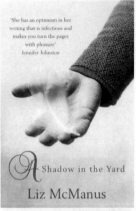

'She has an optimism in her writing that is infectious and makes you turn the pages with pleasure'
Jennifer Johnston

A Shadow in the Yard

Liz McManus

ACTS OF SUBVERSION

LIZ McMANUS

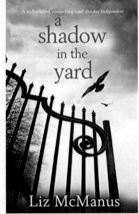

'A well-crafted, compelling read' *Sunday Independent*

a shadow in the yard

Liz McManus

THIS IS A RACE

I am 73 years old and I'm in the middle of writing my third novel. This is a race, I tell my friends, between me and dementia. They try and cheer me up with examples of creative octogenarians: Picasso, George Bernard Shaw, Molly Keane, even Leonard Cohen. You're only getting started, they say, but I'm not persuaded. All I can think of is poor, mindless Iris Murdoch plonked in a chair and left to watch her favourite Teletubbies show.

That said, there are benefits to being old: I'm a better writer now than I was when I was thirty, more assured, less risk-averse. The only problem is that so many words are getting away from me: the delicious phrase I wanted to include in Chapter 7 of the novel, the clever remark I overheard that I intend to steal – if I could only remember what it was and who said it …

I write slowly. I always have. The difference now is that time is running out. Still, I comfort myself, all the years weren't wasted. When Death comes, Rabindranath Tagore wrote, all the earnings and gleanings of my busy life will I place before him at the close of my days … That is exactly what I'll do when my time comes, although on one point I disagree with the poet. I don't see why Death, like God, is always depicted as a man.

I choose to imagine Death as a mother calling her children home.

I was born in Montreal, Canada, the youngest child of three, all girls. My father was a civil servant who represented the Irish State at a number of international fora including – after we moved to Paris – the Marshall Plan talks. Ireland was neutral in WW2 but somehow, money was secured for worthwhile projects here, presumably to ensure Ireland held out against communism. In 1950s Ireland there was no danger of that bulwark being breached. The Communist Party of Ireland barely figured on the political landscape. Its leader, Michael O'Riordan, a Spanish Civil War veteran, even suffered the ignominy of being dunked in the Grand Canal by Catholic fanatics.

In those days I was a dutiful daughter of the One, Holy, Catholic and Apostolic Church. When I was an adolescent I wondered if I had a religious vocation. In the end, other influences in my life won me over. Books, in particular, opened up the world. I got my love of reading from my father. Looking back, I can see how he was a modernising influence, both in his career and at home. There were lots of books in our house. I was free to read to my heart's content and to play my father's records. I remember us both listening to Jack McGowran growling his way through Samuel Beckett, our laughter matched only by our lack of comprehension.

At the age of sixteen I finished school. My academic results were good but I was clueless when it came to planning my future. My mother decided I should study architecture and after five years in UCD, I duly qualified. Although I was a terrible architect, the training did come in handy when, years later, I was appointed Minister of State for Housing and Urban Renewal, but when I left UCD my inadequacy was a source of shame. I got work as an architect and was grateful that my bosses were kind. During the early years I followed my husband, a young doctor, as he worked in various hospitals around Ireland.

Living in Derry's Bogside in 1969 and then on the docks in Galway in the early 1970s taught me just how insular growing up in Dublin had made me. It was an experience that fed my imagination. Later I set my first novel *Acts of Subversion* in Galway and my second *A Shadow in the Yard* along the Donegal border.

The economic downturn in the 1980s finally liberated me. Since there was no architectural work to be had, I became a full-time mother of my four children and began to write seriously. My first short story appeared in *The Irish Press*. I was physically sick at the sight of it, but excited too that such an amazing thing should happen. That story won me a Hennessy award for New Irish Writing. The judge Heinrich Böll said he liked the story because it was very short (or words to that effect). Foolishly, I thought that winning that award would open doors for me but, of course, it didn't. Rejection slips came thick and fast and I became discouraged. I had almost given up in despair when I made one last ditch effort and enrolled in a workshop run by the inestimable Clare Boylan. She was an inspiration: pretty, blonde and with a mind as sharp as a razor. 'You don't have to be intelligent to be a writer,' she told us, 'but you have to write a novel if you want anyone to take you seriously.'

So I wrote my first novel. It took four years to write and Poolbeg Press published it in 1989 with the aid of an Arts Council grant. In those days grants for publishers were plentiful. Not anymore, unfortunately, but there is one support for writers which thankfully has survived intact: the Tyrone Guthrie Centre at Annaghmakerrig. I went there for the first time in 1990 and have been privileged to go back many times since. In the early days, I was one of the few residents with a car and spent many evenings transporting a gaggle of writers, half-crazed from the want of drink, to the nearest pub. After the pub closed, we returned home and the talking and singing continued. One

time, I remember, a writer passed out at the dining table. We thought he had died. These days a typical writer at Annaghmakerrig is a vegetarian who likes to jog, meditate and drink a small glass of wine with a gluten-free dinner.

While a student in UCD I had developed an interest in radical politics. I left the Labour Party in disgust over coalition (twenty years later, I was a member of a coalition government, how the wheel turns ...). In Galway I joined the Workers Party, a left-wing movement which demanded dedication to the Revolution and endless intellectual arguments on how to bring it about. We had no shortage of enemies: Charles Haughey, the multinational oil companies, the Church, of course, and the Provisional IRA. Since writing fiction was an impossibly bourgeois occupation I edited a small newspaper instead, full of earnest articles about the working class of which I knew practically nothing.

After we left Galway we settled in Bray, County Wicklow. I became a housewife who was rearing a young family and who also wrote. Then the Irish Women's Liberation Movement happened and all was changed utterly. The lack of women in positions of power became a personal affront. I stood for the local council in 1979 and won a seat. In 1992 I was elected a TD and my political career took over my life. I gave up writing a weekly column in a national newspaper. There was no space for reflection, no room for the imagination. In a way I was relieved. My attempts at writing a second novel had been a failure. I suffered from writer's block, I used to say grandly, but in fact I had just lost heart.

Much later I discovered my urge to write was not dead, just dormant. In 2011 I retired from Dail Éireann and immediately applied for an M.Phil in Creative Writing in Trinity College, Dublin. On the first round, I was turned down. A few weeks later, unexpectedly, I was given a place on the course. What followed was a year of pure,

unadulterated joy. I was a student, immersed in the world of writing. I had fine teachers who believed in my talent even before I did. More importantly, I was writing again and I knew what I wanted to write about.

By then, the Troubles in Northern Ireland had come to an end. In order for the Good Friday Agreement to work, a collective amnesia about the past was required of people North and South but particularly of those directly affected: the victims and the families of victims. As a politician I understood the need for silence. As a writer I wanted to explore it. I chose to write, in John Hewitt's words about 'a young woman who strayed into the line of fire.'

At times I found it difficult to separate my politics from my fiction, but I persisted. I took to heart the distinction made by the South African writer Nadine Gordimer. No stranger to political activism herself, she wrote, 'The novel is what happens after the riot is over. It's what happens when people go home.'

Eventually the task I had set myself was complete. My agent, Jonathan Williams, took the book, filleted out the last vestiges of didacticism, corrected my grammar, extracted the misspellings and found a publisher.

In 2013, almost a quarter of a century after my first novel, my second novel appeared in print. Coincidentally it was also published by Poolbeg Press. To my delight *A Shadow in the Yard* sold well and got good reviews.

Now all I have to do is to finish my third novel before the dementia sets in.

LIZ MCMANUS

Born in Canada in 1947, Liz McManus was brought up in Dublin. She worked as an architect in Derry, Galway, Dublin and Wicklow and was a newspaper columnist from 1985–1993. Her first novel, *Acts of Subversion,* was shortlisted for the Aer Lingus/*Irish Times* Award for New Writing.

She has written several short stories, for which she was awarded a Hennessy New Irish Writing Award, Listowel Short Story Award and Irish PEN Award. She was conferred with an M.Phil in Creative Writing (Trinity College) in 2012.

A parliamentarian for 19 years, she was Minister for Housing and Urban Renewal (1994–97). She has been a campaigner for women's rights and a Chairperson of the Board of the Irish Writers Centre.

BIBLIOGRAPHY

Acts of Subversion (Dublin, Poolbeg Press, 1992)
A Shadow in the Yard (Dublin, Ward River Press, 2015)

Mary Rose Callaghan

Confessions of a Prodigal Daughter

Mary Rose Callaghan

Mary Rose Callaghan

I Met A Man Who Wasn't There

a novel

THE VISITORS' BOOK

MARY ROSE CALLAGHAN

The Deep End

A Memoir of Growing Up

Mary Rose Callaghan

Billy, Come Home

Mary Rose Callaghan

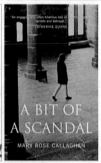

A BIT OF A SCANDAL

MARY ROSE CALLAGHAN

Has anyone seen Heather?

Mary Rose Callaghan

MOTHERS

a novel by Mary Rose Callaghan

the Awkward girl

Mary Rose Callaghan

MARY ROSE CALLAGHAN

EMIGRANT DREAMS

Mothers

Mary Rose Callaghan

Kitty O'Shea

A LIFE OF KATHARINE PARNELL

MARY ROSE CALLAGHAN

How I Became a Writer

I became a writer when I went to America. It would never have happened if I had stayed in Ireland where I grew up. Two of my mother's cousins were writers, but there were none in my immediate family: my father was a farmer and my mother a nurse. My mother, a strong role model, was brought up in America, which made a difference to her outlook. She was a great reader and encouraged me to be a writer, although no one else did. There were no writers' workshops in my youth, or none that I knew of. During a period of unemployment, a sensible friend asked me what I would be if she waved a magic wand. When I said a novelist, she thought I was mad. It seemed as unattainable as an astronaut.

But I had always wanted to write. I found a diary entry from age thirteen: 'I will be a writer.' I think this must have been due to circumstances. W.H. Auden believed artists are made by childhood embarrassment. My family was middle class, but my father got a brain tumour when I was about twelve, which affected our finances. Also, reading makes a writer. It was my salvation from aged eight when I was given the Anne books by L.M. Montgomery. I discovered other writers and went on to love both popular and classic fiction, such as Georgette Heyer and Agatha Christie, the Brontës, and Dickens. My mother subscribed to American magazines – *The Saturday Evening Post* and *The Ladies' Home Journal* – where I read short stories. She

also told me about her Florida youth and the people she met later when training to be a nurse in Dublin. This gave me an interest in character, essential for a novelist.

At nine, I was sent to Mount Anville boarding school where novels were read aloud at sewing class. By age fifteen, I had changed to Loreto Abbey, Rathfarnham, where the education was sound but dominated by rote learning and exams. Although everyone in my class got their Leaving, we were not taught to think critically; nor was there much talk about writing, or how to write. Our weekly essay was on topics such as 'The Picnic' or 'A Day Out'. I was an average student but had a short story published in the Loreto *Mission* magazine at age sixteen. This didn't translate into encouragement from my English teacher who advised me to try writing for religious pamphlets. In those days, the young weren't praised.

I don't remember any women writers on my Leaving course, either Irish or otherwise. I believed women wrote for children or were in the past such as the Brontës who had been obliged to pretend they were men. To me writer almost equalled man. There were exceptions – I had read Kate O'Brien and heard of Mary Lavin, but Edna O'Brien was still unknown to me. This low status permeated into all aspects of society. A feminist scholar in America told me women are considered a deprived class by sociologists. Career expectations were low in Ireland in the sixties: most women did commercial courses and worked in a bank or the civil service, or became nurses or teachers. Marriage was the main goal and this ruled out many jobs. Three out of my 1962 Leaving class of twenty-four graduated from UCD – although I had walked around Earlsfort Terrace for three years, I was one of them. But my father had died by then and it was a struggle to get my degree for several reasons. After that I did a H.Dip. in Education and taught in England for a few years, getting a job in a secondary modern school and then as a resident teacher in a girls'

boarding school in Oxford.

By now, I had abandoned all ambitions to write: I would read books, rather than write them. I was daunted by famous Irish writers, especially Joyce. But the bug wouldn't go away. Where and how could I begin? One day I decided to try a short story. The head of the school English department, who was recovering from a hangover in my bedroom, asked me what I was doing. When I told her, she said, 'Write a novel, don't bother with short stories.' I muttered something about Joyce having said everything worth saying. 'He brought the novel down an alleyway,' she replied. 'Your experiences are equally as valid as his.' My experiences valid? This was news to me. Around this time, I confided my ambitions to a boyfriend who told me I was no great writer. It was true, as I hadn't written anything, but in retrospect he did me a favour. His comment spurred me on.

In 1973 I returned to Dublin and got a job on an art magazine as assistant editor. I knew nothing about art or editing, and when the editor talked about galleys, I though he meant Roman ships, rather than proofs to edit. But the Dublin gallery scene was fun. I went to openings and seemed to have a permanent hangover from drinking plonk. Also, I met some eccentric characters who were to provide background material for my first novel. I was still terrified to write anything and didn't sign the only article I wrote for the magazine about a northern art gallery. But I gradually gained confidence by writing book reviews for *The Catholic Standard*, edited by the late John Feeney who was a friend.

Two years later I met Bob Hogan, an American academic and critic, at a play in the Project. We got on well and I went to live with him in Delaware, where he taught in the university. At first I didn't have a Green Card, so couldn't get a job. I now had time and no excuse not to write. What if I couldn't do it after all my talk? I started

Mothers, my first novel, which deals with the challenge of unplanned pregnancy, and tells the story of three generations of women whose lives intertwine. It was not autobiographical, except for the minor characters: I invented the three stories. But starting a first draft is difficult, so I soon ran out of ideas, preferring to play tennis in the sun. 'I don't see you writing,' Bob said one day. He believed in me, so I persevered.

A few months later Benedict Kiely came to the university as visiting professor, and I joined his creative writing class, nervously reading the first section of my novel aloud. I finished the book in 1978, but sent it out to different publishers without success. Then a prominent New York publisher liked the book and bought champagne to celebrate. All his assistants were ash blonde clones, I noticed, and he was something of a flirt, so nothing came of it.

Back in Dublin for the summer, I was sitting in Bewley's when I overheard a conversation about a nun caught shoplifting. It seemed to capture change in Ireland and inspired me to write a short story, which was a runner-up in the first Maxwell House short story competition run by Arlen House in 1978 and was published in *The Wall Reader* in 1979. The publishers asked if I had more short stories. I said no, but I had finished a novel, so they asked to see it and they published *Mothers* in 1982. It was launched in the Peacock Theatre by Mervyn Wall, who compared me to Thomas Hardy!

It was much easier to get reviewed back then. Arlen House were good at marketing and my novel was mentioned favourably in all the daily and Sunday papers. I was interviewed by Jennifer FitzGerald in *The Guardian* by long distance telephone. I had returned to America by then, but friends told me *Mothers* was read on the bus. I was on my way.

I met Angus Wilson, another visiting professor in

Delaware, who had tried to get my first novel published with one of the London houses. He encouraged me when writing my second, *Confessions of a Prodigal Daughter*, which was co-published by Arlen House and Marion Boyars, the London and New York publisher. The book was launched in New York, alongside a Danish writer who thought I was staff and gave me his letters to post! *Confessions* was reviewed in the *New York Times*. I went on to publish two more novels with Attic, the feminist press, and a biography of 'Kitty O'Shea'/Katherine Parnell with the feminist publisher Pandora Press in London. Poolbeg Press, who had hired the wonderful Kate Cruise O'Brien as an editor, published two more of my novels. Kate sadly died young. Then Steve MacDonogh of Brandon took *The Visitors' Book, Billy Come Home* and *A Bit of a Scandal*. Steve also died in 2010 and, although it was much harder on him, his writers were bereft.

I have published everything I have written so far, and been reviewed mostly favourably, but things seem to be harder now. I couldn't find an Irish publisher for my last book, *The Deep End*, a memoir which came out in 2016 with an academic press in America. There have been no reviews either, but this is probably due to the price of the book and poor marketing.

Age is not an impediment to writing but it could be to getting published. A few years ago, I met Brendan Kennelly, always supportive, who asked if I was being published. 'Too old for a bikini,' I joked. He laughed, saying, 'A good title!' Age and appearance are considerations for women in ways that would never exist for men, who are always either writers or men, never men writers.

Gender has definitely affected women playwrights, as there are hardly any. It probably affected fiction writers of my generation too. Being a woman didn't hinder Maeve Binchy's bestseller status, but she was writing popular

fiction and marketed by a mainstream publisher. Many popular crime writers are women, but literary fiction has always been a hard sell. Perhaps women are ghettoised by feminist presses? But it's hard to know. Virago and Arlen House have published many fine contemporary fiction writers and resurrected others.

Making money has never been my reason for writing. I have made some, but never enough for a mortgage. My first payment for writing was £5 for a reading in a pub. The next evening Liam Miller, publisher of Dolmen Press, called to see Bob and I bought a bottle of whiskey with my earnings to entertain him. The memory makes me smile.

I am fortunate to have followed my dreams and met the people I did through my writing. It's important for beginning writers to seek out those who will help them to hammer out a voice. That's the value of the workshops so popular today. I have been blessed by being a member of WEB writers' group whose members have encouraged me. Confidence is everything in life.

MARY ROSE CALLAGHAN

Mary Rose Callaghan was born in Ireland in 1944 and emigrated to the United States in 1975, where she lived for many years. She has written nine novels, some of which have been translated into German and Danish, and was an assistant editor of *The Dictionary of Irish Literature*. She is also a playwright and biographer, and an award-winning short story writer. Her memoir, *The Deep End*, was published in 2016 by the University of Delaware Press. She was married to Robert Hogan, a drama critic and playwright, and now lives by the sea in Bray, County Wicklow, where she teaches and writes.

BIBLIOGRAPHY

Mothers (Dublin, Arlen House, 1982; NYC, Marion Boyars, 1984)

Confessions of a Prodigal Daughter (Dublin, Arlen House, 1985; London and NYC, Marion Boyars, 1985)

'Kitty O'Shea': The Story of Katharine Parnell (London, Pandora Press, 1989, 1994)

The Awkward Girl (Dublin, Attic Press, 1990)

Has Anyone Seen Heather? (Dublin, Attic Press, 1990)

Emigrant Dreams (Dublin, Poolbeg Press, 1996); *I Met a Man who Wasn't There* (London and NYC, Marion Boyars, 1996)

The Last Summer (Dublin, Poolbeg Press, 1997)

Jumping the Bus Queue, editor (Dublin, The Older Women's Network/Age and Opportunity, 2000)

The Visitors' Book (Dingle, Brandon, 2001)

Billy, Come Home (Dingle, Brandon, 2007)

A Bit of a Scandal (Dingle, Brandon, 2009)

The Deep End (University of Delaware Press, 2016)

CRITICAL APPRAISAL

Maryanne Felter, *Crossing Borders: A Critical Introduction to the Works of Mary Rose Callaghan* (University of Delaware Press, 2010)

The Web: New Writing by Women, Vol. 1 (Arlen House/Women's Education Bureau). General Editor: Eavan Boland. Guest Editors: Evelyn Conlon, Mary Rose Callaghan.

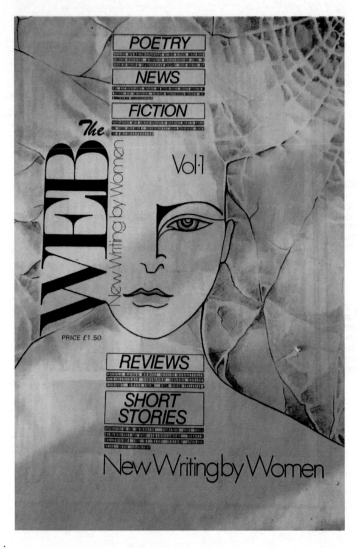

Contributors include Liz McManus, Máiríde Woods, Joan McBreen, Louise Barry, Christine Michael, Frances Molloy, Joni Crone, Eithne Strong, Joan O'Neill, Jean O'Brien among others.
The Arts Council refused to financially support any further issues.

Phyl Herbert

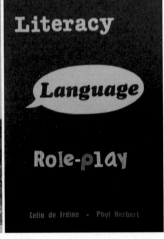

The Fruit of a Life

Samuel Beckett put it best when he said that we are born 'astride of a grave'. It's only now in my mid seventies that I fully understand this quote and realise that the short space between birth and the grave is somewhat random and improvised, and for some people out of their control.

I grew up in Dublin, the middle child of a family of eleven, seven brothers and three sisters. My mother was a very gentle soul, a country woman, but I could never understand why she gave my brothers bigger portions at meal times. After all, unlike me and my sisters, they never did any housework. This unconscious act on my mother's part was just unfair. Looking back I know now that this was when the seeds of becoming a feminist were sown.

During my primary school days at the Presentation Convent in Terenure I noticed that the nuns, well some of them, made pets of the girls from well-off families, while tolerating the rest of us. This was the 1950s, and when it came time for my second level education I was lucky to be sent to Sandymount High School, a co-educational school founded by Patrick Cannon, where a very liberal curriculum was practised. In this school students weren't reprimanded for speaking out. Above all, in this school there was equality between the boys and the girls. We were all equal. My English teacher used to read my essays to the class – this was the first time in my life that my voice

was affirmed. But those happy school days in Sandymount High didn't last long because my parents couldn't continue to pay the fees. I had to leave after the Intermediate Examination. Free education for secondary schools was announced in 1966, but not introduced until 1967, but that came too late for me.

In order to get a good job so that I could contribute to the household, I was sent to O'Donnell's commercial college in Rathmines where I studied shorthand and typing. After one year there I got a job with Aer Lingus at Dublin Airport as a clerk typist and so began my entry into the adult world. My short and happy time at the airport also came to an abrupt end.

I didn't write during this time but words and dialogue were always of constant interest to me. Sometimes I would imagine a scene in my head, I would rehearse the dialogue and explore the characters' backgrounds. A colleague in Aer Lingus invited me to audition for a part in John B. Keane's *The Highest House on the Mountain*. The Unicorn Theatre on North Great George's Street, located in the basement of a Georgian house, was a real theatre with a stage and raked seating. I not only got the part of the young girl, but I also got the attention of the director, who insisted on driving me home every night. Events got out of control and I became pregnant. In 1966 contraception in Ireland was illegal, and the concept of abortion hadn't found a space in our vocabulary. I told no one. Not even my family. The only person who knew was the father, and he was a married man. The concept of living as a single parent was unheard of then, it just wasn't in the ether, nor was sex outside of marriage. The biggest sin in Ireland then was sex.

I gave up my good job in Aer Lingus and pretended to my parents that I had found work in Paris and that I needed to take up the job immediately. I argued that the big bonus meant I would learn how to speak French. A

German doctor on the far side of the city arranged everything for me – a hostel in London's Euston Square for my period in hiding, then returning to a Mother and Baby Home in Dublin for the birth and adoption of my child.

The good nuns at St Patrick's colluded with my Paris story. My letters were sent to their Paris mother house in Rue du Bac and the nuns there would post them back to my parents bearing a French envelope and postmark. In 1967, 97% of babies born to unmarried mothers in Ireland were given up for adoption. It was still the era of the Magdalene Laundries and the unquestioned power of the church. It was only at the beginning of the 1970s, through the influence of the international feminist movement, the Irish Women's Liberation Movement, and later the gay rights movement, that a public questioning of sexual mores started, and Irish society was forced to begin to change. I left the Mother and Baby Home on the Navan Road in Dublin – where I had been treated well – six weeks after my daughter was born. I then returned to my family. Thankfully nobody asked me any questions in French.

The next few years were spent trying to reinvent myself. I had a secret that I couldn't share with anybody. I thought about my beautiful lost daughter constantly and looked for traces of her in every child's face I saw. Twenty-six years later I finally met her. The first letter she wrote to me bore a French stamp from where she had been on holidays. Our first face to face meeting took place in a city centre hotel, two strangers to each other with a grain of familiarity connecting us. Her luminous presence had the air of accomplishment and confidence. I inhaled her into my bloodstream knowing she was someone else's daughter and then with open arms she offered me the biggest gift of my life – an invitation to enter hers.

At the end of the 1960s, I had two big life changing creative experiences. The first was becoming a night

student in UCD. Denys Turner, the philosophy lecturer, introduced us to the existentialism of Jean-Paul Sartre. I can still hear his English accent saying something to the effect, 'It doesn't matter what your past circumstances have been. We have the power to decide our own destinies.' At least those were the words that were imprinted on my consciousness at the time. I immediately felt liberated from the 'sins' of my past.

The second experience was joining the Actors' Studio in the Focus Theatre. Deirdre O'Connell *was* the Focus Theatre incarnate. She reigned as Artistic Director from 1967 until her death in 2001. It is true to say that she introduced a new style of theatre to Dublin, not only in her training of actors but in introducing an Irish audience to the European classics such as Ibsen, Chekhov, Strindberg and many other unseen plays during this time. She alone was responsible for introducing the Stanislavski method of acting to Ireland. It was a privilege to be in the audience and see ensemble-style theatre with actors like Sabina Coyne (now Higgins), Mary Elizabeth Burke Kennedy and Tom Hickey and, of course, Deirdre herself. These actors later became my role models. Deirdre presided over the weekend workshops where the main component was improvisation – a new approach to both rehearsing a play and developing the skills necessary for acting. No script was provided; you were on your own navigating the direction of the story, just like writing. It was, as a result of this time at the Focus, that I discovered I could write and direct plays.

My day job was PA to Allen Figgis, Managing Director of Hodges Figgis bookshop on Dawson Street and publisher of many of the leading Irish writers of the time. Brendan Kennelly and Eavan Boland were frequent visitors to his office, Figgis having published Boland's debut collection, *New Territory*, in 1967, and numerous Kennelly volumes. Derek Mahon also used to call in

regularly. I remember typing the manuscript of the novel *Sausages for Tuesday* (1969) by Brendan's brother Patrick Kennelly on the new IBM electric typewriter. For many Irish writers of this period being published by Allen Figgis was the ideal.

In 1972 I qualified from UCD with a BA degree and in 1973 with a H.Dip in Education.

Dublin in the 1970s was a place where drama unfolded in a number of basement theatres. On the north side of the Liffey were The Unicorn, where I started my acting career, and the Dublin Shakespeare Society, where in 1973 I directed my first play, *The American Dream,* by Edward Albee. The theatres were on different sides of North Great George's Street. I directed two Shakespearean plays, *Coriolanus* and *Hamlet,* over the following years. During this period I honed my skills and brought my Stanislavski experience into the rehearsal space. Other women directors in the Dublin Shakespeare Society were Eilís Mullan and Celia de Fréine. It was also during this time that I started my teaching practice in Clogher Road Vocational School and where I met Gabriel Byrne and cast him in his first acting role – playing the part of Aufidius in *Coriolanus* in 1974.

In the early 1970s the theatre scene in Dublin was changing. The Project Arts Centre, founded by Colm Ó Briain and Jim Fitzgerald, was engaged in opening its doors to visiting theatre companies from abroad as well as staging new plays. Jim Sheridan's *Mobile Homes* (1976) explored new territory and earlier, in 1972, Heno Magee's *Hatchet* at the Peacock shocked audiences with its stark and dramatic depiction of working-class life. Male playwrights were finding a voice for the time. But where were the women playwrights? They were largely invisible then; one notable exception being Maeve Binchy who – many years before publishing her first novel – had two plays produced by the Abbey Theatre, *End of Term* (1976)

and *Half-Promised Land* (1979), the latter of which addressed themes of racism, persecution and identity, and had an abortion scene; it played to sold-out audiences and poor reviews.

Women writers of this period hadn't in general as yet expressed their emotional voices and tended to explore the lives of historical female characters. Notable exceptions from previous decades included Maura Laverty and Máiréad Ní Ghráda, whose play, *An Triail*, was the hit of the Dublin Theatre Festival in 1964. Colette Connor states 'this play was twenty years ahead of its time in terms of subject matter – the trial by jury [the audience] of a young unmarried mother who has committed infanticide'.

The Lantern Theatre in Merrion Square, founded by Paddy Funge, started a new venture in the mid 1970s, 'The Writers' and Artists' Workshop'. Readings of new plays were performed every Tuesday night to an invited audience, which included actual theatre reviewers such as Kane Archer from *The Irish Times* and John Finnegan from the *Evening Herald*. Each reading was followed by a Q and A session which was often continued around the corner in O'Dwyers's pub on Mount Street. Bernard Farrell was the first contemporary Irish playwright I met and I had the pleasure of directing his first play, *Goodbye Smiler, It's Been Nice*. It is interesting to observe that there was only one woman playwright, Dorothy Rudd, there among the playwrights. The Lantern was the most exciting and enlightening theatre workshop I was ever engaged in. The collaborative process necessary for the development of plays happened there. Playwrights, actors, directors, designers and, of course, an invited audience all worked together in the making of a theatre piece. These are the ingredients necessary in my opinion. Play development needs a theatre community.

It was also around this time that David O'Brien, Gabriel Byrne and I founded a new theatre company, Bell

Productions. We performed at Players in Trinity College for two seasons with Sean Walsh's plays, *Earwig* and *The Dreamers*. Our last production, *Fanthology*, involved a series of short scripts by prominent Irish playwrights like Hugh Leonard, Heno Magee, Donal Foley among others – but again no women playwrights. It was towards the end of this run that a crossroads appeared in my life, whether to accept a permanent teaching job or to continue professionally in theatre. I chose the safe option, a permanent job. Gabriel and David decided to continue on in theatre.

Drama in education was now my focus. I was lucky to receive a year's leave of absence from my teaching job to study with Dorothy Heathcote at Newcastle upon Tyne university for a Master's degree. On my return I began teaching in the Dublin prisons. The standard of literacy among the prison population was very low at the time and I found that the use of drama as a tool in the development of communication skills was very effective. When I looked for written plays as reading material it was impossible to find anything suitable. The answer then was to write my own. I invited a friend, Celia de Fréine, to contribute to my collection of plays and the result was *Literacy, Language and Role-play* published by Sarsfield Press in 1991. We were fortunate to receive a grant from the City of Dublin Vocational Educational Committee. This wasn't the only grant I was to receive and again it was in collaboration with Celia.

In 1984 I directed Miriam Gallagher's play *Dreamkeeper* for the Dublin Theatre Festival. Miriam later published a collection of her plays, *Fancy Footwork*. Miriam's death in 2018 is a loss to the theatre world.

In 1989 the Arts Council advertised a funding scheme for theatre projects. Celia and I met to discuss applying for funding to address the issues facing women playwrights, and we then put in an application under the title, 'Women

Playwrights'. We were looking for new plays and new themes. Women's voices were not being heard in theatre, but we knew women were writing plays. We set up a group and called ourselves 'The Women Playwrights' Forum.' The playwrights were Ivy Bannister, Leland Bardwell (sadly deceased in 2016), Colette Connor, Celia de Fréine and Clairr O'Connor. A grant of £2000 was awarded to us. The letter from the Arts Council stated:

> The adjudicators were particularly conscious of the validity of the assertion in your application that 'a public performance for any playwright is very difficult but for women playwrights it would appear to be almost impossible'.

In short, we made an application for our project to be given a day of rehearsed readings at the Peacock Theatre. Garry Hynes, co-founder of Druid, was appointed in 1991 as Artistic Director of the Abbey Theatre and her Literary Editor was journalist Fintan O'Toole. In June 1991 we participated in a series of rehearsed readings of 'Plays by Women' in the Peacock, playing to a packed audience, with a Q and A session chaired by me at the end of the performances. The general consensus at the debate was that the National Theatre needed to be more proactive on behalf of women playwrights if women's voices were to be heard. Sad to say, none of the women playwrights were offered the chance of a full production by the Abbey. And suffice to say that not all theatre patriarchs are men.

Ivy Bannister's play, *The Rebel Countess*, was a vivid account of Constance Gore-Booth's journey from the Big House to Irish nationalism. The play would later be performed on RTÉ Radio 1 as *The Road to Revolution*, directed by Aidan Mathews. She has subsequently had a number of professional play readings in major theatres and has published collections of poetry, short stories and a memoir.

Leland Bardwell's play, *Jocasta*, explored the Greek myth from a feminist point of view. In 1979 her play *Open-Ended*

Prescription, was given a full production at the Peacock. Her extraordinary body of creative work, including novels, short fiction, poetry and memoir, spanned many decades.

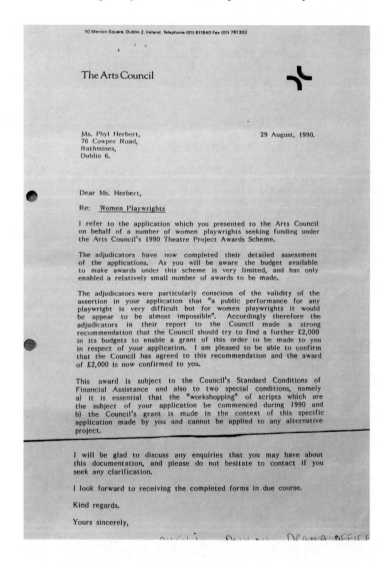

70 Merrion Square, Dublin 2, Ireland. Telephone (01) 611840 Fax (01) 761302

The Arts Council

Ms. Phyl Herbert,
76 Cowper Road,
Rathmines,
Dublin 6.

29 August, 1990.

Dear Ms. Herbert,

Re: Women Playwrights

I refer to the application which you presented to the Arts Council on behalf of a number of women playwrights seeking funding under the Arts Council's 1990 Theatre Project Awards Scheme.

The adjudicators have now completed their detailed assessment of the applications. As you will be aware the budget available to make awards under this scheme is very limited, and has only enabled a relatively small number of awards to be made.

The adjudicators were particularly conscious of the validity of the assertion in your application that "a public performance for any playwright is very difficult but for women playwrights it would be appear to be almost impossible". Accordingly therefore the adjudicators in their report to the Council made a strong recommendation that the Council should try to find a further £2,000 in its budgets to enable a grant of this order to be made to you in respect of your application. I am pleased to be able to confirm that the Council has agreed to this recommendation and the award of £2,000 is now confirmed to you.

This award is subject to the Council's Standard Conditions of Financial Assistance and also to two special conditions, namely a) it is essential that the "workshopping" of scripts which are the subject of your application be commenced during 1990 and b) the Council's grant is made in the context of this specific application made by you and cannot be applied to any alternative project.

I will be glad to discuss any enquiries that you may have about this documentation, and please do not hesitate to contact if you seek any clarification.

I look forward to receiving the completed forms in due course.

Kind regards.

Yours sincerely,

DRAMA OFFICE

Colette Connor's play, *Generations* (The National Front), was an original political drama exploring fascism through the eyes of a family at the death of their mother. Colette is

also a poet, and the author of the meticulous study, *Women Playwrights at the Abbey 1904–2004*, where she unearthed the names of numerous women playwrights who had work produced there.

Women
at the
Peacock

Extracts from five plays by
Clairr O'Connor
Celia de Fréine
Leland Bardwell
Ivy Bannister
Colette O'Connor

Saturday, 29th June, 11AM-1PM, 2-5PM

Admission: Morning £2, Afternoon £3

Discussion, 5PM-6PM

Clairr O'Connor's play, *Bodies*, was another original drama. The dominant character, a young woman, an anthropologist completing a book on the rituals of the Aquanda tribe, and head of her department at college, who is happily married but does not want children. The play

was adventurous and cutting edge and was later given a full production by the Cork Arts Centre and a rehearsed reading in New York to rave reviews at the New Dramatists' Theatre. Clairr is also an accomplished writer of novels, poetry and radio plays.

Celia de Fréine's play, *Two Girls in Silk Kimonos*, centred on the relationship between the two Gore-Booth sisters. It is one of the many successful plays she has written, alongside her poetry and fiction written in both English and Irish. Celia later co-founded The Umbrella Theatre Company with Gerald D'Alton.

Colette Connor describes the debate in her pioneering book, *Women Playwrights at the Abbey 1904–2004*:

> A discussion followed the readings. Chaired by Phyl Herbert of the Women Playwrights' Forum and attended by Garry Hynes, the discussion centred on the reasons why so many of the plays written by women failed to make it to the full production stage at the Abbey Theatre. The debate that followed showed those present firmly united in the belief that the National Theatre needed to be much more proactive on behalf of women playwrights if women's voices were to be heard.

> In response, Hynes said the present series of 'Plays by Women' was just part of a 'range of artillery' the Abbey hoped to deploy in the future in relation to all kinds of works. Two years later, however, Hynes resigned her position as Artistic Director.

While Garry Hynes resigned from the Abbey in 1994, she returned two years later to direct Marina Carr's play, *Portia Coughlan*.

In 2015 Fiach Mac Conghail, then artistic director of the Abbey Theatre, announced the 2016 programme, entitled 'Waking the Nation', commemorating the Easter Rising of 1916. There were eighteen men on the programme. All the plays were written by men apart from one play, *Me, Mollser*, written by a woman, Ali White, referred to as a 'monologue for children.'

The result of this exclusion of women writers was Waking the Feminists born to ensure that women's voices would be heard. It appears that there needs to be a constant Women Playwrights' Forum or a Waking the Feminists in existence to order for the gains made not to be lost, and for basic questions of equality and diversity to be asked of our theatre makers and funding bodies.

It was only when I took early retirement from teaching that I faced the question of my own writing practice. It occurred to me that I had spent a long time being involved in other people's writing. I immediately sought out a writing workshop and in 2005 was very fortunate to find Susan Knight's class, 'The Short Story and Beyond', at UCD. Susan is a successful novelist and playwright, and winner of many awards, including the RTÉ P.J. O'Connor competition for *Mr. Moonlight* (1986). Her workshops were another awakening for me. It was really at this advanced stage of my life that I started to feel the need to write again.

In 2008, during my time in Trinity College's M.Phil in Creative Writing, I learnt how to write to a deadline. My first interest, though, was playwriting and it seemed to me surprising that Trinity couldn't put a playwriting course together with all of the theatres around them. Short stories began to emerge and I found that my life experience was a deep source for my writing. *After Desire*, my debut collection of short stories was published in 2015 and in 2016 a second expanded edition, *The Price of Desire*, was published.

There is the presumption that the term 'Emerging Writer' refers to a young person. And it is certainly easier for young writers to get attention and praise. I was astonished and delighted when my publisher told me that 1000 copies of my short fictions had been sold. I was fortunate to find Arlen House as my publisher, with their almost 50 year record as Ireland's original and oldest

feminist press, and their longstanding commitment to publishing women writers of all ages. My short stories are a witness to a life lived and I was happy to be in a position to explore the voice of the older woman.

I returned to my first passion, playwriting, in 2010 when I wrote a play for women called *Lunar Ladies*, and then in 2017 wrote a one woman play, *My Name is Grace*, which was performed by Merci Horan and staged at the Red Line Book Festival. At the moment I am working on a memoir. It will be published by Arlen House in 2021.

I'm not finished yet, Mr Beckett.

PHYL HERBERT

Phyl Herbert was born in Terenure, Dublin and worked for many years as an English and Drama teacher in the prison schools and in Liberties College. Her creative interests were mainly around drama as a tool in the curriculum and theatre making as an art form. In 1987 the Curriculm Development Unit at Trinity College published her first book, *Role Play and Language Development*, with illustrations by Martin Fahy, another prison teacher. Her second book, a collection of plays written with Celia de Fréine, *Literacy, Language, Role-Play*, was published in response to International Literacy Year and was grant aided by CDETB. Mid-way through her teaching career she did a Masters in Drama in Education in 1982 with Dorothy Heathcote at Newcastle University. In 2008 she achieved an M.Phil in Creative Writing from Trinity College. Her work is published in the anthology *Sixteen After Ten*, she has broadcast essays on radio over the years and her stories have been shortlisted in literary competitions. Phyl's first collection of short stories, *After Desire* (Arlen House, 2015), was longlisted for the Kate O'Brien Award and the Edge Hill Short Story Prize in 2016.

BIBLIOGRAPHY

Role Play and Language Development (Dublin, 1987)
Literacy, Language, Role-play, with Celia de Fréine (Dublin, Sarsfield Press, 1991)
After Desire (Arlen House, 2015)
The Price of Desire (Arlen House, 2016)

Irish Literary Feminisms, 1970–2020

Alan Hayes

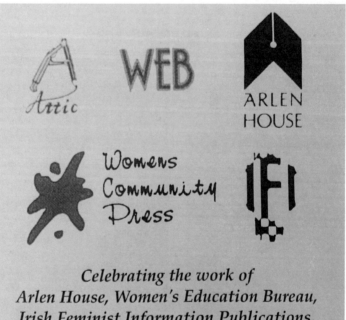

Celebrating the work of
Arlen House, Women's Education Bureau,
Irish Feminist Information Publications,
Women's Community Press & Attic Press

Books and ephemera from Irish feminist publishers Arlen House,
Irish Feminist Information, Women's Community Press, Attic
Press and Women's Education Bureau, 1975–1997

Publishing is implicitly a political activity and experience. In Ireland a small number of book publishers and funding organisations have traditionally held the power of veto – and the power of enabling – over what is published, how it is published, when it is published. 'Women', as a general category, have been particularly marginalised by this unofficial (sometimes unwitting) censorship.

The quest for equality, diversity and inclusion in Irish literature commenced with a small group of women in 1970s and 1980s Ireland. They addressed inequality head on, thus changing the face of Irish literature and publishing forever. While the past fifty years has seen an impressive amount of progress and change, much more work remains to be done in order to integrate and embed equality and diversity lastingly. And new challenges and obstacles have presented themselves. This essay seeks to present a survey of the past half century, acknowledging the feminist publishers and activists who have made such an impact; to give a snapshot of mainstream publishers' work, and to address some of the current challenges.

A SNAPSHOT OF WOMEN AND PUBLISHING

At least 700 Irish women published during the nineteenth century according to pioneering research conducted by Anne Colman in the early 1990s. Her *Dictionary of Nineteenth-Century Irish Women Poets*, published by Kennys Bookshop in 1996, is a fascinating work of scholarship and reclamation. During the first half of the twentieth century hundreds of Irish women continued to publish with prestigious publishers, both in Ireland but most importantly in Britain and the USA. It was not unusual if a young writer signed her book deal with Longmans or Heinemann or Hutchinson in London, or Houghton Mifflin in Boston or Doubleday in New York. In Ireland, for example, during this period over 100 women were published by one Dublin press alone, according to research

currently in progress (supported by the Arts Council) by this writer.

Post-independence, Ireland became an increasingly-conservative society, and the position of women disimproved. From the 1930s, the Censorship of Publications Acts caused much damage to the careers and livelihoods of numerous Irish writers, including Norah Hoult, Kate O'Brien, Maura Laverty and Edna O'Brien. Publishing became more conservative, less risk-taking, more boring, with fewer opportunities for new writers, and especially for women writers. The power and authority of the Censorship Board waned later in the century, though it could easily be argued that the Arts Council/An Chomhairle Ealaíon, in its judgement of what books and authors they chose to support, acted as a gatekeeper of contemporary Irish writing and publishing.

The feminist presses founded in the 1970s and 1980s – Arlen House (1975), Irish Feminist Information (1978), Women's Community Press (1983), Attic Press (1984) and Women's Education Bureau (1984) – broke new ground, challenged authorities and power structures, established new audiences and markets, and created a new vision of Irish publishing. The repercussions of this continue to be felt today. I wonder now how many of the recipients and beneficiaries know the names of the women responsible for changing the literary world in their favour?

The publishing scene of the 2010s and the 2020s is vastly different from that of the late twentieth century. It appears so much easier now for women to get agents and to be published. However, the landscape is not an equal one for everyone. Gender, age, sexuality, ethnicity remain stubborn obstacles for those who don't fit the ideal publishing model. And there are other challenges.

'Diversity' appears to be the biggest buzzword in the arts in recent years. Government, organisations and businesses have publicly announced their commitment to

diversity, introducing impressive new schemes, opportunities and events. These are all to be welcomed, encouraged and supported, as indeed are all initiatives which aim to create a more representative and equal cultural world.

However, why has it taken so long?

The original Equal Status Act was introduced in 2000 and covers nine discriminatory grounds – gender, race, sexual orientation, age, disability, marital status, family status, religion and membership of the Traveller community. It prohibits discrimination in the provision of goods and services under these grounds; it respects, values, accommodates and encourages diversity. The 2000 Act, with its subsequent amendments, was envisaged to actually welcome and encourage more diversity in Irish society. Why did the Irish arts world not embrace the equality legislation then and incorporate diversity at its core and in its funding models and decisions? Why was it impossible, then, to address power and privilege? Particularly so when members of the arts world have been, and still are, especially susceptible to discrimination.

We are in a cultural world of buzzwords now. Social media, which lack nuance, have become increasingly powerful and potent. The so-called 'cancel culture' can act as a noose in attempts to destroy people's careers and lives, based on weak evidence and dubious interpretations bayed by a mob mentality.

Another term used problematically at times is 'privileged white male'. Attempts to call out power and privilege are brave and are to be welcomed, though it is disturbing when done by those who fail to name *their* own power and privilege. And it would be naïve to assume that some women have not supported the patriarchy in the discrimination of women, while it is also true that some men have worked towards equality and justice in the arts world.

Wise woman Edna O'Brien, who has well-earned her legendary status, said in a powerful speech (8 March 2021):

> In this troubled, berserk world of ours there are women all over the world who cannot write ... We as writers have an obligation to those women to write their stories ... We are the mere messengers, and what we have to do is research, follow, investigate, as far as we can, into the minds of those girls so that their feelings, their intensities, comes as though by a current to us, to understand, or at least understand as much as any human being can understand the other. And also I would suggest that we forget as writers, or rather omit, the current incendary gripe about cultural appropriation. There is no such thing. There are no borders to the imagination. Writing at its best is a testament to our shared humanity.

Most books do not have long lives, and many writers are forgotten about, even in their own lifetime. Those writers who are brave, take on challenges and become part of the living canon of literature are few, and unique.

Publishing is increasingly now about marketing and numbers, rather than artistic talent and quality work. The marketing budgets authorised by power brokers indicate what they want prioritised, ranging from bookshop buyers and allocation of shelf space, to the media and the reading public. Books can be marketed as the 'first', the 'original', the 'ground-breaking', even when their content clearly isn't. Books can be declared 'bestsellers' before they are even published. Books can be shortlisted for, and win, awards they are not even eligible for. These problems, sadly, are not gender neutral. They also need to be called out through vigorous and rigorous scholarship, rather than jumping on bandwagons with the masses whooping praise.

Poor practices in the arts world were (and still are) tackled by brave people – mainly women. In the 1980s it was incredibly difficult for women to receive bursaries, get published, be reviewed, or to be elected into the artistic organisation Aosdána and receive annual financial support

for their art. Some organisations worked then with passion, integrity and a genuine commitment to diversity, yet their work was ignored in favour of other agenda-driven ideologies. There was a lack of an overall vision for equality in the arts. Would or could an anthology of literary work by Traveller women have been refused funding, then, yet the same anthology be met with substantial funding and rapturous praise, now?

Simplistic presumptions, and problematic use of language and buzzwords, need to be called out. It appears that the mistakes of the past – created and utilised by privileged white men – can also be adopted by others now, thus perpetuating inequalities rather than stamping out bad practices. Equality is a two-way street. As the 'woke' agenda is becoming increasingly more judgemental and toxic, we need to find a way to create a new common ground where all can start on an equal footing. Diversity policies will work best if integration is key. Quality must be at the core of all endeavours. Tokenism is unacceptable. One set of power and privilege cannot be substituted for another. Re-inventing the wheel is no longer an option. Sustainable solutions must be found.

Sustainable solutions *were* found from the 1970s onwards to create opportunities for a large proportion of the literary-minded public previously denied access to the published word – women.

Ailbhe Smyth, in a US feature article published in 1987, stated that Arlen House and Attic Press have played 'a central part in the process of reclaiming women's history and identity'. She interviewed Arlen House founder Catherine Rose in a 'sophisticated but miniscule space they now occupy in a brand-new Dublin office block ... a far cry from the livingroom in Galway where it all began'. Catherine Rose (who had worked in publishing in Cork in the 1960s) had been commissioned to write a book on first wave feminism in Ireland but the:

publisher let her down very badly, leaving her with a broken contract, no money and the conviction that if women's knowledge, ideas and dreams were to be recorded, women would have to do it themselves.

And so they did. Arlen House thrived and survived because 'so many women gave so much of their time for nothing'. Editorial meetings took place in each others' houses, around kitchen tables, 'with small children under the table and sticky fingers in the proofs'. A photo survives from a national newspaper of one 1970s editorial meeting with directors Catherine Rose, Janet Martin, Terry Prone, and editor Eavan Boland making history.

They did make history. The most famous feminist press in the world is Virago Press, founded in London in 1973 by Carmen Callil, although it was to be September 1975 before the first Virago book appeared, published in association with a mainstream press (due to capital and resource issues). That same month, September 1975, Arlen House published its first book, in Galway, from an independent publishing house established as a limited company owned by a woman. *The Female Experience* was advertised as:

> an informative and entertaining book of social comment in which the author charts the course of the women's movement in Ireland. Giving reasons for Irish women's apathy and for the lack of a vigorous women's movement, Catherine Rose sets the Irish situation in the context of international women's liberation.

From the *Books Ireland* review:

> summing up helpfully and critically the multiple entrapments and role-casting of women ... using snappy quotations to get our interest – for one of the problems is a disinclination by both men and women to do more than adopt a stance without much reading or thought – she roves in a free-thinking way over the history and sociology, but without making much effort to argue in the language (or on the level) of the Catholic traditionalist whose attitude is mostly expressed in such

different terms that no real dialogue is possible. One feels that the author could have come to grips with her entrenched opponents better ... she angrily shoots down the idea that women must change to fulfil themselves better in existing society. No, she says, it is society that must change to allow them room for fulfilment, but after that her conclusion seems rather lame: that we can only concentrate on research, information and education.

The Essential Guide for Women in Ireland, originally entitled 'What Every Woman Needs to Know', was written by Belfast journalist Janet Martin, former *Irish Independent* women's editor. This, the first practical handbook for women in Ireland, was launched in 1977 at Listowel Writers' Week:

> Janet Martin guides women through the bureaucratic maze of legal rights and social welfare entitlements. She deals with education, retraining, going back to work, equal pay as well as giving advice on problems concerning sex, marriage, children, health, pregnancy. Concise and comprehensive, this is an essential guide for women in Northern Ireland as well as the Republic.

Catherine Rose remembered in 1987:

> It's hard now to understand just how radical that *Guide* was. As well as dealing with the standard sorts of information – which no one in fact had ever dealt with before – it broached the taboo subjects of contraception and abortion.

Both author and publisher, young women with young children, took the risk of imprisonment under the terms of the Censorship Act when they published it. A supplement was released in 1978 giving additional information.

Early feminist publishing output was focused on political and social affairs, health, children's rights and childcare, family status, education, inspiring biographies and history, new and classic literature and art. Arlen House distributed a pamphlet, *Make Sure You Get Equal Pay* (1977) compiled by the Trade Union Women's Forum. Mollie Lloyd's *The Change of Life* (1979/1981), sold over

20,000 copies; other bestsellers included *Who's Minding the Children* (1981) by Ronit Lentin and Geraldine Niland, *Coping Alone* (1982) by Clara Clark, Maire Mullarney's *Anything School Can Do, You Can Do Better* (1983), which sold over 10,000 copies, and Stanislaus Kennedy's *But Where Can I Go? Homeless Women in Dublin* (1985) – all of which imparted knowledge to tackle power structures. They also published men. *Children First* (1979) by Charles Mollan was commissioned for International Year of the Child. Feminism, as an inclusive politics of equality, was at the heart of all that they did, and achieved.

From *Books Ireland*, August 1979:

> Arlen House, the Women's Press, did things in style on 21 June when they launched their first anthology of short stories in Dublin's Berkeley Court Hotel. The Arts Council and Maxwell House were the generous sponsors and the vibrant, mainly youthful, gathering was fêted with, among other goodies, lashings of coffee, iced and coffee braced and coffee cake ... Fiona Barr, imminently expecting her second child, went up to receive her cheque for £100 as overall winner ... Cheques for £50 were awarded to the other winners and it was remarkable how many had Northern Ireland backgrounds and teaching as a profession ... The County Cork printers were criticized for poor performance and production issues. Dr Margaret Mac Curtain stated that Irish printers are, on the whole, so unreliable and such messers and how could they be otherwise when women are still excluded from their union!

In March 1980 *Books Ireland* reported they:

> received over a thousand entries for this year's Maxwell House sponsored competition to discover new feminine writing talent, for which the prize money will run to nine awards of £100. Fifty per cent of the entries were gunge, Catherine Rose told us ruefully, but to us that sounds a remarkably low proportion, especially when you consider that poetry as well as short stories are eligible this year.

In June 1981 they announced a Women's Literary Competition bursary of £500 for women writers 'who could best benefit from a subvention to buy writing materials and books or attend courses'. At this time it was incredibly difficult for a woman to receive a bursary from any funding agency. In 1984, they founded WEB (Women's Education Bureau), which was the national association for women writers, with Eavan Boland as artistic director and Eleanor Murphy as administrator. In 1986, at the National Gallery of Ireland, they organised the first ever Writers and Readers Day, with speakers including Medbh McGuckian and Maeve Kelly. Catherine Rose commented in 1987 that the literary competitions revealed the 'store of stifled imagination, wit and ability of women' writing throughout the island.

From that 1987 interview, Ailbhe Smyth declared that Arlen House have:

> a plethora of plans and are clearly full of optimism and enthusiasm ... They would like to expand into contemporary American and European fiction by women, and translations are a dream Catherine Rose is determined to realise. She is emphatic that Arlen House has to become self-supporting.
> – It's not only a service – you have to trade. Publishing is super-capital-intensive. We need to raise the print run, keep ahead all the time. Editorial policy has suffered in the past because of our precarious finances – that has got to change ... we have got to move outside and beyond ourselves. We can't afford to be isolated. It's very important for Arlen to bring the diverse experiences and creativity of women elsewhere into Ireland – we need an enriching, nurturing exchange.

She admitted to having been idealistic:

> ... quite simply I wanted to change the world. I'm not disillusioned, but feminist publishing is a difficult business, and although I've lost the naïveté, I get immense pleasure from working with women who have their own ideals and visions. The thrill is still there, the books are so exciting, the potential is vast ... Isn't all feminist publishing, in fact any feminist project, a risk? Which doesn't mean the gamble isn't worth it.

Arlen House was bought by two female investors and a substantial new publishing programme was developed for spring 1987. Shortly before the books were to go to print, the press was closed down.

In 1988 *Books Ireland* commissioned a special feature on feminist publishing with guest editor June Levine. They announced an upcoming revival of Arlen House:

> The pioneer of women's publishing in Ireland and a name justifiably respected by the trade, Arlen House launched many women writers on their writing careers and did much to redress the unbalanced representation of women in publishing.

That revival didn't happen. Catherine Rose had just completed a 20 week stint as director of the first 'Women into Writing' course jointly organised by AnCO/FÁS and WEB, with former Arlen House/WEB staff member Eleanor Murphy working as the administrator. The course, with 27 women students, was strongly orientated towards the practicalities of marketing and presenting work to editors and publishers. Catherine Rose was 'delighted to have been part of the course, but disappointed by the lack of employment opportunities for such an immensely talented group'.

With Arlen House closed, WEB completed some of its publishing plans, most importantly Mary Cullen's *Girls Don't Do Honours: Irish Women in Education in the 19th and 20th Centuries*. The final book was a co-publication with

Carcanet Press in Manchester of Eavan Boland's *Selected Poems* (1989).

The WEB workshops continued, some being day-long courses, others full weekends. An array of prestigious writers conducted the workshops, including Clare Boylan, John McGahern, Seamus Heaney, Jennifer Johnston, Nuala Ní Dhomhnaill, Mary Elizabeth Burke Kennedy, Terry Prone, Mary Rose Callaghan and, most importantly, Eavan Boland. She wrote: 'it struck me too often and too forcibly that women had to struggle at a physical and metaphysical level to be writers in this country'. WEB, as the national representative organisation for women writers in Ireland, was a membership body, and it had over 600 members. During the early 1990s, the WEB board of directors continued to meet, trying to find a way to relaunch the press, but no solution appeared then. A WEB writing group still exists in Dublin to the present day, which includes many of the writers featured in this anthology.

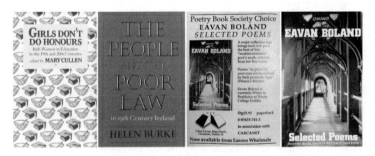

In 1998, the Women's Studies Centre at NUI Galway hosted an exhibition on Irish feminist publishing, co-ordinated by this writer, gathering together an expansive collection of books and archival material. From this research project and event came the idea of relaunching Arlen House, with encouragement from original directors, Catherine Rose, Margaret Mac Curtain, Eavan Boland and Mary Cullen. That story is for another day.

* * *

Dr Margaret Mac Curtain OP (1929–2020)

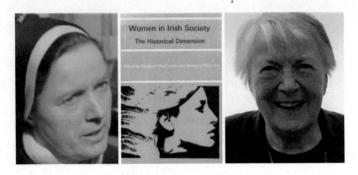

Margaret Mac Curtain is the only author who published with Arlen House, Women's Community Press and Attic Press, and worked with Irish Feminist Information and Women's Education Bureau.

Born in Cork in 1929, she was a student activist in UCC in the 1940s before entering the Dominican order in 1950, where she took the name Sister Benvenuta. A life of teaching and religious work lay ahead, but she was granted permission to enrol for a MA (1958) and a Ph.D (1963), necessitating travel around Europe for research. Back teaching in Dublin, social justice was at the heart of her beliefs. She took public stands on key issues such as feminism, equality, domestic violence, apartheid, corporal punishment, the right to remarry. She was a political activist, with a public profile and reputation, even before the Irish Women's Liberation Movement started in 1970. She mentored generations of activists, including some Irish Presidents. One newspaper referred to her as the most famous woman in Ireland. *Women in Irish Society* (1978), the first Irish women's history text, sold over 10,000 copies.

Intellectually razor-sharp, she wore her genius lightly, using her gifts to impart knowledge and inspiration to vast numbers of people over her 60-year-long career. It would be unwise to underestimate the influence of Margaret Mac Curtain on Irish society. #Legendary.

Eavan Boland (1944–2020)

All those interested in Irish literature, and all women writers, I believe, owe a debt of gratitude to Eavan Boland. She was the first to create spaces – physical, emotional, financial, practical – for women, both fiction writers and poets, in the days when they were not always welcome in the Irish literary world.

In 1978 Eavan Boland contacted Arlen House, offering her support. Terry Prone had come up with the idea of a literary competition to discover new women writers, and secured funding from Maxwell House. Eavan agreed to be a judge, she promoted the initiative in the media and addressed the backlash against the need for a women-only competition and book. She also wrote the foreword to the first book, *The Wall Reader*, published in 1979.

She became an editor at Arlen House, enthusiastically got involved in reclamation projects and, most importantly, in setting up WEB (Women's Education Bureau) and developing and conducting workshops for women writers countrywide – Áine Ní Ghlinn was a participant in her first workshop held in Kilkenny in 1982. Arlen House published *In Her Own Image* (1980), illustrated by Constance Short; *The War Horse* (1980); *Night Feed* (1982); *The Journey and Other Poems* (Arlen House, 1986/Carcanet, 1987) and *Selected Poems* (WEB/Carcanet, 1989).

Arlen House the Women's Press can thank the male chauvenism of Coolock car thieves when their *In Her Own Image* by Eavan Boland and Constance Short appears ... When

the Gardaí finally ran their stolen car to earth everything of value was missing from it, except the typesetting and artwork for the book (*Books Ireland*, March 1980).

In an interview with Jody-Allen Randolph, Boland stated:

The early eighties were a time when some of the very stubborn resistances to women writing the Irish poem surfaced. Those resistances need to be analysed more carefully than I've ever done to be sure what they consisted of. But there's a fair argument to be made that the male poetic community sensed that women poets would disrupt a privileged vantage point ... male poets spoke about the limitation of women's themes, and the mediocrity of women's writing. There was a sort of condescension in the air, and occasionally something more raw and exclusive ... power has operated in the making of canons, the making of taste, the nominating of what poems should represent the age and so on ... I was incredibly lucky during those years to have Arlen House to publish me. They were a feminist publisher and Catherine Rose, who ran it, was a wonderfully steady presence. She was very committed to women participating in the levels of decision-making in the arts (*Irish University Review*, 1993).

In *The WEB* journal (1987), general editor Eavan Boland said it is 'part of the search for different, more sensitive structures which might be more responsive to the needs and growth of emerging women writers in Ireland'. In 2016 in Poetry Ireland, Eavan Boland stated that her favourite publisher over her 55 year career was Arlen House.

The Journey
and Other Poems

THIS IS NUMBER FOURTEEN
OF A LIMITED EDITION OF
FIFTY COPIES

In 1982 a 'Publishers Against the Amendment' group was founded to fight the forthcoming abortion referendum as:

1) it will achieve nothing (abortion is already illegal)
2) it is sectarian
3) a gross waste of public money
4) it removes control from women over their own bodies
5) it ignores the real needs of society.

Signatories included Catherine Rose (Arlen House), Róisín Conroy (Irish Feminist Information), Mary Paul Keane (Wolfhound Press), Rena Dardis (Anvil Books), The Irish Writers Co-op, Anne Tanahill (Blackstaff Press), The Irish Times, Dolmen Press, Gallery Press and O'Brien Press. They offered services and skills to the Anti-Amendment Campaign to improve the quality and effectiveness of their literature and advertising and to help in any practical way.

Also in 1982 a Women in Publishing group was established; its large number of members included Siobhán Parkinson, Mary Paul Keane, Breda Purdue, Sheila Crowley, Helen Litton, Mary Flanagan. They held seminars, workshops and conducted research; in a 1983 survey only 14% of 800 books examined were written by women. 11% of books from Irish publishers were by women; 9% from Arlen, with 2% from mainstream presses.

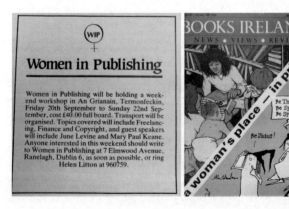

Róisín Conroy and Mary Doran founded Irish Feminist Information Publications in 1978 'in response to a felt need regarding the lack of information/contacts for distributing work written on women's issues'. They produced the very first women's calendar, *An End ... and a Beginning*, and in 1979 started the annual *Irish Women's Diary and Guide Book*, which lasted until its eighteenth edition in 1997. This diary was a crucial source of information for many women, and it serves now as a brilliant reference in demonstrating the vitality of the women's movement.

In 1983, IFI decided to run a new training course for unemployed women to provide them with the skills necessary to work in the publishing industry, in a 'socially significant and innovative' way. They received funding from AnCO and the European Social Fund of the EEC. IFI's ethos was woman-centered, with a commitment to ensuring full participation of all women in the publishing process. They provided not only the technical skills and marketing expertise necessary but also the stimulus for women to think through ideas, record experiences and research neglected areas within a specifically feminist frame of reference.

The first Women in Community Publishing course, co-ordinated by Róisín Conroy and Patricia Kelleher, resulted in 3 publications being researched, compiled and published by the participants, namely *Singled Out: Single Mothers in Ireland*; *Missing Pieces: Women in Irish History*; and *If You Can Talk, You Can Write*. The biggest development, though, was the decision of a number of women on the course to set up their own publishing house, Women's Community Press.

Following the success of its first training course, IFI commenced a second course in 1984 which was co-ordinated by Róisín Conroy and Mary Paul Keane. Out of

this second course came 4 more titles published under the banner 'Women in Community Publishing Course, 1984/1985 in conjunction with Attic Press', namely *More Missing Pieces; Rapunzel's Revenge: Fairytales for Feminists; Who Owns Ireland Who Owns You?* and *Did Your Granny Have a Hammer?*

These two courses were amongst the most successful run by AnCO in the 1980s, with high job placements and critical success. Attic Press was then established as an imprint of IFI, under the directorship of Róisín Conroy and Mary Paul Keane.

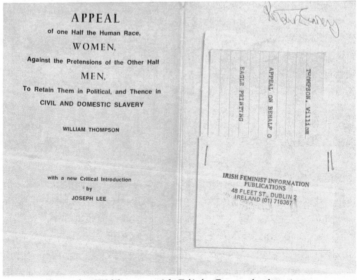

from the IFI library, with Róisín Conroy's signature

This co-operative enterprise originated out of IFI's 1983 Women into Publishing course, when a small group, including Noreen O'Donohue, Marianne Hendron, Mary Flanagan and Sue Richardson decided to establish a press after receiving funding from the EEC. Their aim was to open up the print medium to individuals and groups effectively denied access to it – 'those who are more often written about than able to speak for themselves'. Their first book, *Pure Murder: A Book about Drug Use* (1984), was a bestseller, followed by *The Irish Feminist Review '84* which recorded and illustrated the work of feminist groups and campaigns. Ailbhe Smyth said: 'Given the disturbing lack of documentation and analysis of women's movement activities, the testimony provided by the *Review* has become all the more precious'. They also reprinted *If You Can Talk, You Can Write*, and published a series of pamphlets on co-operatives for UCC, *Write Up Your Street: An Anthology of Community Writing* (1985); *Making Your Mark: Producing Your Own Publication* (1986); *The Parliament of Labour: 100 Years of the Dublin Council of Trade Unions* (1986), and, of special importance, the first ever non-sexist books written by children for children, *I Hate Mustard* (1984) and *Talk About Weird* (1987).

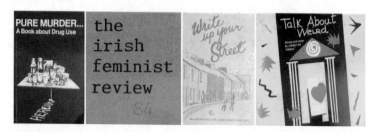

Their most successful enterprise was the publication of feminist and political postcards; hugely popular in 1980s recession-hit, conservative Ireland. Over 100,000 postcards were sold, some being regularly reprinted, though the anti-nuclear cards were less popular. I still remember Mary Ryan, my teacher, bringing postcards into our school in

Donaghmede in 1987, asking us to discuss the themes.

Their most important book was *Out for Ourselves*, which exposed ignorance, censorship, church condemnation and criminalisation of gay men and lesbians. On RTÉ's *Liveline*, Marian Finucane interviewed two of the authors, Clodagh Boyd and Maura Molloy, and referred to callers' commenting on 'dirty sluts' and 'why does Marian have these people on who are spreading AIDS all over the world'. The Sinn Féin and Workers Party bookshops refused to stock it, maintaining that 'our customers wouldn't read it ... there's too much sex in it ... these are private things and there is no need to write about them'. Ailbhe Smyth felt that 'Such crass ignorance and blatant prejudice is especially distressing coming from professedly left-wing political parties', but Marianne Hendron replied 'there's no point banging your head against a stone wall, but we were very upset about the other bookshops', those more mainstream shops that also didn't stock the book.

By 1986 they had 3 staff, despite somewhat precarious finances. They worked on an open, genuinely democratic structure, with decisions being reached by consensus. 'We really do sit down and discuss everything together. Yes, it does work and we find it positively energizing and not especially time-consuming'. They hoped to publish more work by the unemployed, by prisoners, by those deprived of literacy. In 1986 they were working with a group of Traveller women, and on an account of the long-running strike led by women supermarket workers against the importation of South African goods. They were attracted by the idea of opening a women's bookshop since none yet existed. (After Mary Paul Keane left Attic Press she established Sheela-na-Gig in Galway in 1988). When Women's Community Press was forced to close down, some of the women re-organised as Spellbound Books, keeping the postcards in print and publishing another collection of children's writing, *Olly's Honeycottage Restaurant: Non-Sexist Stories and Verse by Children for Children* (1988).

postcards from Women's Community Press/Spellbound 1980s

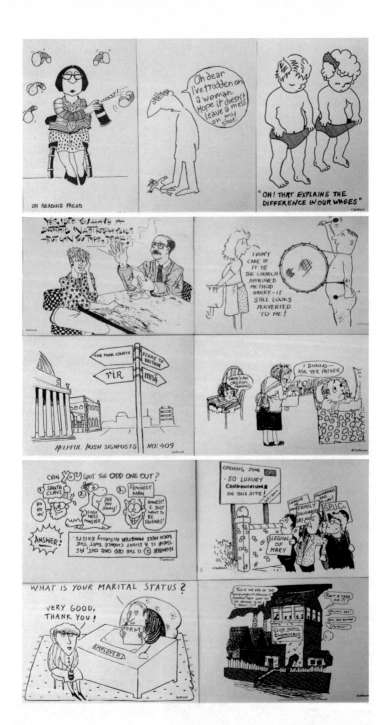

Attic began publishing in autumn 1984 with two remarkable titles, *The Best of Nell* and Rosemary Cullen Owens' *Smashing Times: A History of the Irish Women's Suffrage Movement*. Nell McCafferty's collection generated much commentary and sold in huge numbers (going into its 8th edition by 1994). One Irish printer stated he would not print other Attic books because of what Nell had written.

Books Ireland magazine remains a fascinating, if quirky, resource for Irish publishing history, and while it clearly had a positive relationship with Arlen House, there was tension with Attic from early on, and muted support for, and interest in, their work over the coming years:

> ... rather amusing notion that Attic Press boasts eight members ... Surely *Books Ireland* is not taking the directors' names at the end of our notepaper, a legal requirement, as paid-up staff. IFI does not favour double jobbing as *Books Ireland* implies; all of these women are already occupied in full-time jobs, except for the two full-time worker directors of IFI. This is either a very silly mistake or a conscious wish to misrepresent – I wonder which? (Mary Paul Keane, 1985)

One of the most important books which Attic produced was June Levine and Lyn Madden's *Lyn: A Story of Prostitution* (1987), a horrifying account of 20 years 'on the game'. It was Attic's all-time biggest seller; a book which received a huge amount of attention, including personal threats necessitating police protection for the publisher.

During this period Attic produced other important titles such as Ursula Barry's *Lifting the Lid: A Handbook of Facts and Information on Ireland*; *Around the Banks of Pimlico* by Mairin Johnston, one of the founders of the Irish Women's Liberation Movement, and her *Dublin Belles: Conversations with Dublin Women*, and *Personally Speaking: Women's Thoughts on Women's Issues*, edited by Liz Steiner-Scott, of which *In Dublin* acclaimed 'at last, we have the beginnings of a native feminist anthology'. By 1988, of Attic's 25 titles to date, 7 had made the bestseller charts, and 60% of its output was being exported to the US and UK.

The expansion of Attic Press in the late 1980s/early 1990s coincided with the appointment of Ailbhe Smyth as editor. She developed much of the fiction output and the LIP series of provocative pamphlets which eventually included 15 contributions by Eavan Boland, Margaret Ward, Carol Coulter, Ruth Riddick, Gretchen Fitzgerald, Clodagh Corcoran, Maureen Gaffney, amongst others. During 1989/1990, ten Attic Handbooks were published on such subjects as *Surviving Sexual Abuse; Body Matters for Women; No Body's Perfect: Dealing with Food Problems; Separation and Divorce Matters for Women; Sex Education and Health Matters for Girls*.

The Bright Sparks series for teenagers was particularly groundbreaking, generating many awards and huge sales. The first title, Joan O'Neill's *Daisy Chain War* (1990) went into 8 editions in Ireland alone, yet met some controversy over a sex scene, and some editions were re-edited/censored. Mary Rose Callaghan's *Has Anyone Seen*

Heather? was reprinted numerous times, with its sequel *The Last Summer*, published by Poolbeg in 1997. Geraldine Mitchell's first book, *Welcoming the French* (1992) sold over 10,000 copies.

New fiction included one of the first Irish lesbian novels, *The Kiss* by Linda Cullen, and Attic's contribution to the then newly-thriving 'chick-lit' phenomenon, *Whispers on the Wind* and *Glenallen* by Mary Ryan, and *Promised* by Joan O'Neill – controversial publishing decisions in some feminists' opinions as they felt Attic's feminist credentials were being damaged. Róisín Conroy was unrepentant in the face of criticism, explaining that profits from commercial projects helped fund unsustainable feminist titles. The two Mary Ryan titles were phenomenal sellers, and rights were sold to publishers in the US, UK and Germany.

Ailbhe Smyth's edited collections, *Wildish Things* (1989), *The Abortion Papers Ireland* (1992) and *The Irish Women's Studies Reader* (1993), which included a contribution by Mary Robinson, President of Ireland, were important titles in Attic's history. In 1992, Róisín Conroy wrote *So You Want to be Published?* which was the first account of the publishing process in an Irish context. It sold 5000 copies. Also published was Noreen Byrne's *Choices (in a Crisis Pregnancy)* and Ann Owens Weekes' *Unveiling Treasures: The Attic Guide to the Published Works of Irish Women Literary Writers*. Many health and lifestyle titles were developed during this time, with books on women and alcohol, stress, childcare, parenting etc.

Titles of historical interest published included *A Link in the Chain* by Hilda Tweedy, co-founder of the Irish Housewives Association which celebrated its half century in 1992. 1994 saw the publication of Suellen Hoy and Margaret Mac Curtain's *From Dublin to New Orleans: The Journey of Alice and Nora,* and Daisy Lawrenson Swanton's *Emerging from the Shadows: The Lives of Sarah Anne*

Lawrenson and Lucy Olive Kingston Based on Personal Diaries, 1883–1969. Mary Cullen and Maria Luddy's edited collection of biographical portraits, *Women, Power and Consciousness in Nineteenth Century Ireland*, appeared in 1995 (its sequel, *Female Activists*, was published in 2001 by Woodfield Press, who have a prestigious record in publishing feminist and women's history titles), and in 1996 appeared Maureen Murphy's edited *I Call to the Eye of the Mind*, a memoir by Sara Hyland who had worked with the Yeats' sisters in the embroidery workshop of the Dun Emer, later Cuala Industries.

Important political titles included Emily O'Reilly's *Candidate: The Truth Behind the Presidential Election* in 1991, while in 1992 her *Masterminds of the Right* looked at the people behind the 1983 referendum on abortion and the 1992 referendum on the Maastricht Protocol and exposed the 'leadership and the tactics of the extreme right-wing activists who have hi-jacked Ireland's social agenda for almost two decades creating unprecedented political turmoil'. In 1992, Kate Shanahan's award-winning *Crimes Worse than Death: How Violence is Terrorising Women* appeared, along with Úna Claffey's *The Women Who Won: Women of the 27th Dáil.*

From its conception, Attic was run on firm business lines, and they benefited from numerous grants, nationally and internationally, including successfully receiving Arts Council support for some years. Without doubt, Attic Press was one of the most significant publishing houses in Ireland in the 1980s and 1990s.

Nell McCafferty is Attic's most important writer. Indeed, she is one of the most important voices in Irish society over the past 50 years. Attic Press started with her journalism collection, *The Best of Nell* (1984), followed by her Kerry Babies exposé (the back cover of which had to be censored due to demands by an Irish book chain). The large format photography collection, *Women in Focus: Contemporary Irish Women's Lives*, had text by Nell and Pat Murphy, then *Goodnight Sisters,* a second journalism collection followed and a monograph, *Peggy Deery: A Derry Family at War* (1988). Another collection, *Nell on The North: War, Peace and the People*, was scheduled for 1995, but Róisín Conroy cancelled the publication because the peace process was at a delicate stage and they didn't want to create controversy.

'*A Woman to Blame* is a brilliant exposé of the tensions and contradictions, the narrow-minded hypocrisy and profoundly sexist double-think which marks our daily lives. Investigating the "case" against Joanne Hayes, accused but acquitted of infanticide, McCafferty slides under the microscope virtually the entire battery of the Irish State and its institutions – the Family, the Church, the legal and medical professions. It is a deeply disturbing and passionate indictment ... raw, direct, witty, gritty and must evoke a response in even the most jaded, dispirited feminist heart and mind' – Ailbhe Smyth

NEW LITERATURE BY IRISH WOMEN WRITERS

Caroline Walsh (ed.), *Virgins and Hyacinths: An Attic Press Book of Fiction* (1993), 'the very best short stories by a new generation of Irish women writers, reflecting collectively the experience of what it is like to be a woman in Ireland today. Humorous, novel and brave, this collection will enthral you from cover to cover'. Includes Ivy Bannister, Liz McManus, Máiríde Woods, Mary Morrissy, Éilís Ní Dhuibhne, Mary Dorcey, Maeve Binchy, Anne Enright. The original working title was *Baby Please Stop Crying*.

A new Queer Views series was launched in 1994. *Sugar and Spice: A Lesbian Anthology* was advertised but not enough contributors were identified, so short stories by Cherry Smyth and Jo Hughes were included in Brian Finnegan (ed.), *Quare Fellas: New Irish Gay Writing*.

BASEMENT PRESS, an imprint of Attic Press

A.P. Clarke, *The Way of the Bees: An Ovarian Yarn* (1995)

Mother Nature, and Saint Gubnet of Ballyvourney, her lover, have built Mother Nature International into a huge empire. But trouble is at hand. Her renegade island of Ascourt is rejecting The Way of the Bees on which Mother Nature's empire is founded, preferring to live in a land without males, and striving to create a scientific breakthrough which will allow woman-to-woman reproduction. And her lover has upped and left her ...

Ruthless in pursuit of profit and productivity, Mother Nature will stop at nothing, even murder, to get her own way. But she has to deal with a cast of hilarious, finely-drawn characters including princesses Bea, Vee and Min, Queen Porshia, hack journalist Montague du Pont, the Old Dames and Cook. This compelling blend of detective story, fantasy and satire is a completely original debut.

Maureen Martella, *Bugger Bucharest* (1995)

The night JC was born, sleeply little Ballysheel appeared to hold its breath, as if nature itself was aware that a momentous event was taking place. But nobody ever dreamed just how momentous that night was. Even when mysterious healings began, even when the horrendous deaths occurred, the town carried on as usual.

Only when the inexplicable pregnancies became noticeable did people realise that something extraordinary was happening. What was turning winter into summer, sending pious people screaming out of their parish church? And just who was this 'young healer'? Was he the fake Fr Denny claimed or a god recognised and followed by delighted young children? This debut is a sharply-observed, quietly-savage satire.

In 1997 Róisín Conroy sold Attic Press to Cork University Press and deposited her large archive in UCC. She was ready to pass the pen on to a younger generation:

> Attic Press has contributed enormously to the debates on, by and about women's issues that have dominated Irish society in the last two decades. These issues include poverty, divorce, violence, equality legislation, health, contraception, abortion, pay and public representation.

Sara Wilbourne, publisher at CUP, had big plans for Attic, including reprinting key titles, commissioning new ones and relaunching the Bright Sparks series. They reprinted *Lyn: A Story of Prostitution* multiple times, and released Lyn Madden's sequel, *Lyn's Escape*. Anne Maguire's *Out on Fifth Avenue*, on the Irish lesbian and gay movement's campaign against homophobia in New York, was scheduled for 2003, but ultimately cancelled.

Atrium, a new imprint of Attic, was established in 1999 to publish books for the trade, starting with the bestselling *Cafe Paradiso Cookbook*. Attic had published cookbooks by Máirín Uí Chomáin (1992/1994) and *Tasty Food for Hasty Folk* (1990) by Lorna Reynolds – a lesbian icon whom Róisín admired and whose photo hung on the Attic wall.

Flyer for Éilís Ní Dhuibhne's first book, and related bookmarks

1971 1972 1973

Banshee, 1976 *Wicca*, 1978 *Wimmin*, 1981

Status magazine (1981) edited by Marian Finucane

Women's News, 1984–2011

Ms.chief, 1990s f/m: feminist magazine, 1999

UCG Women's Studies Review/Women's Studies Review, 1992–2004

Irish Journal of Feminist Studies, 1996–2003

Irish Feminist Review, 2005–2007

COMMUNITY PUBLISHING

Since the 1980s island-wide there has been a huge amount of local/community publishing, including many anthologies edited by contributors to this book. Some shine a spotlight on women writers, others have a more thematic or geographic focus in which women generally feature significantly. These anthologies were crucial for developing confidence and a publishing record and reputation.

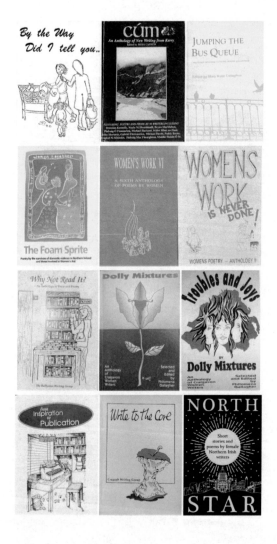

Over the past fifty years a number of Irish publishers, extant and defunct, have made significant and brave contributions towards developing a more egalitarian literary scene. Often, the most impressive contributions came from independent, poorly-funded or non-funded organisations, while State-funded publishers sometimes tended towards conservatism and avoided risk-taking.

Mercier Press, Ireland's oldest independent publisher, has always had an open attitude to supporting women writers. They published Kate O'Brien, Patricia Lynch, Frances Browne, Annie Smithson and Nuala Ní Dhomhnaill in the days when it was neither profitable nor trendy to do so. Poolbeg Press, founded in 1976, has always had a healthy commitment towards publishing women. David Marcus, its first editor (acclaimed by many women as their first mentor) published an impressive list which was developed not from a feminist consciousness but from his commitment to short fiction which didn't discriminate on gender grounds. From the late 1980s, Poolbeg led the way in publishing a new style of fiction – what is patronisingly and dismissively called 'chick-lit'. Poolbeg started the careers of a large number of women writers who have since achieved international acclaim and some wealth. The publishing world continues to downplay serious literary writing by women under the frivolous chick-lit moniker.

Two writers who immediately stand out are Maeve Binchy, and Marian Keyes, whose 3rd novel, *Rachel's Holiday* (1998) astonished in its depiction of addiction and recovery, while *Anybody Out There?* (2006), addresses grieving and healing so movingly, but was given a frivolous, inappropriate pink cover.

The legendary Maeve Binchy had a publishing career that should have won her many prestigious literary awards,

and would have if her name had been masculine. Binchy covered a vast array of themes with integrity and bravery. I'm reminded of the headline from a tabloid review when *Brooklyn* was published: *Colm Tóibín has written a Maeve Binchy novel and he will win literary awards for it.* Thankfully, bitterness is missing from Binchy and Keyes' personal vocabulary. Their contribution to Irish *literature* is acknowledged and rewarded, and will be honoured.

From its foundation in 1976 Co-op Books published only a handful of women writers; its publisher Steve MacDonogh then moved to Kerry in 1982 and founded Brandon, imbuing its publishing programme with a healthy independent spirit, an international perspective and a commitment to freedom of speech. Until his untimely death in 2010, he published an impressive array of new voices, including a substantial number of women. O'Brien Press have kept the Brandon imprint alive, and it adds to their large list, particularly their important commitment to children's literature. Brandon published Susan Lanigan's impressive debut, *White Feathers*, in 2014.

Lanigan has successfully self-published her second novel, *Lucia's War* (2020), dealing with race, identity and prejudice. Rose Servitova has also self-published, very successfully, two novels, *The Longbourn Letters* and *The Watsons*. The traditional publishing route may not be the best way for all writers, and indeed publishing may increasingly go the way of the music industry.

Raven Arts Press was founded in Dublin in 1977 by Dermot Bolger, and again published an impressive body of more than 100 books over the next 15 years, though only a handful by women, including Nuala Ní Dhomhnaill, Sara Berkeley and Rosita Boland. Raven Arts merged with New Island Books in 1992, who over the past three decades have made a major contribution to Irish women's literature, particularly with anthologies by Éilís Ní Dhuibhne, Evelyn Conlon/Hans-Christian Oeser, Sinéad Gleeson, and Linda

Anderson/Dawn Miranda Sherratt-Bado. Lilliput Press since its foundation in 1984 has also made a significant impact, nationally and internationally.

In 1986 Máire Bradshaw founded Bradshaw Books in Cork. Its first book, *The Box Under the Bed*, a collection of women's writing, was edited by Christine Michael and introduced by Eavan Boland.

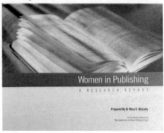

Women in Publishing
A RESEARCH REPORT

Prepared By Dr Mary E. Mulcahy

Their final publication was the *Cork Literary Review* (2017), edited by Kathy D'Arcy. Over 30 years Máire Bradshaw published about 300 books, largely by women and children, introducing an impressive number of new voices into Irish literature. She deserves to be acknowledged.

A small number of women owned their own presses, such as Terri McDonnell at Woodfield, Treasa Coady at TownHouse and Rena Dardis at Anvil/The Children's Press. All made important contributions to Irish literature.

Blackstaff Press, particularly during the 1980s under the direction of Anne Tannahill, has had a long and honourable tradition of publishing women writers. The defunct Belfast publisher, Lagan Press, also started the careers of many women, while Summer Palace Press, based between Belfast and Donegal, has introduced dozens of women poets. Lapwing, publishing in Belfast since 1989, have released hundreds of chapbooks, with a large number of new female voices.

In terms of the mainstream poetry presses, Salmon's Jessie Lendennie has led the way since 1981 with limited support but with extraordinary vision and courage. Gallery Press (founded in 1970), despite its claim for preeminence and its ability to shape the canon, has disappointed with its diversity record and its funding, while Dedalus Press from its foundation in 1985 published only a handful of women, until the situation improved in

recent years. Within Irish language publishing, Coiscéim has supported many women writers. The prestigious publishers, Cló Iar-Chonnacht and Cois Life have published a smaller number of fine women writers. And in 2010 children's literature in Ireland received a major boost with the establishment of Little Island, founded by Siobhán Parkinson – who was an activist in the Women in Publishing group in the 1980s.

In more recent years a small number of small presses have received high levels of funding from the Arts Council. Some have achieved impressive success, introducing important new voices, such as *The Stinging Fly* (debuts from Mary Costello, Danielle McLaughlin, Wendy Erskine, Claire-Louise Bennett); Skein Press, Doire Press and *Banshee*. Tramp Press has debuted fiction by Oona Frawley, Sara Baume and Arja Kajermo (who worked with Women's Community Press and Attic in the 1980s); published memoir and polemic, reprinted contemporary international novelists, and classics by Charlotte Riddell, Dorothy Macardle and Maeve Kelly among others.

Looking towards the future, if power brokers and their protectors are not publicly challenged, then the 'canon' and all who sail within it and benefit from it, will not be an accurate reflection of the breath and diversity of the living literary scene.

When the history of women's writing in Ireland comes to be extensively written, please write in the names of those truly ground-breaking publishers Catherine Rose, Róisín Conroy, Mary Paul Keane, and the editors of crucial anthologies – Eavan Boland, Janet Madden, Ruth Carr, Christine Michael, Ailbhe Smyth, Caroline Walsh, Éilís Ní Dhuibhne, Joan McBreen, Mary Rose Callaghan, Evelyn Conlon, Nuala Ní Chonchúir, Rebecca O'Connor, Jessie Lendennie, Sinéad Gleeson, Kathy D'Arcy, among so many. Their names must be sung loud and clear. Let's not write women out of literature and history any longer.

Recent work by women writers from Arlen House

Orfhlaith Foyle

Red Riding Hood's Dilemma

Maighread Medbh

IMBOLG

Mary Turley-McGrath
AFTER IMAGE

Geraldine Mitchell
MUTE/UNMUTE

Belongings

Joan Newmann, Kate Newmann

Train to Gorey

Liz O'Donoghue

Una O'Higgins O'Malley
TWENTIETH
CENTURY
REVISITED

Preparing
for Spring
Nell Regan

Dairena Ní Chinnéide

FÉ GHEASA | SPELLBOUND

Travelling West

Rita Kelly

CUISLE FHIÁIN | WILD PULSES
Rogha Dánta | Selected Poems

Deirdre Brennan

Colette Ní Ghallchóir

AN tAMHARC DEIREANNACH : THE LAST LOOK

selected and introduced by Cathal Ó Searcaigh

Celia de Fréine
I bhFREAGAIRT AR RILKE
IN RESPONSE TO RILKE

Eithne Ní Ghallchobhair
MÚSCAIL, A GHIORRIA

COOLCHAINT

Dolores Stewart

Tattoo : Tatú
Bríd Ní Chuinidír

Clemency Emmet
FIRESEED

Artwork by Elizabeth Cope

TWELVE BEDS
FOR THE DREAMER

Maighread Medbh

Geraldine Mitchell
Of Birds and Bones

Maeve McDonald
CIRCLING

LEAVING THE LADIES
Sinéad McCoole

Deirdre Brennan
SMIDEADH : MAKEUP

Orfhlaith Foyle
MAY'S END

ARLEN CLASSIC LITERATURE
Maeve Binchy
Deeply Regretted by ...

OPEN-EYED, FULL-THROATED
An Anthology of American Irish Poetry

Edited by Nathalie Anderson

Mary Coll
SILVER

Eileen Casey
A FASCINATION WITH FABRIC

NOIR BY NOIR-WEST
Dark Fiction from the West of Ireland
James Martyn Joyce Editor

WASHING WINDOWS?
Irish Women Write Poetry

Celebrating 250 Years of Hodges Figgis
READING THE FUTURE
New Writing from Ireland
Alan Hayes Editor

Siobhán Campbell and Nessa O'Mahony Editors
EAVAN BOLAND: INSIDE HISTORY

The Danger and the Glory
Irish Authors on the Art of Writing

¡DIVAS!
new irish women's writing

BENEATH CASTLES OF WHITE SAIL

¡DIVAS!
new irish women's writing
'A Sense of Place'
NUALA NÍ CHONCHÚIR, editor

María Baranda
If We Have Lost Our Oldest Tales
Translated by Lorna Shaughnessy

MOTHER TONGUE
Pura López Colomé
Translated by Lorna Shaughnessy

Bewick
SEVEN AGES

Kelly reads Bewick
Rita Kelly, Poet, interprets the paintings of Pauline Bewick

PAULINE Bewick
SEVEN AGES